TRANSFIGUREMENTS

TRANSFIGUREMENTS

On the True Sense of Art

JOHN SALLIS

THE UNIVERSITY OF CHICAGO PRESS

CHICAGO AND LONDON

JOHN SALLIS is the Frederick J. Adelmann Professor of Philosophy at Boston College and author of many books, including *The Verge of Philosophy* (2007), published by the University of Chicago Press.

The University of Chicago Press, Chicago 60637
The University of Chicago Press, Ltd., London
© 2008 by The University of Chicago
All rights reserved. Published 2008
Printed in the United States of America

17 16 15 14 13 12 11 10 09 08 1 2 3 4 5

ISBN-13: 978-0-226-73422-4 (cloth)
ISBN-10: 0-226-73422-6 (cloth)

Library of Congress Cataloging-in-Publication Data

Sallis, John, 1938–
 Transfigurements : on the true sense of art / John Sallis.
 p. cm.
 Includes bibliographical references and index.
 ISBN-13: 978-0-226-73422-4 (cloth : alk. paper)
 ISBN-10: 0-226-73422-6 (cloth : alk. paper) 1. Aesthetics. 2. Art—
Philosophy. I. Title.
 BH39.S25195 2008
 111'.85–dc22 2008005216

♾ The paper used in this publication meets the minimum requirements of the American National Standard for Information Sciences—Permanence of Paper for Printed Library Materials, ANSI Z39.48–1992.

FOR
Hannah

νῦν δὲ κάλλος μόνον ταύτην
ἔσχε μοῖραν, ὥστ᾿ ἐκφανέστατον
εἶναι καὶ ἐρασμιώτατον.

Plato, *Phaedrus* 250d–e

CONTENTS

ACKNOWLEDGMENTS

I am grateful to Northwestern University Press for permission to include in the present volume my paper "Carnation and the Eccentricity of Painting," which appeared in *Hegel and the Arts*, ed. Stephen Houlgate; also for permission to use material from my paper "Mixed Arts," published in *Proceedings of the Eighth International Kant Congress*, ed. Hoke Robinson (Marquette University Press, 1995); also for permission to adapt some material from my paper "Nature's Song," which appeared in *Revue Internationale de Philosophie* 45 (1991). My thanks especially to Jerry Sallis, Nancy Fedrow, and Shane Ewegen for their fine and generous assistance.

Freiburg
April 2008

REFERENCES

Jacques Derrida

TP *La verité en peinture.* Paris: Flammarion, 1978. Translated by Geoff
 Bennington and Ian McLeod as *The Truth in Painting* (Chicago: University
 of Chicago Press, 1987).

G. W. F. Hegel

A *Ästhetik.* Edited by Friedrich Bassenge. 2 vols. West Berlin: Das
 europäische Buch, 1985. Translated by T. M. Knox as *Aesthetics: Lectures
 on Fine Art*, 2 vols. (Oxford: Oxford University Press, 1975) (continuous
 pagination).

Martin Heidegger

HN *Nietzsche.* 2 vols. Pfullingen: Günther Neske, 1961. Translated by D. F.
 Krell as *Nietzsche*, 4 vols. (New York: Harper & Row, 1979).
UK *Der Ursprung des Kunstwerkes.* In *Holzwege.* Vol. 5 of *Gesamtausgabe.*
 Frankfurt a.M.: Vittorio Klostermann, 1977. Translated by Albert
 Hofstadter as *The Origin of the Work of Art*, in Heidegger, *Basic Writings*,
 ed. D. F. Krell (San Francisco: Harper, 1993).

Immanuel Kant

KrV *Kritik der reinen Vernunft.* Vol. 3 (2nd ed., 1787) and vol. 4 (1st ed., 1781) of
 Werke: Akademie Textausgabe. 9 vols. Berlin: Walter de Gruyter, 1968.
KU *Kritik der Urteilskraft.* Vol. 5 of *Werke.*

Friedrich Nietzsche

WM *Der Wille zur Macht.* Edited by Peter Gast and Elisabeth Förster-
 Nietzsche. Stuttgart: Alfred Kröner, 1964.

William Shakespeare

D *A Midsummer Night's Dream*. Edited by Harold F. Brooks. Arden edition.
 Walton-on-Thames: Thomas Nelson, 1997.
M *Much Ado about Nothing*. Edited by A. R. Humphreys. Arden edition.
 London: Methuen, 1981.

For Platonic dialogues the standard abbreviations and Stephanus numbers are given.

All translations are my own, though I have consulted available translations. In cases where there is neither standard pagination nor invariant section numbers, the page number in the English translation is given following that in the original text.

PREFIGUREMENTS

Fully imagining a scene requires not only bringing it before one's imaginative vision but also displacing oneself, imagining oneself at the site where the scene would be visibly present. Merely entertaining an image of the scene does not suffice, not even if one's imaginative vision is thoroughly engaged with the scene imagined. Rather, the imagining must also compensate for one's actual absence from the scene, breaking with the indifference based on the pretense that anything can be seen from anywhere. The imagining must, then, be such that, in imagining the scene, one also imagines oneself looking on at the imagined scene. It must be an imagining in which one resituates oneself in the place where the scene would be visible. It must be an imagining in which there is comportment not only to an image but also to a place to which one imaginatively transports oneself.

In this fashion imagine yourself on a Greek landscape. Transport yourself there just as dusk is falling. Your back is to the sea. You are facing westward. Just ahead a single bare mountain rises prominently above the surrounding plane. The sun has just set behind the mountain, and its last fiery brilliance has now given way to the softer glow that portends the evening to come. In the twilight little can be seen distinctly on the slopes, and yet the contour of the mountain, set against the lighter sky, is all the more conspicuous.

The line traced against the cloudless sky curves sharply upward to its apogee and then slopes gently downward to the level of the surrounding plane. Imagine engaging your vision with this graceful contour, not just passively perceiving it but actively taking it up, letting your vision be enthralled by the beauty of this singular sight. Such enthrallment is not unlike the visual immersion required in order to let a painting open

I

up and reveal the depth of its shining. It is neither mere seeing nor sheer phantasy set apart from perception but rather an imagining that comes to animate and transform perceptual vision. The advent of this distinctive imagining both engages vision more vitally with the visual scene—so that one is captivated by the life of the scene, whether natural or artistically represented—and simultaneously detaches it in such a way that it can trace and retrace the scene in ever varying ways, freely, playfully.

Imagining, imaginatively transported to the site imagined, can issue, then, in a doubling, becoming in this respect an imagining of imagining. Furthermore, the imaginative engagement by which vision actively, freely, playfully, traces the outline of the mountain can be enlivened by a certain aesthetic sensitivity to the varying curvature of the line and to its over-all shape; and in this event you will no doubt let your vision range still more freely along the contour silhouetted against the slowly darkening sky. Even as your vision enfolds the figure taken up in imagination, you will also no doubt be drawn to the scene in such a way that the distance across which you would have observed it gives way to an affective proximity. A feeling for the lovely figure will be aroused, its inwardness balanced by its directedness to the figure, by its intentionality. If the quality of the feeling were to be described as pleasurable, it would be imperative to insist that such pleasure has little in common with that which results from the satisfying of appetitive needs. It would be more fitting to call it contempla-tive pleasure, or simply joy in the beautiful.

In such an affective imaginative vision, something is given to under-stand, something is yielded to understanding. This gift of understanding pertains no less to a beautiful natural scene than to a work of painting or sculpture. Yet in these connections understanding has little to do with knowing, with the production of knowledge. There is perhaps no better indication of this remoteness from knowledge than the experience that, when one stands before a beautiful natural scene or a work of visual art, speech is inhibited. Indeed it may even happen that the greater the engage-ment of imagination and understanding in the scene or work, the less the inclination becomes to venture to say what the spectacle yields. While inviting the most vital and active exercise of imagination, such scenes and works demand silence. They require that one forgo operations of significa-tion, which would set, in place of what is understood, the concepts thereby signified. Instead, we linger in the quiet contemplation of the beautiful. We are drawn along in playful, enlivening contemplation, and it is as if there were a mutation of time itself, a relief from the incessant rush from one moment to the next.

Perhaps then, if contemplative joy is taken in the graceful contour of the mountain, it will appear marvelous that this figure drawn in nature, drawn by nature, offers itself in this way. Perhaps it will appear marvelous that it is drawn in such a way that it can engage imagination, arouse feeling, and yield something to understanding. For it is as if it had been drawn in just the right way, intended for precisely these subjective powers. It is as if the inscription had been purposively designed to call forth their play. It is as if nature's art were aimed at the human heart and mind. It is likewise with nature's music, for instance, in the guise of bird songs: these appeal to the human ear and indeed to the heart, so that joy is taken in the music making of these creatures, as if they sang just for us.

Yet as night falls over the landscape, the birds grow silent, and even the cicadas, who sang their hearts out under the noonday sun, are now heard only faintly and intermittently. As night comes on, the contour of the mountain grows indistinct, as if night came to erase the line that dusk had drawn. As the very last vestige of twilight disappears from the moonless sky, the mountain withdraws almost entirely into the darkness. In its nocturnal retreat, nature enacts a more inexorable withdrawal; it prefigures the move by which it mounts its guard against human intrusion and attests to a reserve anterior to all that it offers to the human heart and mind. As darkness falls, nature is released to itself, and we, sensing its utter aloneness, are given back to ourselves.

> Now in the stillness and the aloneness
> the blossom returns to the tree,
> and the bird to its nest,
>
> the light returns to the water,
> the shadow to the boulder,
> and I return to myself.[1]

>>> <<<

Though imagination, allied with joy in the scene, readily comes to transfigure sense, both reconfiguring and elevating it, sense is what in every case grants the initial opening onto the scene. It is before and for sense that the natural scene is laid out, even if, from the very moment of opening, imagining and its accompanying joy already come into play, taking up the scene and letting the shining of its beauty commence. It is also from

1. Elizabeth Coatsworth, "Now in the Stillness," in *Down Half the World* (New York: Macmillan Company, 1968), 65.

sense, with sense, that art is compelled to begin, with the things of sense, with so-called material objects as sensibly apprehended. Yet in art, too, as with the beauty of nature, everything depends on the transfiguring of sense. In the discussion of the poet presented in his book *Nature*, Emerson refers to *The Tempest*, citing certain passages that serve to illustrate how thoroughly the fabric of this play consists of interwoven imaginings. Emerson notes explicitly how Shakespeare's poetry presents (through the characters Ariel and Prospero) the imaginative and creative powers that engender poetry and indeed all art. Emerson writes of the "transfiguration which all material objects undergo through the passion of the poet."[2] The poet, according to Emerson, "animates nature," lets it announce what lies beyond the reach of mere sense, the resplendent beauty either of nature itself or of nature transfigured into art. Since in both cases the beautiful gives something to understand, its advent launches the transfiguring of sense into meaning, even though—decisively—the meaning given to understand remains irreducible to signification, resists translation into concepts and purely theoretical assertions. At the same time, this transfigured sense provides a medium into which such expressions of truth—that is, significations, concepts, denotative assertions—can be transposed and thereby rendered, in Hegel's phrase, more friendly to sense.[3] Thus, with Hegel, art as such is determined as the sensible presentation of the true. In the words of the poet:

> Doch uns gebührt es, unter Gottes Gewittern,
> Ihr Dichter! mit entblösstem Haupte zu stehen,
> Des Vaters Stral, ihn selbst, mit eigner Hand
> Zu fassen und dem Volk ins Lied
> Gehüllt die himmliche Gaabe zu reichen.[4]

Art presents the true, the heavenly gift, by wrapping it in song or in some other sensible cloak, by infusing it into the sculpted marble, by making it

2. Ralph Waldo Emerson, *Nature*, in *The Selected Writings of Ralph Waldo Emerson*, ed. Brooks Atkinson (New York: Random House, 1950), 30.

3. Hegel uses the phrase in indicating the limit of art, namely, in declaring that there is "a deeper comprehension of truth" for which "it is no longer so akin and friendly to the sensible" (*A* 1: 21/10). Art's incapacity for presenting truth as thus comprehended is what renders art, in Hegel's view, a thing of the past (*ein Vergangenes*).

4. "And yet, it behooves us, you poets, / To stand bare-headed beneath god's thunderstorms, / To grasp the father's [lightning] flash itself with our own hand / And to offer to the people / The heavenly gift, wrapped in song" (Friedrich Hölderlin, "Wie wenn am Feiertage," in vol. 1 of *Sämtliche Werke und Briefe*, ed. Günter Mieth [Munich: Carl Hanser, 1970], 255).

shine through the colors of a painted surface, or by letting it resound in the human voice.

Thus, in the middle world of art both sense and truth are transfigured. Indeed, the middle world of art, the true sense of art, is precisely this double transfigurement.

In a sense there is nothing but sense and its transfigurings; or rather, since its transfigurings only produce other senses, other senses of sense, there is, in broadest perspective, nothing but sense. For, in what it says, the word spans the most gigantic interval, that between pure concept and mere intuition, between the intelligible and the sensible. Furthermore, with only the merest supplements, it can be made to designate not only the terms encompassing the full range of what is but also the corresponding forms of apprehension: one can sense something sensible, apprehend by sense a sensible thing, and one can have a sense for what it means, comprehend its sense. The word is both unlimited, since everything belongs, in a sense, to sense, and abysmal, since the distinction between its senses presupposes this very distinction: to distinguish between different senses is already to operate within the framework of the distinction between meaning or signification and the other sense or senses of sense.

For Kant the problem of aesthetic judgment, specifically of the judgment of taste, lies precisely in the fact that it cannot be determined by sense in either of the primary senses, neither by a concept nor by a singular thing with its sensory, material content. The problem becomes especially acute in the case of music, which seems to be so thoroughly immersed in the sensory content of audition that its very status as fine art has to be called into question. Yet with music, as, more readily, with the other arts, Kant's strategy is to seek within sense a dimension of form capable of rendering the artwork beautiful. In every case the pertinent form must be distinct from form in the sense of concept; it must be a form, a kind of form, that belongs to the intuitive, perceptual sphere, yet without being bound to the materiality, the sensory content, belonging to the things of that sphere. It must be a form that, through the transfiguring of sense, can be freed from mere sense and, as the true sense of sense, taken up into the imagination.

For Hegel sense is, in a sense, the very element of art. Since art is the sensible presentation of the true, that is, of the idea or of spirit, it is sense that both opens the range of possibilities of art (as in prescribing the division into the particular arts) and at the same time determines its limits, since the true—whether thought as the idea, as spirit, or as such—does not in every respect yield to sensible presentation. Yet, in the guise in which

it determines the possibilities and limits of art, sense has already been transfigured. It has been detached from the materiality that belongs to the sensible object as merely intuited or desired, and what counts for art is, instead, the very shining of the sensible. Art commences only through the transfiguring of mere sense into the shining of sense.

While, with Heidegger, the question of the sense of art remains in play, its development occurs in direct proximity to Heidegger's rethinking of truth as unconcealment. As a result, the question of the sensible in art assumes a different guise and gains a certain counterdirectionality. Initially the bond of art to sense is construed in terms of the thingly substratum of the artwork; yet this construal, submitted to deconstruction, eventually gives way to reflection on the bond of the artwork to the earth. By means of this transition, the shining of the artwork is referred back to a reserve, a closure, anterior to the space of shining. Thus, in this connection, too, there occurs a transfiguring of sense, its reconfiguration in the figure of the earth.

In art everything depends on sense and its transfigurings, not only on the side of what is sensed (sensible things as well as sense in the sense of meaning) but also on the side of sensing, of sensibility, of having a sense for certain kinds of things. The artist relies on a gift, however imperative it may be to develop the fine craftsmanship that allows him to shape or compose the elements of his art. He relies on a natural gift, one by which, in Kant's phrase, "nature gives the rule to art" (KU 307). This donation transfigures the common sense for the beautiful into the imaginative sensibility of genius. It draws one beyond oneself, beyond the sensibility that one naturally enjoys on one's own; it makes the prospective artist receptive, sensitive, to something that quite exceeds his capacities, and it is this excess that limits severely his capacity to explain how the work has been—or is to be—brought about. And yet, what draws the genius beyond his nature is just nature itself, "nature in the subject," as Kant calls it (KU 307), nature operating as nature in the artist.

Even those who simply enjoy the artwork must undergo a certain transfiguring of their sensibility by which it is directed to the beautiful. This is what Kant calls the development of taste.

As regards the relation of art to sense, nothing is quite so remarkable as song. For, purely as music, as vocal tone, it may well be—as Kant supposed—the art most thoroughly immersed in sense, in the sheerly sensible, even though the measure and purity of its tones distinguish it from the mere outcry of pleasure and the shriek of pain. What is marvelous about song is that it installs speech within this sensible medium. Or, more

precisely, in song the very voice that produces the musical tone comes also, in that very production, to speak; and hence, in song there is a melding of the pure sensibleness of vocal tone and the operation of speech by which it signifies a certain intelligibility. Thus, in song the terms engendered by the most fundamental doubling of sense—so fundamental as to determine also the very sense of fundamental—are melded into a beautiful work. This melding attests that it is the human voice that, as Derrida recognized, is uniquely suited for universality or intelligibility. The Greeks bore in their language an intimation of this uniqueness of the voice, for in order to designate speech they referred neither to the lip (as did the Hebrews) nor to the tongue (as did the Romans) but to the voice (φωνή).

>>> <<<

In art sense is transfigured. As so-called material sense, as the sensible of things, it is transfigured into a shining of something beautiful. As purely intelligible sense it is transfigured so as to be brought before our senses, wrapped in a sensible cloak. Art issues from this double transfiguring, carried out—one knows not how—from below and from above, ascensionally and descensionally. The true sense of art lies in this double transfiguration of sense.

Yet in venturing to think art as the transfiguration of sense, it is imperative not to construe this attempt as aimed at determining the essence of art. Even aside from the question whether the determination of essence continues to be pertinent, whether the displacement to which essence is subject is not perhaps so radical as to render it virtually unrecognizable, there is the more immediate consideration that the sense of essence is not independent of sense, that it is a sense of sense, and that consequently it cannot simply be presupposed in an inquiry that, in order to think art as the transfiguration of sense, must venture to rethink sense as such, or rather, to rethink it precisely as it resists consignment to an *as such*.

Yet the primary concern here is to think the transfiguration of sense both in its descensional and in its ascensional directionalities. To think means also to rethink, to reanimate the thinking that, in such texts as the *Critique of Judgment* and the *Aesthetics*, opens to us as a past becoming futural—becoming futural precisely insofar as this thinking is impelled to the limit.

In such texts descensional transfiguration, in particular, is thought in ways that are exemplary. Thus Kant's elaboration of the role of aesthetic ideas in artistic presentation is—at the limit—precisely a discourse on descensional transfiguration. For an aesthetic idea is always paired with or set alongside a concept; and yet, such an idea, as a presentation of

imagination, has a remote bond to the sensible and, as such, exceeds what can be thought in the concept, transfiguring thought so that it exceeds the concept. It is decisive that, unlike the concept, which yields to expression in language, an aesthetic idea requires for its communication a work of art.

Ascensional transfigurement, the elevation of the sensible, is thought and attested much more profusely. For philosophy the paradigmatic texts in this regard are certain Platonic dialogues such as the *Republic*, the *Symposium*, and the *Phaedrus*, though in these texts it is primarily the ascent empowered by philosophy, not by art, that is at issue. Yet in another ancient, though very different text there is an attestation that is of exemplary significance, not only because its words portray such ascent but also, above all, because, in the history of translation, it comes to stamp decisively the words *transfigure* and *transfiguration*.

This attestation is bound to an event in the life of Jesus. Though it is multiply reported in the Gospels, the most extensive report is found in Matthew 17: Jesus led Peter, James, and John up a high mountain, and there "he was transfigured before them, and his face shone like the sun, and his garments became white as light."[5] The report goes on to describe how Moses and Elijah appeared on the scene, talking with Jesus; and how, as Peter began to speak, a bright cloud came over them and from it a voice proclaimed Jesus as the beloved son. It is reported that the disciples were filled with awe and fell on their faces, though Jesus—now alone—calmed them and, as they descended the mountain, instructed them about the coming of Elijah. The Gospel then goes on to relate the story of a father who brought his insane son to Jesus, who exorcized the demon from the boy and cured him.

With respect to this story there are two factors that are especially pertinent to art. One is the depiction of transfiguration: the description of Jesus transfigured bespeaks nothing but light and shining. Jesus is elevated into the light, and his face comes to shine like the sun, to shine

5. The translation cited is that of the Revised Standard Version. The King James Version (1611) does not differ significantly. It reads: "Jesus . . . was transfigured before them; and his face did shine as the sun, and his raiment was white as the light." In Luther's translation: "Und ward verkläret vor ihnen, und sein Angesicht leuchtete wie die Sonne, und seine Kleider wurden weiss als ein Licht." In the original: καὶ μετεμορφώθη ἔμπροσθεν αὐτῶν, καὶ ἔλαμψεν τὸ πρόσωπον αὐτοῦ ὡς ὁ ἥλιος, τὰ δὲ ἱμάτια αὐτοῦ ἐγένετο λευκὰ ὡς τὸ φῶς. The same word, a form of μεταμορφόω, is used in the account given in Mark, though not in the account of Luke. According to Liddell-Scott, the word can mean *transform* and also *disguise*, though it is used mostly in the passive and then means *to be transformed* or *transfigured*.

so brightly as to be comparable to that which makes all shining possible. In this respect the description accords, then, with the way in which, in art, mere sensible things are transfigured into the shining of the sensible. The other pertinent factor is that this story became the pretext for the monumental painting by Raphael. His *Transfiguration* was, in turn, interpreted—in very different ways—by Hegel and by Nietzsche. What is remarkable about the painting is that it conjoins, as the upper and the lower halves of the picture, the two somewhat disconnected stories from the Gospels, that of Jesus's transfiguration on the mountain and that of the possessed boy. Hegel finds a certain unity between the portrayal of Jesus transfigured and the lower scene, which he takes as indicating "that the disciples are not able to heal the possessed boy without the help of the Lord" (*A* 2: 233/860). On the other hand, Nietzsche's interpretation, in *The Birth of Tragedy*, brings to bear on Raphael's painting the distinction between the shining of the Apollinian artwork and the Dionysian depth from which it arises: "Here we have before our eyes, in the highest artistic symbolism, the Apollinian world of beauty and its substratum [*Untergrund*] . . . , and intuitively we comprehend their mutual necessity."[6] Only the slightest twist would be required in order to advance from this way of marking the difference to another in which the brilliance of shining would be submitted to a counterdirectionality, to withdrawal toward a radical anteriority. Yet in every case transfiguring is operative. Raphael transfigures the biblical story by his way of assembling the two events on a single canvas. With their respective interpretations both Hegel and Nietzsche transfigure the sense of the painting and thereby, especially in the case of Nietzsche, transfigure the very sense of transfiguration.

In venturing to think art as transfiguring sense and in doing so, to some extent, by engaging texts by Kant, Hegel, Heidegger, and others, transfigurings will be set in motion that are, in various respects, quite heterogeneous and that, in their deployment, mutate to the point where they cease to be recognizable as such and require reframing within another idiom. This heterogeneity needs to be marked linguistically. The word *transfigurement* is taken from the Old French, yet it is still to be found in a few English texts from the nineteenth century. It does not differ semantically from *transfiguration*; yet it has the advantage of not being bound to the upward directionality in the way that its common synonym

6. Friedrich Nietzsche, *Die Geburt der Tragödie*, in vol. 3/1 of *Werke: Kritische Gesamtausgabe*, ed. Giorgio Colli and Mazzino Montinari (Berlin: Walter de Gruyter, 1972), §4.

is, and hence it can more readily serve to designate both ascensional and descensional—as well as recessional—modes. By inscribing the common sense using this rare form, a requisite distancing is effected from the decisive attestation, and the expression of the sense of the word is itself submitted to what the word says.

The Invisibility of Painting

Can one, in any rigorous sense, conjoin invisibility and painting? Do these, in any sense, belong together? Do they, at all, cohere, especially if the mere conjunction is replaced by the genitive, if invisibility is thought not only as coherent with painting but as cohering in it, as belonging integrally to it? Is there anything invisible about painting? What indeed—one will ask—could be less invisible, less a matter of invisibility, less coherent with invisibility, than painting? What could be clearer than that the very element of painting is visibility, that painting installs itself in the very thick of the visible and devotes itself entirely to the visible? Indeed in most cases it seems to be even doubly devoted to the visible: for it both sets before our vision a visible, painted surface (we call it a painting, conflating the name of the artistic artifact with that of the art that brings it about) and also, precisely thereby, presents a visible scene. In other words, the visible forms and colors of the painting itself serve to project, beyond the painting, a visible configuration depicting things that either actually are and could actually be seen or that, even if only imaginary, are imagined as visible. In effect, painting engages three successive planes of visibility: the forms and colors on the canvas, the visible scene thereby composed and projected, and the actual or imaginary scene thereby depicted. Across the entire field nothing, it seems, is to be found but various modes of visibility.

Even if one turns to the other side, that of the painter, that of the painting by which a painting comes about, virtually everything seems to belong to the order of the visible. The painter appears to be utterly occupied with vision and the visible. From a visible scene, either one actually seen or one seen only in the mind's eye, the artist turns his vision to the canvas on

which it is to be depicted; and as he executes the measured brushstrokes required, his vision has already begun to be drawn back to the scene so as to measure, by reference to that scene, the depiction effected by those brushstrokes. Thus, as it guides the movements of his hand, his perceptive eye shifts between two visibilities, circling between the canvas and the scene that would be depicted. To be sure, there is a certain spacing between eye and hand, a void across which the visible must be translated into strokes of color. In the painter's very engagement with vision, there even intervenes a moment of blindness as he shifts his gaze from scene to surface and from surface to scene. In the almost—but not quite—stigmatic moment of transition, he sees neither the one nor the other, and it is across this interruption, across this interval of blindness, that the painter must measure the conformity of depiction to scene. What happens in this momentary interruption of his otherwise absorbing engagement with the visible? Can it be said that a momentary interruption of visibility constitutes an opening onto invisibility? Is it to an invisibility that the painter responds when he comports himself so surely in this moment of blindness as to be able to measure the conformity between two scenes separated by it? The same must be asked regarding the space of translation between eye and hand. While transition across it is precisely what makes possible the doubling of the visible scene that the artist produces on the painted surface, this space is not itself one of visibility. Is it, then, to an invisibility that the painter responds when, guided by his vision, he puts brush to canvas?

If painting were merely depiction of an actual or imagined scene, if it were simply a representation of something seen in advance, then its engagement with invisibility would amount to no more than is entailed by these discontinuities in the circuit of artistic production. Yet even the merest reversals within this circuit, reversals that virtually every painter will have experienced, even if with resistance, serve to indicate that invisibility belongs more decisively to painting. For the look of a painting, the look of the scene depicted, may be determined as much by the painting itself—by the way the scene takes shape, by what is suggested as the brushstrokes of color build up on the canvas—as by any actual scene that the painter might have set out to depict. The look of the scene depicted will seldom, if ever, simply have been visible in advance, either actually or imaginatively; one sees what one will paint only as one paints it, perhaps only after it has been painted. In this sense—and it is the very sense of the painter—the painter is always ahead of himself, engaged with an invisibility that has still to be brought forth visibly on the canvas. But this is

to say, then, that painting produces its depiction of something visible in order to present something that is invisible except insofar as the painting itself bestows on it a certain visibility.

Thus the most ordinary conception of painting begins to mutate toward the understanding of art in general that is our legacy from antiquity. For it was among the ancient Greek philosophers that art came to be addressed and interrogated as regards what it is and how it is related to truth. And it is from what they accomplished in this regard that a certain understanding of art has been passed down, an understanding that remains in certain decisive ways effective, even today amidst the unheard-of transformation that art—and, in particular, painting—has undergone.

The ancient interrogation of the arts took various forms. From Xenophanes and Heraclitus to Plato, those who came to be called philosophers challenged the poets, putting in question both Homer's depiction of the gods and Hesiod's story of their genesis. Yet with regard not only to poetry but also to music and painting, philosophical criticism was paired with the development of a certain understanding of the arts. Thus in Plato's *Republic* there is concern with the ways in which music affects the soul and thus can prepare one's receptiveness to learning. There is concern also with the mimetic practices involved in drama and in painting, a concern whether such practices serve the interest of truth or of obscurity and deception. From these concerns elaborated by Aristotle and later philosophers, there emerged a certain philosophical understanding of art, which, in various forms, remained effective throughout the history of philosophy and continued to govern the assessment of art throughout its development. Even conceptions of art that, as with some forms of aesthetics, seem opposed to this philosophical understanding of art remained nonetheless under its influence and continued to be determined by its basic parameters.

According to this philosophical conception, art has a double character. This double character, this two-sidedness, is perhaps most conspicuous in the case of painting. There is, most evidently, the side of sense: in a painting something is depicted, and the depiction, the visible image, is set before our sight. Yet there is also another side: for a painting does not merely depict something, does not merely provide an image resembling what is depicted, but also, through the depiction, through the image, the painting presents something beyond the merely sensible; it presents something supersensible, essential, intelligible. A Raphael *Madonna*, for example, is not supposed merely to provide an image of the Virgin—either of the artist's model or even of the Virgin herself as imagined by the artist; the intent is, rather, to present through this image something irreducible

to an object of sense, for instance, the spiritual purity of the Virgin or her maternal love for the child. In the painting one sees and yet does not see this spiritual quality. One does not see it, because something purely spiritual cannot as such be seen. And yet, though this quality is invisible, one discovers it there in the visible image. Its apprehension does not require an inferential leap beyond the image, but rather this spiritual quality is presented in and through the image.

This capacity is what is most wondrous and philosophically provocative about painting: that a painting can present the invisible in the very midst of the visible, that it can let something that never appears to the senses—that cannot appear as such to the senses—be presented in and through the very shining of the sensible.

The double character ascribed to painting as such is replicated in the titles given to paintings. The title *Madonna*, for instance, is not intended simply to inform the viewer that the person depicted in the painting is named Madonna; neither is its intent to say that the person depicted is the one whom we know by this name. Even if the title *Madonna* is taken as a proper name for the person who gave birth to Christ, its function is not merely to refer to this person but also, indeed primarily, to present her as the channel through whom the incarnation and thereby salvation were carried out; through the image of the Virgin, the very entrance of the divine into the human is concretely signified. Her depiction is precisely such that she appears as one receptive to the divine spirit and in this way drawn beyond whatever she as an individual may be. Even a portrait bearing as title the proper name of the person portrayed reaches—as does its title—beyond the mere sensible appearance of the person to the more essential inner qualities of character or personality. It displays not only the outward demeanor of the person but also the quality of inwardness that animates the person's life and appearance. For example, in Frans Hals's *Portrait of Jaspar Schade*, the supercilious look of the subject, his look of arrogance and disdain, quite exceeds mere sensible appearance; moreover, this look makes manifest an inward character to which overweening self-assurance and extreme vanity belong. The capacity that a portrait has to reveal the interiority of the subject portrayed is still further enhanced, it would seem, when the subject portrayed is the artist himself, as in the famous self-portraits by Dürer and by Rembrandt. A very different example is provided by Pieter Bruegel's well-known painting *The Peasant Dance*. In this painting peasants are depicted eating, drinking, playing musical instruments, and dancing. All of this is set in the open square of a Prot-

estant, Flemish village. The painting presents an aspect of peasant life in such a village, a certain exuberance of communal life in a society ruled neither by princes nor by the Church. Hegel described such scenes as presenting "the Sunday of life" (A 2: 257/887). Both the title of the painting and Hegel's descriptive phrase designate an essential quality of life that can be apprehended through the depiction of the scene but that transcends any particular scene of peasants engaged in their festivities.

Thus, according to the philosophical conception, painting has a double character. In a painting two different operations are at work, though they are intimately connected. On the one hand, a painting is a configuration of forms and colors, something visible set before our vision. Except in the case of modern abstract painting, this visible configuration takes the form of a depiction, so that what one sees in looking at the painting is a scene and not just areas of color. On the other hand, through this visible configuration and the depiction it effects, the painting presents something that is not itself visible, for instance, an inner spiritual quality or a quality of communal life. In philosophical terms, a painting is something visible through which something invisible is presented. More generally, an artwork is something sensible that shines forth to the senses in such a way that something beyond the sensible, something purely intelligible, comes to be presented.

Hence, the philosophical conception of art has as its basic framework the distinction between the sensible and the intelligible. This framework is presupposed by the understanding of art that has prevailed since antiquity. Consequently, if this framework is threatened, then our very way of understanding art in general and painting in particular is called into question. If this framework collapses, then it becomes necessary to rethink the essence of art anew, to rethink it from the ground up.

It is precisely such a collapse that now confronts us. And thus today we must think the essence of art anew, rethink it from the ground up.

Let us first consider this collapse in its broadest philosophical character.

Although the distinction between sensible and intelligible takes various forms in the history of philosophy, all are variants—however remote—of the originary Platonic differentiation between the sensible (τὸ αἰσθητόν) and the intelligible (τὸ νοητόν). From Plato to Hegel this differentiation remains fundamental to philosophy, indeed so fundamental that it determines the very sense of fundamental. Its endurance across this span of Western thought determines this era as the history of meta-

physics.[1] The philosophical conception of art in general and of painting in particular belongs to this era. Throughout the history of metaphysics, painting is determined as the depicting of something sensible in such a way as to present something intelligible. As this history reaches its completion in Hegel's thought, this conception receives its most rigorous formulation: art in general and painting in particular consist in the sensible presentation of the idea.

Heidegger has shown how thoroughly these classical conceptions have now come to be disrupted. In his lecture courses on Nietzsche, especially the course "The Will to Power as Art," presented in Freiburg in 1936–37, Heidegger took up the inversion of Platonism that had been the persistent goal of Nietzsche's thought from the time of his early notebooks until the final year of his work. As Nietzsche conceived it, this inversion was intended to reverse the classical ordering that had prevailed throughout the history of metaphysics. According to the classical ordering, the intelligible is superior to the sensible; its superiority is not a matter of degree but rather is of the same order as the superiority of an original over its mere image. Indeed in its Platonic formulation the intelligible consists precisely of the originals in relation to which sensible things are merely remote images. The inversion that Nietzsche ventures would reverse this order: what previously was superior, the intelligible, would now be taken as inferior, and its superior position would now be accorded to the sensible.

Heidegger's decisive insight was that the outcome of this inversion is unstable, that the new ordering ventured by Nietzsche cannot simply replace the classical ordering of intelligible over sensible. Because the very sense of the sensible was determined by its subordination to the intelligible, the inversion has the effect of destabilizing the ordering itself; it undermines the very principle of the classical ordering. The inversion of the classical ordering is thus at the same time its displacement. In particular, the inversion leaves the sensible undetermined. Since it can no longer be taken as the remote image of intelligible truth, the necessity of a new determination becomes evident. In his very last writings Nietzsche realized that what was required was a new interpretation of the sensible. Reaching back, in effect, to Leibniz—but without his metaphysics—Nietzsche inter-

1. The endurance of this fundamental distinction does not prevent there being junctures in the history of metaphysics where the distinction, or at least its smooth operation, is put into question: for instance, already in the chorology of Plato's *Timaeus* and in Plotinus's henology. Even in phases where the distinction remains simply operative, its transformations may be so radical that the supposition of a unitary history of metaphysics is put into question and the name *metaphysics* suspended between singular and plural.

prets the sensible as perspectival; this perspectival character foreshadows the role that the concept of horizon and horizonality will come to play in post-Nietzschean reinterpretations of the sensible. A second moment in Nietzsche's new interpretation of the sensible is linked to the word *Schein*, not primarily as *semblance*, nor in its association with *Erscheinung* in the sense of the appearance of something else. Using it, rather, in a sense closer to *shining*, Nietzsche writes that "'Schein' as I understand it is the actual and sole reality of things."[2]

Yet, as suggestive as these efforts may have been, with them Nietzsche ventured only a few first steps toward a new interpretation of the sensible. It was only through Husserl's phenomenology that the conceptual and methodological means for such an interpretation were provided, especially through the concepts of intentionality and of horizon and through the methodological insistence on rigorously binding philosophy to the things themselves. Only thereby could a descriptive, hermeneutical discipline be developed by which to address sensible things directly in their own character rather than regarding them only in their capacity to image an allegedly true world remote from everything sensible. It was primarily Heidegger who, in *Being and Time*, carried out such a new interpretation of the sensible. Most significant in this regard were his differentiations between various modes in which, in our everyday concern, things show themselves and his referral of these modes to his phenomenologically elaborated concept of world. This rigorously executed turn to the sensible was decisive for the further development of phenomenology—in Merleau-Ponty's *Phenomenology of Perception*, for instance—and its legacy continues to inform efforts—in a certain segment of American philosophy, for instance—to renew philosophy by orienting it more rigorously to the configuration of the sensible.

What are the consequences for the understanding of painting? Now that the Platonic differentiation between intelligible and sensible has been disrupted, now that the very schema of intelligible truth and sensible image has ceased to function, the classical framework for understanding painting philosophically no longer remains in force. How, then, once metaphysics has been taken to this limit, is painting to be understood? What sense can be made of it, assuming that any reopening or redoubling from within the sensible remains, for the time being, beyond reach. If now

2. Cited in *HN* 1: 248/1: 215. This theme is addressed in a number of fragments from the late 1880s, e.g., in vol. 3/1 of *Werke: Kritische Gesamtausgabe*, ed. Giorgio Colli and Mazzino Montinari (Berlin: Walter de Gruyter, 1972), 195.

philosophy is entirely centered on the sensible, on the way in which the things around us show themselves in their singularity rather than as mere images of a higher paradigm, what is entailed regarding painting? How is it now to be understood philosophically?

One possibility would be simply to put aside the double character that painting was previously taken to have. Then painting could be regarded simply as depicting sensible things in their singularity and in their connections with other such things. The fact that artists of the past tacitly assumed the philosophical conception of painting and took themselves to be presenting, in their paintings, something beyond the sensible would now prove to have been mere delusion, no less so than metaphysics itself would seem to have been.

Such positivism has proved tempting to certain modern painters. Yet the thoroughgoing critique of mimesis—of art as imitation of nature—that runs throughout much of the history of metaphysics remains, even beyond that history, an obstacle to pure naturalism in painting. If a painting merely depicts a landscape that can also actually be seen, then as Hegel observed, the painting is basically superfluous. What is to be learned by viewing the painting if one can cast one's vision upon the landscape itself? Furthermore, to have recourse to the feelings evoked by the painting—a course often followed by classical aesthetics—seems pointless as long as one cannot explain why a painting could be expected to evoke such feelings while a view of what it depicts would not. If a painting is only a copy of a natural landscape, for instance, then how is it—one must ask—that the painting presents the landscape so as to evoke feelings that a view of the landscape itself does not evoke? Something must be operative—so it seems—in the painting that makes it more or other than merely a copy. The point against mimesis is most vividly illustrated by Hegel's example of a painting by Zeuxis that was admired because grapes were depicted in it so realistically that living doves pecked at them, its alleged beauty thus consisting merely in its capacity to deceive animals.

Such positivism may take a further step and drop entirely the character of painting as depiction. Then a painting could consist simply of a configuration of forms and colors on the canvas surface without any relation whatsoever to things in the natural world. But then, as Kandinsky, the prophet of abstract painting, himself realized, the danger arises that there will be nothing to distinguish a painting from a mere ornamental object, from a necktie, for instance. Unless the depictive moment is somehow retained, for instance, by being turned inward upon the painter's own subjectivity, as in some Abstract Expressionism, the only alternative would

be some other kind of painterly connection to the world or to nature, a connection other than depiction. Otherwise, painting will have lost all relation to truth both in the classical sense and even in the more originary sense that has been retrieved from preclassical thought. From a painting thus utterly disconnected, it will not be possible to learn anything; at best, it will be capable of providing only amusement or entertainment. By a conception of painting as thoroughly disconnected from truth in every sense, it will not be possible to understand, in reference to nonabstract painting, the experience of truth in art to which all past ages have attested.

These positivistic conceptions of painting thus lead, not to a renewed understanding, but to a devaluing of painting. They accord to art no disclosive power, no relation to truth, no capacity to uncover something hitherto concealed and unforeseeable, even though artists and those engaged with art for the most part attest in one way or another to the capacity of art to bring something to light. These dead ends, these aporias, indicate that a very different approach is needed if painting is to be genuinely understood today, if it is to be understood in a way that accords to art its proper disclosive power without setting it back within a metaphysical framework. What is required is not that the double character previously ascribed to painting be put aside, but rather that it be radically rethought. What is required is that this double character be reconceived within the context of the sensible, that the doubling be set, as it were, entirely within the visible.

In his theoretical essay *Creative Confession*, Paul Klee writes: "Art does not reproduce the visible but makes visible [Kunst gibt nicht das Sichtbare wieder, sondern macht sichtbar]."[3] In saying that art does not reproduce the visible, Klee means that its goal is not to produce a copy or image of visible things, that art is not imitation of nature. This is not to deny that painting may indeed depict visible things. In fact, many—though by no means all—of Klee's own works depict persons, animals, or other visible things, though in most cases Klee's mode of depiction is quite unusual, only barely comparable to classical forms of depiction. Often Klee's depictions are charmingly, humorously whimsical, as in the watercolor entitled *Where the Eggs and the Good Roast Come From*. In the margin just below the picture, Klee inscribes the title (*Wo die Eier herkommen und der guter Braten*). He also inscribes the words *Ei* (egg) and *guter Braten* (good roast) near the designated objects, effectively making the inscriptions part of the work. This picture was dedicated and given to the young daughter of a

3. Paul Klee, *Kunst-Lehre* (Leipzig: Reclam, 1987), 60.

close friend, Gottfried Gaston, and Klee inscribed in the lower right the words: "Alle dieser Bilder hat der Onkel Klee gemacht [Uncle Klee made all these pictures]."

In saying that "art does not reproduce the visible but makes visible," what Klee denies is that painting consists solely of depiction. What the statement affirms is that the goal of art is to make visible something that otherwise would go unseen. Through the configuration of forms, lines, and colors on the canvas, something would be made visible, something that, if not utterly invisible, nonetheless borders on invisibility. It is this bordering on invisibility, this being virtually invisible, that is decisive in characterizing that which painting is now taken to present and in distinguishing it from the intelligible to which the metaphysics of painting was oriented. For what painting is now taken to present is an invisible that belongs to the visible rather than being set over against the visible or beyond it, as in the classical conception. The invisible that painting is now taken to present is an invisible *of* the visible. Or, more precisely, by way of the visible configuration of line and color, paintings present various moments of invisibility that not only belong to the visible but also are, in some way or other, involved in making things visible.

Since he was both theorist and artist, Klee's work is especially significant in this regard. Though many invisibles, many different moments of invisibility, come into play in Klee's art, one of the most persistent is that of genesis, of the virtually invisible genesis that lies behind the surface appearance of things yet is essential to such things and to their appearance. Thus vegetative growth is a theme of many of his pictures. An example is his 1938 work *Growth Stirs* (*Wachstum regt sich*). The entire background of the painting is white, suggestive of snow. On this background are various strokes, most of them elongated and arched. They are all colored in the same way: dark brown except for a narrow, dull-orange edging. Both the shape and the coloring of these strokes are such that they suggest the bare limbs of trees, the stems of plants, and so forth. Taking the visible spectacle together with the title *Growth Stirs*, it is manifest that the work presents the first stirrings of growth that come when the outward appearance of things is still that of winter.

A very different invisibility is presented in Monet's work, for example, in the series of at least thirty paintings of wheatstacks that Monet executed in the years 1889–91. All—or nearly all—of the paintings depict the same wheatstack, in some cases adding a second one. It is known that in fact there were such wheatstacks at the time in a farmer's field near Monet's home in Giverny. Yet, though depicting wheatstacks, indeed the

same ones again and again, these paintings are not about wheatstacks. Their aim is not to present the idea or the essence of a wheatstack. Rather, the wheatstack depicted serves only as a mirror or fulcrum (to cite the description given by Monet's friend, the art critic Gustave Geffroy). It serves both to reflect something else—something virtually invisible—and to provide a focal point around which something else—something else virtually invisible—is presented. In a letter to Geffroy in 1890, Monet designated the theme of these paintings as *the envelope,* by which he meant, in his own words, "the same light spread over everything."[4] What these paintings present is the spread of light across the scene. In many of these paintings one sees light reflected from the surface of the wheatstack. Often, too, one is struck by the contrast with the shadow cast by the wheatstack. There are *Wheatstack* paintings in which the houses and woods in the distance are obscured by the glare of the brilliant sunlight, for instance, in the painting entitled *Wheatstack in the Sunlight, Midday.* There are still others where the light picks up the bluish hue of snow and the sky turns brilliant orange with the setting sun, as in the work entitled *Wheatstack, Sunset, Snow Effect.* In each case the title names first that which is depicted (the wheatstack) and then indicates something about the envelope that is presented, often designating the time of day or year when light spreads across the scene in this manner.

Hence, these paintings present something that borders on invisibility, something virtually invisible. They present the light as it spreads across a scene so as to illuminate things. They make visible the light that grants to things their visibility; for normally what we see are visible things and illuminated scenes, not the light that makes them visible, that illuminates them. The light itself remains virtually invisible until the genius of the painter comes to make it visible.

Such are, then, some of the invisibilities of painting. To think painting anew requires that such invisibilities be recognized and described as the proper content presented by painting and that the vast range of such invisibilities—including no doubt sorts that we can as yet barely imagine—be gauged and thought through in its import for the character of painting.

And yet, in every case what is most astonishing is the capacity of painting to present the invisible through the shining of the visible. No one has underlined this character more forcefully than Hegel. In his Berlin lectures on art, he stresses repeatedly the role of color in painting; in

4. Claude Monet, letter 1076. Cited and discussed in my book *Shades—Of Painting at the Limit* (Bloomington: Indiana University Press, 1998), 44.

his view color is what constitutes the basic element of painting. What he finds most astonishing is that the mere spread of color suffices to make everything appear. Hegel marvels at what coloring can produce, at how the most complex and subtle differences between things or persons can, in painting, come down to differences in coloring. No matter what is to be presented, it is—most astonishingly—only a matter of spreading colors across a surface; thereby, by the mere spread of colors, everything—all manner of things in their most complex and subtle differences—is there for us to behold.

CHAPTER TWO

Nature's Song

What is more natural than song? Is there any more natural expression of the most profound sentiments of the human heart? Even where there is no need of expression in the form of communication with others, even in solitude, where expression cannot serve, as Kant would say, the human propension for society, their sociability (see *KU* 296f.), humans sing as if by nature, giving voice to their joys, hopes, fears, and sufferings. It is as if song sounded from out of their very being, as if it belonged to human beings by nature.

Yet from the moment a human being begins to sing, he betrays that he is no mere creature of nature, his seemingly natural gift of song setting him also beyond nature, beyond enclosure in the mere round of the sensible. For in song there is speech; and in singing, in giving their lyrical voice also the sound of articulate speech, humans attest to their ancient determination as ζῷον λόγον ἔχον. To say nothing of Kant's redetermination of the superior endowment, of the capacity for λόγος now taken as reason, that is, his determination of reason in its legitimately constitutive, that is, practical, employment as the power of self-determination through the moral law; and of his insistence that art in the most genuine sense must share in this endowment, degenerating otherwise into mere distraction (see *KU* 326). From the moment humans begin to sing, they will always already have broached (and stationed themselves within) the most classical oppositions: freedom/nature, art/nature, intelligible/sensible, signification/sense. In song they will always already have opened the most gigantic space within sense, that of the very sense of sense. Philosophy—and not least of all Kant—contests this space and yet recognizes that, even in contesting it, thinking must preserve it and move ever again across it. Song resounds within this space, giving voice to the lyrical traces of its contours.

>>><<<

What, then, about nature's song? How could there be a song of nature, one sung within nature, sung by the voice of a natural creature? How could there be such art—or protoart—within nature, granted the differentiation on which, despite all the complications accumulated in the *Critique of Judgment*, Kant nonetheless insists, that between artistic beauty and the beauty of nature? Can what certain voices of nature produce be called song in any but an improper sense? Can one even speak of nature's song without rendering the sense of song utterly equivocal, threatening the very unity of the concept to such an extent that one would finally be driven to ask whether there is any such thing as song as such. Can natural creatures sing as humans sing? How could they if they lack language, that lack constituting even their very differentiation from human beings? Or is speech somehow granted to nature, the voice of nature blending such speech into song? Do natural creatures have the genuine gift of song? Or is it only by equivocation and remote analogy that birds are said to sing?

Birds appear twice in the section of the *Critique of Judgment* entitled "On Intellectual Interest in the Beautiful" (*KU* §42). In the first scene it is the beauty of the bird that is highlighted. In the final scene it is the beauty of the bird's song. Both scenes—it will be observed—involve deception. Between these two scenes there is still another, a scene about the language of nature. Thus, in this Kantian drama of nature and its song, three scenes are staged.

Before raising the curtain on the first scene, Kant addresses the question whether taking an interest in the beautiful in general is a sign of a good moral character. Insisting on the distinction between the beautiful in art and the beauty of nature, he grants that in the case of art there can be no assurance of any such connection. He refers to connoisseurs of art who "apparently as a rule are vain, obstinate, and given to ruinous passions" and who, consequently, "can perhaps even less than other people claim the distinction of being attached to moral principles" (*KU* 298). On the other hand, Kant insists that interest in the beauty of nature is indeed a sign of attachment to morality: "But, on the other hand, I maintain that to take an *immediate interest* in the beauty of nature (not merely to have the taste needed to judge it) is always the mark of a good soul; and that, if this interest is habitual, if it readily associates itself with the *contemplation of nature*, this indicates at least a mental attunement [*Gemütsstimmung*] favorable to moral feeling" (*KU* 298f.). Kant specifies that the interest must

concern the beautiful *forms* of nature and not the mere charms (*Reize*) that nature tends to connect with these forms. To this extent the relevant interest in the beauty of nature is like the pure judgment of taste, based solely on form and not on charm (see *KU* 223). This distinction, to which Kant appeals without further analysis at this point, will return when Kant comes to prepare the final scene, that of the bird's song.

The first scene pictures a person who is alone and to this extent re-moved from all interests linked to society, one who does not intend any communication with others regarding what he is about to observe. He contemplates certain natural things, the beautiful shape of a wild flower, of a bird, of an insect. His contemplation is one of admiration, of love, of wonder at these beautiful forms; and it is such also that he would not want nature to be without them, even though they offer no prospect of benefit to him. Such comportment to nature is not merely a matter of a judgment of taste, though as comportment to beauty it must include as a component a judgment of taste, indeed as an independent component. But to such essentially disinterested judgment an interest is added, a direct interest that Kant calls (without further explanation) intellectual: "Not only is he pleased with nature's product on account of its form but he is also pleased by its existence" (*KU* 299).[1] Again Kant is careful to set charm aside as having nothing to do with this interest.

Now deception makes its appearance. The scene becomes one in which this lover of the beautiful is tricked: artificial flowers are stuck in the ground and artfully carved birds set on the branches of trees. Yet, the de-ception is only momentary, and the lover of natural beauty soon discovers the deceit. With this discovery his immediate interest in these things of nature promptly vanishes, though it may be replaced by other types of in-terest such as those of vanity, especially if this lover were to return to so-ciety and awaken his interest in using such things as decorations intended for the eyes of others. Kant formulates as a conclusion what the events en-acted on the scene have demonstrated: "The thought that this beauty was

1. "D.i. nicht allein ihr Produkt der Form nach, sondern auch das Dasein desselben gefällt ihm." It is important to bear in mind that Kant's general term *gefallen* (along with the noun *Wohlgefallen*), which refers not only to the beautiful but also to the good and to the agreeable or pleasant (*angenehm*), has a directionality that is easily reversed in translation. Thus, in the present case it is nature's product (along with its existence) that pleases him (*gefällt ihm*). If the sentence were to be translated, for instance, so as to say that the person *likes* nature's product, then the directionality would have been reversed and made to run from the subject to nature rather than from nature to the subject. This directionality is quite significant for Kant's analysis of the beautiful: it is one of the semantic means by which Kant limits the as-similation of the beautiful to the subject.

produced by nature must accompany the intuition and the reflection, and the direct interest we take in that beauty is based on that thought alone" (*KU* 299). Along with the intuition and the reflection, which together constitute the judgment of taste, the love of beauty requires also the thought of the *natural origin* of the beauty. Otherwise there is no immediate, intellectual interest in the beauties of nature but only a judgment of taste, accompanied perhaps by some empirical interest referring to society.

Kant raises the curtain on the second scene. The action with which the scene begins is meant to demonstrate the superiority of natural beauty over that of art and to pose dramatically the question of the ground of that superiority. The scene pictures a man with sufficiently refined taste to judge with utmost correctness the products of fine art: it pictures him turning away from the beauties of art, leaving a room filled with art and turning instead to the beautiful in nature, in order, as Kant says—most remarkably——"to find there, as it were, a voluptuousness for his spirit [*Wollust für seinen Geist*] in a train of thought that he can never fully unfold" (*KU* 300). One who makes such a turn, such a choice of nature over art, will be esteemed and thought to have a beautiful soul (*eine schöne Seele*), surpassing anything that can be claimed by connoisseurs who remain indoors with their art. Kant's question: What is the ground of this difference marked by the dramatic turn to nature?

Kant draws a rigorous distinction between two types of judgment: judgment of taste, which is an aesthetic judgment carried out without any reference to concepts, and intellectual or moral judgment, which is exercised on the mere form of practical maxims, thus determining the will, and which proceeds from concepts (or, more precisely, from conceptuality, universality, as such). Strictly speaking, neither type of judgment is based on an interest; but in the case of moral judgment an interest arises from the judgment. It is an interest of reason, its interest that the ideas—ideas of practical reason such as freedom, God, immortality—have objective reality. Whatever attests to an objective reality of the ideas will be of immediate interest to reason, whatever trace (*Spur*) or hint nature may show of its accord, its harmony, with moral feeling, with what is demanded by the moral law. By virtue of the analogy between the purely aesthetic judgment and the moral judgment, this interest, though arising in the sphere of the latter, undergoes a certain transference to the aesthetic sphere: "Hence reason must take an interest in any manifestation in nature of a harmony that resembles the mentioned harmony, and hence the mind cannot meditate about the beauty of *nature* without at the same time finding its interest aroused" (*KU* 300). Nonetheless, Kant insists that this interest is "in

terms of its kinship moral [*der Verwandtschaft nach moralisch*]"—that is, it is essentially moral and is conjoined with aesthetic judgment only by a transference that must be prepared and sustained by an orientation to the moral. Interest in the beauty of nature presupposes—hence always attests to—an established interest in the moral or at least a predisposition to a good moral attitude.

Thus arises human admiration (*Bewunderung*) for nature, wonder in the face of those beauties in which, as Kant says, nature "displays itself as art, not merely by chance but, as it were, intentionally, in terms of a lawful arrangement and as a purposiveness without a purpose" (*KU* 301).[2] By means of the transference between aesthetic judgment of natural beauty and moral judgment, as a kind of reflection from the aesthetic back upon the moral, the purposiveness of nature is referred to a purpose within: "Since we do not find this purpose anywhere outside us, we naturally look for it in ourselves, namely, in what constitutes the final purpose of our existence: our moral vocation" (*KU* 301). On the other hand, such transference cannot operate between moral judgment and judgment of artistic beauty, since it is manifest that art is intentionally designed by the artist to produce aesthetic satisfaction, hence not attesting to any harmony in nature. Thus it is that the judgment of artistic beauty is not connected

2. This reversal of the traditional mimetic relation between art and nature is elaborated in subsequent sections of the *Critique of Judgment*, though the passages involved make it evident that Kant's redetermination of the relation between art and nature is irreducible to a mere reversal of the traditional relation. The most celebrated of these passages reads: "Nature is beautiful [*schön*] if it also looks like art; and art can be called fine [*schön*] art only if we are conscious that it is art while yet it looks to us like nature" (*KU* 306). Having up to this point posed art and nature in their opposition (for instance, in terms of doing [*Tun*] or making [*facere*] in contrast to effecting [*Wirken*]), Kant begins, in this and other adjacent passages, to draw them together. In other words, he introduces a certain crossing of art and nature, a crossing of each over to the other. More precisely, he presents this crossing of art and nature as being such that each must, in a certain respect, appear as—that is, look like, seem like—the other. It is a crossing in which each, while remaining itself (and while we are aware of it as itself), must take on the look of the other. On the one side, beautiful nature must look like art. For, in order to be judged beautiful, nature must appear as purposive with respect to our cognitive powers; yet this requires that nature appear as if it had been made in just such a way as to conform to—and so to evoke—the play of our cognitive powers. It must appear as if an artist—though perhaps not a human one—had made it in this way. On the other side, art, though we know it to be art, must look like nature. It must *appear* as freely purposive (purposive without a purpose) with respect to our cognitive powers, even though we know that, as art, it is not freely purposive but has been intentionally made by the artist in such a way that it accords with our cognitive powers. Kant says: "Therefore, even though the purposiveness in a product of fine art is intentional, it must still not seem intentional" (*KU* 306f.)—that is, it must look like nature.

with any direct interest such as that which in the case of natural beauty can be taken as a sign of goodness of soul.

Everything hinges, then, on the *natural trace:* the trace by which nature shows that it involves some sort of ground (*irgendeinen Grund*) for assuming in its products a harmony with the requirements of practical reason. Not that nature *shows* that ground as such; not that nature makes the harmony manifest *from the ground up.* On the contrary, the ground does not become manifest as such, does not as such get shown; and it is precisely because of this not-showing of the ground that everything hinges on the natural trace, on a showing within nature of a trace of the ground, a showing to whose structure belongs the transference between moral judgment and aesthetic judgment of natural beauty. Here nothing is shown simply as such but only by way of the trace inscribed in nature. Or, as Kant also says: by way of nature's writing, by way of "the cipher [*Chiffreschrift*] through which nature speaks to us figuratively [*figürlich*] in its beautiful forms" (*KU* 301). In and through the beautiful forms of nature something is said, something that could never be present(ed) in nature as are those beautiful forms by which it is inscribed and thus meant. The beautiful forms of nature constitute a language in which nature speaks to us. In contemplating the beautiful forms of nature, the lover of nature is reading, interpreting, the script of nature. Can there be a voicing of what is thus written in nature? Does nature also give voice to what is written in its beautiful forms?

Kant does not say. He does not identify a voice capable of translating nature's beautiful forms into speech or into song. Instead, he introduces still another language of nature, a language that accompanies the language of beautiful forms, that is distinct from this language while being nonetheless fused with it, a language that supplements the language of beautiful forms. By introducing this second language of nature, Kant sets the stage for the final scene, the scene in which the bird contemplated by the lover of nature finally breaks into song.

Kant introduces the second language in relation to the *charms* of nature, which previously were distinguished rigorously from the beautiful forms of nature and set aside as no more pertaining to intellectual interest in nature than to purely aesthetic judgments of taste. Now he observes that the charms of nature are often found fused (*zusammenschmelzend*) with beautiful form. He observes that such charms are matters either of color or of tone, since it is only in such sensations that a space opens for a reflection by which they are not merely felt but found charming, not

merely present but significant. Kant explains: "For these are the only sensations that allow not merely for a feeling of sense but also for reflection on the form of these modifications of the senses, so that they contain, as it were, a language in which nature speaks to us [*eine Sprache, die die Natur zu uns führt*] and which seems to have a higher sense" (*KU* 302). Thus, in those sensations that constitute the charms of nature there is an opening, an opening within sense (and within *sense*), an opening of the space of the sense of sense. By virtue of this opening, enacted through reflection on the form of the modifications of the senses, the charming sensations say something, mean something; they are not merely felt in their mute presence but are significant; and, like the beautiful forms with which they are often found fused, they constitute a language to be read, interpreted, in nature. They are forms of sense that seem to have a higher sense, that shine (*scheint*) as though announcing a higher sense. Kant offers an interpretation of this sense-writing in nature: the white color of a lily "seems to attune [shines so as to attune—*scheint . . . zu stimmen*] the mind to ideas of innocence, and the seven colors from red to violet [seem to attune it to] (1) sublimity, (2) courage, (3) candor, (4) friendliness, (5) modesty, (6) constancy, and (7) tenderness" (*KU* 302).

The curtain rises now on the final scene. It begins with a song: not one that would merely translate into the sound of a voice something already written in nature, but rather a song in which something would sound forth originally, in which something would sound forth vocally in the same way that, in the sense-writing of nature, something shines forth significantly in nature's charming script. It is nature's song that sounds and that in sounding opens a space of signification, which cannot but be also a space of interpretation. Thus: "A bird's song proclaims his joyfulness and contentment with his existence. At least that is how we interpret nature, whether or not it has such an intention" (*KU* 302).

Direct interest in nature's song requires, no less than with nature's beautiful forms, the thought of natural origin. As soon as deception in this regard is detected, as soon as art rather than nature proves to be the origin of a song mistakenly taken to be nature's own, interest vanishes completely, indeed so completely, Kant suggests, that taste will no longer find anything beautiful nor sight anything charming:

What do poets praise more highly than the nightingale's enchantingly beautiful song in a secluded thicket on a quiet summer evening by the soft light of the moon? And yet we have cases where some jovial

innkeeper, unable to find such a songster, played a trick—received [ini-
tially] with greatest satisfaction—on the guests staying at his inn to
enjoy the country air, by hiding in a bush some roguish youngster who
(with a reed or rush in his mouth) knew how to copy that song in a
way very similar to nature's. But as soon as one realizes that it was all
deception, no one will long endure listening to this song that before he
had considered so charming; and that is how it is with the song of any
other bird. (KU 302)

If it is to charm and to interest immediately, nature's song must appear to
originate from nature and not from art. Then and only then does it sound
forth in such a way as to open sound to meaning, to open sense to the sense
of sense. As the song of a bird proclaims joyfulness and contentment.

>>><<<

Nature has other songs too, songs sung by other natural creatures. In
many temperate regions there is a period of a few weeks in late summer
when the approach of evening is regularly accompanied by the woodland
songs of locusts and crickets. Their song begins with a few isolated notes
from different corners of the woods but increases rapidly in volume as new
voices continually join the concord until it is as if an entire orchestra were
performing. Since these creatures are themselves hardly to be seen as they
give voice to their song, it is as though they were nothing but song; they
could almost be taken to be disembodied voices, were it not that each of
them casts its voice from a particular distinct nook of the woods and so
attests at least to its spatiality. Yet their nightly performances last only a
few weeks; as fall arrives, their voices diminish, and soon their song dies
away, as do they too. It is as if, all along, their songs had been like those
that swans—singing more beautifully than ever—are said to sing as the
time of their death becomes imminent.

The songs of such creatures as locusts and crickets go unmentioned
in the account that Kant gives of nature's songs. Yet nothing would pre-
vent their songs from being submitted to such an account. Though some
may stress that the songs of such creatures are more dominantly rhythmic
than sonorous or even that they seem to us less expressive than the songs
of birds, their songs bespeak nonetheless the charm of nature. Who indeed
has not been charmed by their nocturnal symphony? Are these charming
sounds and the form that they display both in their rhythms and in their
distribution throughout the woods—like the various brass choirs of an-
tiphonal music—not such that through these songs nature speaks to us,
confiding to us its secret purposiveness?

The songs of creatures quite similar to these form the theme of an ancient philosophical discourse. Even today, in the olive groves in Greece, one will be impressed by the song that the cicadas sing when, in midday, the light and heat of the summer sun become almost unendurable and drive the exhausted wanderer to seek shade wherever it can be found. Perhaps one even *needs* to have felt the intensity of the Greek sun and to have heard the song to which nature, in response, gives voice. In any case, one will then read, with more concretely attuned sense, the brief discourse about the cicadas in the *Phaedrus.*

Socrates and Phaedrus have gone for a walk in the countryside outside the walls of Athens. At a certain point they turn off the path and walk along the Ilissos River; both are barefoot, and Phaedrus fancies walking with their feet in the water, which, he observes, would not be unpleasant at this time of the year and of the day. The suggestion is that it is midday in summer. They spy a very tall plane tree, sit down in the shade of its wonderfully spreading branches, and immediately begin the storytelling. Yet at this point the story, recalled by Phaedrus, has nothing directly to do with cicadas. Rather, it is a story prompted by the place where they have just sat down alongside the river. Phaedrus wonders whether this is the place where Boreas the North Wind is said to have carried off Oreithyia. Observing that the place Phaedrus has in mind is actually a bit farther downstream, where, he thinks, there is an altar to Boreas, Socrates launches into a discussion as to whether he believes such stories to be true. The crux of the discussion lies in the way Socrates redirects the question. He observes that to explain such stories in the way currently fashionable with those who are wise—that is, to explain them away as stories—requires a great deal of leisure. Pleading lack of such leisure, Socrates insists, instead, on the priority of another task: "I am not yet able to know myself, as the Delphic inscription enjoins; and it seems laughable to me to inquire about other things when I am still ignorant about myself. So, leaving those matters aside, I accept the customary beliefs about them, and I inquire not about them but about myself" (*Phaedr.* 229e–230a). If, on the contrary, Socrates should on some occasion concern himself with such matters as are told of in these stories, then such concern—one must suppose—will have a bearing on the task of self-knowledge.

It is only much later in the dialogue, following the series of speeches, that Socrates tells the story about the cicadas. Again Socrates refers to leisure, but now in order to suggest that they have leisure—presumably the leisure to devote to stories, even if still not without requiring that they have some bearing on self-knowledge. The story is prompted by Socrates'

remark that the cicadas, singing overhead (in the plane tree no doubt) and conversing with each other in the stifling heat, are looking down at them to see whether they will be lulled to sleep by the cicadas' song or whether they will sail on in their conversation, as if past Sirens. In the latter case, says Socrates, the cicadas will perhaps bestow upon them the gift of honor received from the gods for bestowal upon humans. One cannot but suppose that this gift has to do with self-knowledge.

The story is that the cicadas were once human beings, long ago, before the birth of the Muses. But, when the Muses were born and song (ᾠδή) appeared, then—as Socrates tells the story—"they were so overcome with the pleasure of it that they just sang, neglecting food and drink, until they died without even noticing. From them the race of cicadas afterwards arose" (*Phaedr.* 259b–c). From the Muses—thus the story continues—they received the gift of needing no sustenance; thus, taking neither food nor drink, they sing continually until they die and then go off to the Muses to report regarding who on earth honors each of the Muses.

Since Socrates and Phaedrus have resisted—and will continue to resist—the Siren song of the cicadas, persisting in their conversation rather than being lulled to sleep, they are presumably worthy of the gift that Socrates mentioned (though without actually identifying it), a gift that, he said, these creatures receive from the gods for bestowal upon those humans who demonstrate their capacity to remain alert. What is this gift, and do Socrates and Phaedrus actually receive it? One might suppose that the gift consists in the promise that the cicadas, when after death they go off to the Muses, will carry good reports about Socrates and Phaedrus, reporting, in particular, to those Muses whom they will have honored by pursuing philosophy, namely Calliope and Ourania. And yet, however much Socrates and Phaedrus might cherish the esteem of these Muses—if they actually took the stories to be true—it is not self-evident that the promise of such esteem would contribute significantly to Socratic self-knowledge. What the story of the cicadas teaches, on the other hand, is the power of song.[3] Recognizing this power, the power that music exercises on the soul, bears directly on self-knowledge—for instance, recognizing, on

3. This theme is also taken up in several respects in the *Republic*. Perhaps most striking is the connection that Socrates indicates between music and politics: "For they must beware of change to a strange form of music, taking it to be a danger to the whole. For never are the ways of music [μουσικῆς τρόποι] moved without the greatest political laws being moved, as Damon says, and I am persuaded" (424c). See my discussion in *The Verge of Philosophy* (Chicago: University of Chicago Press, 2007), chap. 4.

the negative side, the need not to be lulled to sleep but to remain alert and to continue to inquire.

What the story teaches is that the power of song is so great that it can make one oblivious to all other pleasures. Indeed its power is even to be measured against the power of death: caught up in the enjoyment of their singing, overcome by the power of song, the human ancestors of the cicadas died without even noticing, thus escaping the agony and suffering of death that is the lot of less musical humans. Though not explicit, it seems that it is the same with the cicadas themselves. In any case, Socrates does make explicit that they are entirely relieved of the need of food and drink, of the need to go in search of sustenance; thus they are freed to do nothing but sing. In these purely lyrical creatures and their human ancestors, song proves so powerful, so utterly engaging, that they are released from the natural compulsions to which all other natural creatures are bound by nature. Once freed from nature by song, they are reborn as natural creatures that are freed for singing, that have no need to do anything but sing.

The charming sounds of nature are not merely sounds, are not simply to be sensed, felt, passively registered. Rather, in these sounds a doubling of sense has already begun to take shape. Kant calls it a "reflection on the form of these modifications of the senses" (*KU* 302). His description suggests that it is as if a language (*eine Sprache*) were paired with these sounds, as if a higher sense (*Sinn*) were unfolded from the merely sensed sense. There is, in other words, an opening within sense that serves to install a space of something like signification; it releases the sense of sense, even if not yet detaching it from sense, nor even rendering it detachable. Because there is such an opening in the charming sounds of nature, because there is something like signification, something like language, that is distinguishable yet set into these sounds (as human song sets words to sounds), it is extremely difficult, perhaps impossible, to mark a limit beyond which things of nature would no longer be capable of song.

As the cool wind blows through the pines and is given voice by them, it says something and says it in this very voice. It may announce the coming storm, but it may also simply bespeak coolness, the sense of refreshing coolness. Is this setting of nature's speech to the voice that the wind acquires not its song? Is there not a song of the wind and not just its passively sensed sound? Is it not likewise with the sound of rain falling? Depending on its fall and on the conditions, it may bespeak gentleness or it may seem threatening and bespeak the violence of nature. In any case, there is, in what is sensed, an emergent sense, hence a double sounding, a song.

Who has not listened to the song of a brook as its water flowed over the rocks? The proverbial attribution expressed in the words *babbling brook* attests that we take its sound to have, as in song, an affinity to speech, even if to a speech more natural than human, a language in which, as Kant says, nature in its charm speaks to us. Surely, for the guests who come to a country inn, the sound of the babbling brook is hardly less charming than the song of the nightingale, though it is decidedly more difficult to trick the guests into believing they hear such a song even when no brook is present. But in most cases the innkeeper will have made such deception unnecessary by building his inn alongside a charming brook and by offering his expectant guests rooms with windows opening toward the brook, that even in their sleep they might be charmed by its song.

That water can have its song, indeed even when removed from natural surroundings, is demonstrated in the most remarkable way in Tan Dun's *Water Concerto.*[4] The composition is for water percussion and orchestra. Along with a traditional Western orchestra, equipped however to produce also some unusual sounds mimicking Chinese folk instruments, there is a solo water percussionist positioned at the front and center of the stage; he is flanked by two other water percussionists who mirror and respond to the soloist. The soloist has before him two transparent hemispherical basins filled with water; he also has a variety of objects that serve to release various sounds from the water (a bottle, a long tube, four bells, a water shaker, four wooden bowls that float upside down in one of the water basins and that are used as drums, etc.). Using these objects, the soloist lets the water sound in various registers and modes; the sound is sufficiently amplified that it can match the sound of the orchestra, indeed in much the same way as in concertos with traditional instruments. What is most remarkable about the *Water Concerto* is the way in which the sounding of the water—its music, its song—is matched, blended, and contrasted with the sound of the orchestra.

Not only wind and water but other elements as well have their song. The sound of thunder as it rumbles quietly in the distance or as it follows the lightning bolt at close hand and reverberates all around is never merely something to be sensed. Its echo in a mountain valley reveals something of the contours of the valley; as one hears it, one also apprehends its spatial

4. This composition, commissioned by the New York Philharmonic, was first performed in Avery Fisher Hall in New York in June 1999 under the direction of Kurt Masur with Christopher Lamb as soloist. It was performed also by the Boston Symphony Orchestra in Symphony Hall, Boston, in January 2006 with the same conductor and soloist. The work is dedicated to the memory of the Japanese composer Torū Takemitsu.

deployment as well as the boundaries of the space in which it resounds. It offers a sense to be understood: that, for instance, a storm is approaching or is receding into the distance. In its very sounding it conveys a sense of weather conditions; because its sounding is always, in some respect and to some degree, from above, thunder directs our attention to the atmosphere, the clouds, and the sky. Even the sky itself, apart from the other elements, has—so it is said—its song, the silent music of the celestial spheres. Perhaps even the earth, silent and self-secluding though it be, also has—as some attest—its song. Is there not indeed a song of the earth?

To be sure, such songs as those of earth and sky are very different from the songs of charming natural creatures. In the case of earth and sky the higher sense, the language of nature, that Kant identifies in the charming songs of birds remains muted; it is in need of being released in a manner analogous to that in which the *Water Concerto* releases the sound of water. Perhaps indeed the sense of the songs of earth and sky can only be released by art. Perhaps such songs can sound from the silence of these elements only by sounding elsewhere, by sounding in human song.

The very remoteness of these elemental songs from human song serves to render the interplay productive. Yet human song is different also from the songs of brooks, cicadas, and birds. It is different because humans can speak as none of these beings can. It is different because in human singing there is human speech and not just a language of nature. It is different because in it there is signification that is more than the mere echo of sense, signification that is set over against sense as the sense of sense, even though, within song, this signification is set back (though in its distinctness) into sense, into the tones of the voice. In the case of nature's charming things, signification has only begun to emerge from the sense with which it is melded in the song; in the case of human song, signification that has been detached from sense is set back into sense, that is, words are sounded by the lyrical voice. Along with the detachment of signification from sense, there is also a certain detachment of audition, which in turn establishes the possibility of exchange between singing and hearing: one hears oneself singing and so is capable of singing as one hears oneself.

Nothing is more remarkable than the interplay between human song and nature's song. Human song may mimic certain musical sounds of nature, for instance, by reproducing a characteristic rhythm. But also humans may attest to nature's songs by actually singing about them. Indeed songs abound in which we sing of nature's songs, and in singing of these songs we sing with them and in response to them.

Schubert's *Die schöne Müllerin* is exemplary of such songs: several of the songs in the cycle are explicitly about songs of nature, most notably, about the song of the brook, indeed so much so that the entire cycle is infused with the charming songs sung by the brook.[5] The very first song invokes the water of the brook: it is from the water that the one who sings has learned of the delight of traveling, and it is the water that now prompts him to undertake his *Wanderung*. As he sings, the figure in the piano suggests movement, that of the wheels turned by the water, that of the stones set dancing by the flow of the water, and, above all, that of the one who sings, as, following the lead of the water, he sets out on his *Wanderung*.

It is not long before the brook is heard rushing out of the rocky spring and down to the valley; it is heard both in the words of the second song in the cycle and also in the sound of the piano, suggestive, as it is, of the rushing water of the brook. Flowing swiftly on, the brook guides the one who sings. Its course supplies the answer to his question as to where ("whither?") he is headed as he continues

Downward and ever onward,
Ever following the brook[.][6]

Arriving at the mill, listening to its singing, singing of the sweet mill-song, the one who sings asks the brook whether this is indeed where it meant to lead him, to the mill, to the fair maid of the mill (*die schöne Müllerin*). This is what he asks as the third song of the cycle ends and again as the fourth begins: Was this what you meant? Was this what you meant with

Your singing, your sounding,
Was this what you meant?[7]

As the cycle continues, it is the brook that the singer addresses when he asks whether the fair maid loves him; he promptly adds however that

5. Schubert composed this cycle of twenty songs in 1823. The poems are by Wilhelm Müller.

6. This song is entitled "Wohin?" The lines cited in translation read: "Hinunter und immer weiter / Und immer dem Bache nach[.]"

7. These lines, from the fourth song, entitled "Danksagung an den Bach" read: "Dein Singen, dein Klingen, / War es also gemeint?"

he would enlist the aid of various voices of nature to echo his appeal to the maid, teaching the young starling to sing with the sound of his voice, breathing his message to the morning wind that it might convey his assurances to her. When, later, he is with the maid, it is into the brook—now trickling—that they look together. And still the brook calls

... with singing and sounding[.][8]

In the penultimate song the voice of the one who has sung is withdrawn, and now the brook sings a duet with the miller. The miller is all sadness as he sings of a true heart that dies of love. Yet the song of the brook is otherwise:

And when love
Conquers pain,
A new star
Twinkles in the sky[.][9]

The miller's response ends with the words

Ah brook, dear brook,
Sing on then.[10]

As indeed it does in the final song: "The Brook's Lullaby" is sung to the weary wanderer who is now silent:

Rest you well, rest you well,
Close your eyes!
Wanderer, tired one, you are at home.
. .
Good night, good night![11]

8. The phrase comes from the tenth song, entitled "Tränenregen" and reads: " . . . mit Singen und Klingen[.]"

9. The song is entitled "Der Müller und der Bach." The lines cited read: "Und wenn sich die Liebe / Dem Schmerz entringt, / Ein Sternlein, ein neues, / Am Himmel erblinkt[.]"

10. "Ach Bächlein, liebes Bächlein, / So singe nur zu."

11. From "Des Baches Wiegenlied," the lines read: "Gute Ruh, gute Ruh! / Tu die Augen zu! / Wandrer, du müder, du bist zu Haus." Then at the beginning of the final verse: "Gute Nacht, Gute Nacht!"

There are also compositions in which we sing of the elements and of elemental song. In these compositions the interplay between human song and nature's song appears most productive. Even in singing just of the elements—apart from their song—a disclosiveness comes into play that goes completely beyond mere characterization. Mahler's *Song of the Earth* is not simply descriptive of the earth, indeed is hardly descriptive at all.[12] Rather, it is a song that puts in force artistically the capacity of the earth to disclose human mortality, that lets the bond between earth and death be lyrically sounded. Into this song a truth is set: that while, in Homer's words, to live is to see the light of the sun, to inhabit the earth is to be bound to die. It is of the darkness that death spreads even into life that the tenor sings in these lines from the first song:

> A brimming cup of wine at the right time
> Is worth more than all the riches of the earth!
> Dark is life; dark is death.[13]

The orchestral sound becomes itself lyrical, then almost meditative. It swells, and then, as it grows almost tranquil, the song continues with words that pose the perpetual beauty of the sky and the enduring fecundity of the earth in their most profound opposition to human mortality:

> The heavens are ever blue, and the earth
> Will long stand fast and blossom forth in spring.
> But you, O man, how long will you live?[14]

12. Mahler composed *Das Lied von der Erde* in 1908–9. The text is based on *Die chinesische Flöte*, a collection of ancient Chinese poems, published in 1907 in a German translation by Hans Bethge.

According to Bruno Walter, Mahler at first called this work a "Symphony in Songs" but then dropped the idea of calling it a symphony, since it would have been his ninth and he feared his ninth would, as with Beethoven and Bruckner, be his last. Walter reports that Mahler gave him the manuscript to study and tells how, when he returned it, Mahler turned to the final song, "Der Abschied," and said: "What do you think? Is it at all bearable? Will it drive people to make an end of themselves?" Then, Walter continues, Mahler referred to some of the difficulties that would be encountered in performing the work and said in jest: "Have you any notion how this should be conducted? I haven't!" (Bruno Walter, *Gustav Mahler*, trans. L. W. Lindt [New York: Alfred A. Knopf, 1958], 67f.).

13. The first song is entitled "Das Trinklied vom Jammer der Erde." The lines cited in translation read: "Ein voller Becher Weins zur rechten Zeit / Ist mehr wert als alle Reiche dieser Erde! / Dunkel ist das Leben, ist der Tod."

14. The lines read: "Das Firmament blaut ewig, und die Erde / Wird lange fest stehn und aufblühn im Lenz. / Du aber, Mensch, wie lang lebst denn du?"

The opening of the final song, "The Farewell," sets the scene of eve-
ning falling. It is heard first in the orchestra, mostly in the woodwinds,
and then in the voice of the contralto. A brief pause leads to an abrupt
change in the mood of the music. The voice soars, almost as nowhere else
in the entire cycle, as the song becomes a song of the heavens, soaring to
the height that is soon to be counterposed to the deep repose of the earth.
It is a nocturnal sky that the soaring song celebrates:

> See, how the moon above floats like a silver ship
> On the blue sea of the heavens.
> I feel a gentle wind blowing
> Behind the dark pines![15]

Once nature in its more elemental character—sea and sky, wind and
forest—is thus invoked, the song inclines to the earth. Now it becomes a
song of how the earth draws all things to its self-secluding silence, even
those that, like the brook, continue their song into the night, as well as
those that, like the birds, cease their singing:

> The brook sings loud and melodious through the darkness.
> The flowers grow pale in the twilight.
>
> The earth breathes deeply in rest and sleep.
> All longing now has turned to dreaming,
> The weary people go homeward,
> To find forgotten happiness in sleep
> And to learn youth anew!
>
> The birds crouch silent on the branches.
> The world falls asleep . . . [16]

The orchestral music is momentarily suggestive of the sound of birds, as if,
themselves falling silent, these creatures had given their songs up to the

15. From the final song, "Der Abschied," the lines read: "O sieh! Wie eine Silberbarke
schwebt / Der Mond am blauen Himmelssee herauf. / Ich spüre eines feinen Windes Wehn /
Hinter den dunklen Fichten!"

16. The lines read: "Der Bach singt voller Wohllaut durch das Dunkel. / Die Blumen blas-
sen im Dämmerschein. // Die Erde atmet voll von Ruh und Schlaf. / Alle Sehnsucht will nun
träumen, / Die müden Menschen gehn heimwärts, / Um im Schlaf vergessnes Glück / Und
Jugend neu zu lernen! // Die Vögel hocken still in ihren Zweigen. / Die Welt schläft ein . . ."
The final ellipsis belongs to the text.

orchestra, to its pure tones. As the voice dies away, the orchestral sound
descends into the quietness of sleep—or of death.

It will return, and the song will continue, until finally, as if forever, it
dies away, leaving only earth and sky, forever:

> Everywhere the lovely earth blossoms forth in spring and grows green
> Anew! Everywhere and forever the blue spreads into the distance!
> Forever . . . Forever . . . [17]

It will have been a song of the earth, a song sounded by voice and orchestra
in order that the silent song of the earth might be heard.

17. These are the final words of the final song: "Die liebe Erde allüberall blüht auf im
Lenz und grünt / Aufs neu! Allüberall und ewig blauen licht die Fernen! / Ewig . . . ewig . . ."
The ellipses belong to the text; they mark brief intervals of silence on the part of the singer.
This double *ewig* is repeated again and again as the song comes to its end.

Bruno Walter relates that in 1908 he received a letter in which Mahler described his fore-
bodings of death. Though not known by Walter at the time, Mahler had received a medical
diagnosis that left him with little hope. Walter goes on then in his account to ask how Mahler
surmounted this crisis and suggests that he did so primarily by composing *Das Lied von der
Erde*. Walter continues: "When he was nineteen he closed a letter to a friend with the words:
'Oh, beloved Earth, when wilt thou take the deserted one to thy bosom? Oh, Eternal Mother,
receive a lonely, restless heart!' Now doomed to die, he ends his most individual work with the
[following] words." Citing the final words of the final song, Walter concludes: "Loving greet-
ing to the Earth was part of the nature of the young man, as of the aging one; now, under the
shadow of his nearing end, it filled his whole soul" (*Gustav Mahler*, 172).

Mixed Arts

Exquisite . . . ad L. *exquīsīt-us,*
pa. pple. of *exquīrĕre* to search out,
f. *ex-* out + *quærĕre* to search, seek.
—*Oxford English Dictionary*

I t goes almost without saying: arts do get mixed.
Neither is there much need to attest to such mingling by producing examples. Yet, since in this domain Kant does privilege the example as such, taste standing "most in need of examples . . . because its judgment cannot be determined by concepts and precepts" (*KU* 283), and since there are some very remarkable examples, let me begin with one that seems to me among the most remarkable. Or rather, let me begin by asking you to imagine this example or, if you have had the good fortune of witnessing it, perhaps to recollect something of what you saw and heard. For drama, both seen and heard, is readily taken to be a mixing of poetry with a kind of pictorial presentation of its subject. The case of Shakespeare's *A Midsummer Night's Dream* is as such exceptional in this regard, but even more so because of the exquisite music that Mendelssohn composed for Shakespeare's drama. For Mendelssohn's music is blended with the drama with utmost appropriateness. This blending is manifest already in the overture, composed seventeen years before the incidental music, which Mendelssohn joined seamlessly to it for the production of *A Midsummer Night's Dream* that Ludwig Tieck organized in 1843 at the Neue Palais in Potsdam. The incidental music is even more literally mixed into the drama. In some instances the music sets the mood for the scene it introduces or accompanies, as with the eerie chromatic figure that the violin and then

the viola play *andante* while Oberon, squeezing the juice of the flower on Titania's eyelids, casts his spell on her, declaring:

> What thou see'st when thou dost wake,
> Do it for thy true love take.
> (D 2.2.26–27)

In other instances Mendelssohn's composition supplies music that is actually called for in Shakespeare's text, sometimes literally setting Shakespeare's words to music. As when the fairies sing Titania to sleep:

> You spotted snakes with double tongue,
> Thorny hedgehogs, be not seen;
> Newts and blindworms, do no wrong,
> Come not near our fairy queen.
> (D 2.2.9–12)

And as when, at the end, Oberon, Titania, and their train of fairies sing, dance, and bless the house in which the newlyweds are asleep:

> Hand in hand, with fairy grace,
> Will we sing, and bless this place.
> (D 5.1.385–86)

Even when the music serves as an entr'acte, it is integral to the particular dramatic developments: as when, between Acts 2 and 3, the restless, circling agitation of the Intermezzo accompanies Hermia's despairing search for Lysander, until finally giving way to the jocular tune, first sounded by the bassoons, that announces the entry of the mechanicals as the curtain rises on Act 3.

How is it that such mixing is possible? How is it that a presentation can blend with poetry in the production of drama? And how, especially, can music be mixed into the drama? Could it suffice merely to declare that in such instances the poetry, the presentation, and the music have the same subject, that they are about the same set of imaginary or idealized events? Is it even possible to isolate something like a subject that could then be the detached, common subject of various distinct arts? Or is not the subject of a drama always something distinctively dramatic? Is not the subject of music—if there is such a thing—something decidedly musical? That music, even music for the theater, is not just expression of something

essentially nonmusical, perhaps even nontheatrical—this is attested by
the response given by Mendelssohn when some years later he was asked to
contribute to the program to be distributed at a concert featuring the mu-
sic for *A Midsummer Night's Dream:* "It is impossible for me to outline
for the [concert] program the sequence of ideas that gave rise to the compo-
sition, for just this sequence of ideas is my overture."[1]

In any case the peculiar appropriateness displayed by such mixing of
arts as one sees and hears in *A Midsummer Night's Dream* would seem
to be constituted by something other than mere identity of subject. It is
not as though the poetry, the presentation, and the music all simply ex-
press the same thing, so that, at a performance of *A Midsummer Night's
Dream* accompanied by Mendelssohn's music, one would simply witness
the same thing being expressed in three different ways, through three dif-
ferent artistic media. The famous Nocturne does not just represent night
and get added to the representation of night that the drama provides at the
end of Act 3; rather, the music comes to complete the scene of the four lov-
ers sleeping as Puck declares:

> On the ground
> Sleep sound:
> I'll apply
> To your eye,
> Gentle lover, remedy.
> (*D* 3.2.448–52)

And then:

> When thou wak'st
> Thou tak'st
> True delight
> In the sight
> Of thy former lady's eye;
> And the country proverb known,
> That every man should take his own,
> In your waking shall be shown:
> Jack shall have Jill,
> Nought shall go ill;

1. Cited in Eric Werner, *Mendelssohn: A New Image of the Composer and His Age* (Lon-
don: Collier-Macmillan, 1963), 87.

The man shall have his mare again,
And all shall be well.
(D 3.2.453–64)

It would come nearer, then, to what one experiences, if one were to say that the presentation comes to supplement the poetry and that the music comes to supplement the entire drama—*supplement* in the sense of filling out more exquisitely something already in play, filling it out more fully by having sought it out within that which it then comes to fulfill, to supplement. A presentation can come to supplement poetry because poetry already opens a vision that can then be presented on stage, because poetry already contains within itself something like a presentation, because it already presents a scene to (as we say) the mind's eye. Likewise, music can be written for a drama because there is already within the drama something like music, because a certain tone, a configuration of tones, still unsounded, is already prepared within it. The arts will already have been mixed as the very condition of the possibility of mixed arts.

In the *Critique of Judgment* Kant includes a short, though separate section focused, as its title declares, "On the Combination of the Fine Arts in One and the Same Product" (*KU* §52). He mentions several mixed arts, beginning with drama, which he regards as a combination of oratory (*Beredsamkeit*) with pictorial presentation. It is, to say the least, curious that he identifies the linguistic moment in drama as oratory rather than poetry, especially in view of the inferiority that, as we shall see, Kant ascribes to oratory. In song, on the other hand, it is poetry that is said to be combined with music; song is, in turn, combined with pictorial (theatrical) presentation in an opera, which thus combines the same elements, though differently, that one sees and hears in a performance of *A Midsummer Night's Dream* accompanied by Mendelssohn's music. In dance—which is not lacking, one should note, in Shakespeare's drama nor usually in opera—music is said to be combined with the play of figures; but the music in dance would as a rule no longer be song, and Kant refers to it specifically as the play of sensations in a piece of music. Extending even further, Kant mentions finally the forms in which a presentation of the sublime would be combined with beauty—namely, in a tragedy in verse, in a didactic poem, or in an oratorio. He offers no further elaboration but in effect concludes with a declaration that in these combinations fine art (*schöne Kunst*) is even more artistic, though it may be doubted, he says, whether it is also more beautiful (*auch schöner*) in view of the complexity of the

crossings in these mixed arts. Yet, however much these crossings of the various arts and of their ways of pleasing (*Arten des Wohlgefallens*) might compromise the beauty of the products of mixed art, Kant voices not the slightest suspicion—at least not yet—that such crossings might already be operative prior to and as the very condition of the various combinations he mentions, that in poetry, for instance, there might already be a musical, lyrical moment that song would then come to fill out exquisitely. One does not find even the slightest suggestion that the mixings, the crossings, that occur in drama, song, or opera might only reduplicate mixings within what are taken to be the various distinct arts. Nothing in the combination would seem to suggest that there is any threat to the security of the division of art into various distinct arts.

Indeed, the short section on the combination of the fine arts comes immediately after a much longer section entitled "On the Division of the Fine Arts"; it is as if the section on mixed arts were little more than an appendix to the previous section, in which the rigorous differentiation of the primary arts would have been established. Yet it is striking that, having barely begun this division of the arts, Kant adds a cautionary footnote, advising the reader not to judge the division—"this sketch of a possible division"—as if it were intended as a theory; it is, he says, "only one of a variety of attempts that can and should still be made" (*KU* 320n). Clearly Kant is less than confident that the division he is undertaking will be definitive.

Kant bases his division of the arts on an analogy. The basis is "the analogy between the arts and the way people express themselves in speaking [*im Sprechen*] so as to communicate with one another as perfectly as possible, that is, not merely as regards their concepts but also as regards their sensations" (*KU* 320). Even if the division of the arts that Kant bases on this analogy is only one of a variety of possible divisions, there are grounds for his choice of this analogy as the principle for the division. Indeed, the section "On the Division of the Fine Arts" begins by declaring—not without a certain abruptness—that beauty, whether natural or artistic, can be called "the *expression* of aesthetic ideas" (*KU* 319). If artistic beauty, that is, beautiful art, fine art (*schöne Kunst*), has fundamentally the character of expression, then as such it must be analogous to linguistic expression in general, to communicative speaking. Like speaking, art is linked to communication, or rather—marking the difference—to communicability: while speaking communicates concepts or sensations from one subject to another, a product of fine art, judged with taste, produces a feeling that

one is entitled to assume is universally communicable without any mediation by concepts.

Kant begins with the division of speaking, from which then the division of fine art is to be derived. Linguistic expression consists of three moments: word, gesture, and tone—that is, articulation, gesticulation, and modulation. In communicative speaking these three moments are combined, and through their combination—says Kant—thought, intuition, and sensation are conveyed to others. One is to understand that each of the three moments is suited to convey one of these three elements: thought is communicated by word, intuition by gesture, and sensation by tone. One should note also how in this division and correlation Kant puts into play a systematic grid derived from the *Critique of Pure Reason*. At the same time, however, he resists allowing that grid to govern the analysis directly. For immediately after having applied the analogy so as to identify the three corresponding kinds of fine art, Kant observes that the division *could*, instead, be arranged as a dichotomy, in which case one would distinguish between the art of expressing thoughts and that of expressing intuitions, the latter then being divided according to whether it deals with form or with matter, that is, sensation. One notes that the application of the critical grid would then have been quite direct and would have controlled completely the division of the arts. But, says Kant, "in that case the division would look too abstract and less in keeping with ordinary concepts" (*KU* 321). Thus Kant resists giving the critical grid complete control and instead leaves something of an opening in which a view of art in its specificity over against knowledge might guide the division.

The three kinds of fine arts are, then, the art of speech, visual or formative art, and the art of the play of sensations (*die redende, die bildende, und die Kunst des Spiels der Empfindungen*). One will note that the application of the analogy puts into play considerable mediation—so much so that Kant later turns back to explain specifically the transition from gesture (as a moment in speaking) to the visual or formative arts: "What justifies this is that through these figures [namely, in visual or formative art] the artist's spirit gives corporeal expression to what and how he has thought and makes the thing itself speak, as it were, by mime" (*KU* 324). One could say, then: speaking by mime, the products of the visual arts are expressive in the same way as are the gestures of a speaker.

But if there are gaps in the general application of the analogy, they are almost as nothing compared to the discontinuities, incongruities, and indecision that one finds in the specific divisions and elucidations that Kant gives within each of the three kinds of fine arts.

The arts of speech come first, and Kant divides them into oratory and poetry (*Beredsamkeit und Dichtkunst*). Poetry is soon declared to hold the highest rank, not only with respect to the other art of speech, but among all the arts. It is hardly surprising—indeed it is already systematically predetermined—that the art of highest rank must come from the kind of art that, in terms of the analogy, corresponds to the expression of thought, in distinction from that of intuition or of sensation. In this regard the analogy and the grid that it tends to impose are decisive.

Whereas poetry is said to expand and fortify the mind, rising aesthetically to ideas, oratory is castigated as an art of deceiving by means of beautiful illusion and is branded as corruptive and reprehensible. The contrast with poetry becomes more and more pointed as Kant's elucidation proceeds, until finally he construes it thus: "In poetry everything proceeds with honesty and sincerity. It informs us that it wishes to engage in mere entertaining play with the imagination, namely, one that harmonizes in form with the laws of the understanding; it does not seek to sneak up on the understanding and ensnare it by a sensible presentation" (*KU* 327). Even after this concluding, sharp contrast, Kant adds a note that serves not only for resuming the contrast within a more historically oriented context but also for drawing out the consequence of the devaluation of oratory. Kant's procedure is curious indeed. He introduces another division, distinguishing between rhetoric (identified as excellence and power of speech) *and* oratory (now called *ars oratoria* and *Rednerkunst* rather than *Beredsamkeit*). While granting that the former belongs to fine art, he declares oratory "unworthy of any *respect* whatsoever" (*KU* 328n). Though he stops short of an explicit declaration, it is as if oratory, now divided off from rhetoric, were being entirely excluded from the fine arts. It is as if one part, or rather a part of a part, of the fine art of speech ended up entirely outside the fine arts.

The visual or formative arts (*die bildenden Künste*) come second in the general division. These are the arts of expressing ideas in sensible intuition, in contrast to presentations of mere imagination that, in poetry, are aroused by words. The contrast could tempt one to reopen the question of rank, but that would require loosening the hold of the systematic grid that sets thought above intuition, a move that, though Kant does not venture it, could find considerable warrant precisely in the *Critique of Pure Reason*, in the specific priority assigned to intuition within the field of knowledge.[2]

2. This priority is expressed most directly at the very beginning of the Transcendental Aesthetic: "In whatever manner and by whatever means a mode of knowledge may relate to

Kant subdivides the visual arts by bringing into play the opposition between truth and illusion, distinguishing the arts of sensible truth (*der Sinnenwahrheit*) from those of sensible illusion (*des Sinnenscheins*). The first kind he calls plastic art (*die Plastik*), and it is subdivided still further into the specific arts of sculpture and architecture. Kant takes the difference between these to lie largely in the submission of a work of architecture to a use, in contrast to a piece of sculpture, made, as he says, "solely to be looked at . . . , meant to be liked on its own account" (*KU* 322). One recalls, however, that the Athena sculpted for the Parthenon by Phidias was not solely to be looked at or merely liked on its own account. And one might well wonder to what extent the sheltering that a Greek temple provides for a god could be captured under the rubric of use. The force of the distinction seems hardly sufficient to prevent its unraveling as soon as it is confronted with such examples. And the example as such is, as we know, not without a certain privilege.

Initially Kant identifies the second kind of visual art, that of sensible illusion, as painting. Like plastic art, it expresses ideas by making figures in space that image in each case the original idea. Painting offers such figures only to sight, presenting them as pictured by the eye rather than as the image itself, as an object, would exist, in this respect setting forth illusion. Yet the division of visual art does not end here, as one might expect. Rather, Kant goes on to subdivide painting into painting proper and—most curiously—landscape gardening, the former rendering nature beautifully, the latter arranging nature's products beautifully. What is perhaps most remarkable here is that Kant almost immediately calls attention to this curious inclusion of landscape gardening under painting and alongside painting proper. The long note that he adds begins: "It seems strange that landscape gardening could be regarded as a kind of painting despite the fact that it exhibits its forms corporeally" (*KU* 323n). On the other hand, Kant suggests that it could not simply be placed with sculpture, for it actually takes from nature those forms that it arranges beautifully, namely, its trees, shrubs, grasses, and flowers. Kant insists even that to this extent landscape gardening is not art at all. Thus apparently situating landscape gardening both inside and outside art, as if placing it on the boundary that would separate fine art from merely agreeable art, Kant concludes this curious elucidation by again declaring his entire division of the arts to be something less than definitive: "All of this the reader should judge only

objects, *intuition* is that through which it is in immediate relation to them, and to which all thought as a means is directed" (*KrV* A19/B33).

as an attempt to combine the fine arts under one principle—in this case the principle of the expression of aesthetic ideas (by analogy with a language)—rather than regard it as a decisive derivation" (*KU* 323n).

And yet, the elucidation of landscape gardening is hardly more curious than the further extension that Kant makes of painting, of what he now begins to call painting in the broad sense. Here are some of the things he proceeds to include under painting in the broad sense: the decoration of rooms with tapestries, wall edgings, and all beautiful furnishings whose sole function is to be looked at; also the art of dressing tastefully (with rings, snuffboxes, etc.); also a room with all sorts of ornaments (including even ladies' attire), which makes a kind of painting at some luxurious party. What is perhaps most curious in this extension of painting is not, however, the somewhat odd kinds of objects included but the lack of any indication as to the logical character of the inclusion. Are these forms to be included with landscape gardening in a species of improper painting, a species that would be, to say the least, incoherent, a catchall for whatever is not painting proper? Or is Kant proposing an indefinite proliferation of types under this loose generic unity that he calls painting in the broad sense, so that along with painting proper it would include, as further types, landscape gardening, artistically decorating and furnishing rooms, dressing tastefully, setting up a room as a scene for a party? This elucidation seems not at all to produce a closed system of division but rather a proliferation of types and a blurring of distinctions. It is as though what one would have expected to be rigorously distinguished as, for instance, painting proper cannot be contained within the boundary that would delimit it: for as soon as one came to decorate one's room or even one's dress by using the painter's brushes and palette, one would, it seems, have thoroughly eroded that boundary.

Yet, even more remarkably, painting even in the broad sense proves not to be containable within the boundary that would delimit visual art in general. This remarkable result comes to light as soon as Kant begins to elucidate the third general kind of art, the art of the play of sensations, corresponding to tone and modulation on the side of linguistic expression. For there is play of the sensations both of hearing and of sight and therefore two arts of this kind, music and the art of color. Yet, even if one grants without qualification that in painting it is, as Kant insists, design (*Zeichnung*) that is essential (see *KU* 225), there is still no denying that painting must include an art of color. The result is astounding: painting is separated from itself, dissevered so that it falls partly in the visual arts and partly in the arts of the play of sensations. But these would-be parts of

painting are utterly inseparable. From the moment a painter touches brush to canvas, both design and color begin to appear inextricably.

But what of music? Kant's elucidation of the third kind of fine art begins by characterizing this kind as the art, not just of the play of sensations, but of the *beautiful* play of sensations. This placement of the word *beautiful* marks Kant's primary concern and points to what is problematic—and remains so for Kant—about music as a fine art. For without beauty there is no fine art. But, since beauty lies only in the form, not in the matter, of sense, there can be no beautiful sensations as such, hence, no art of the play of beautiful sensations. Thus, if music is to be considered a fine art, then it must produce a beautiful play of sensations—that is, in the play of sensations produced by it, in the musical work, there must be a formal element in the reception of which the listener could reflectively judge the artwork beautiful.

The principal question is thus whether one merely hears, or also judges, music. The question is whether the receptivity to music is only a matter of hearing agreeable sounds or whether reflection enters in response to—and so as to judge—the form of the play of sensations. What is remarkable in Kant's elucidation of this question is his indecision. For instance: "We cannot say with certainty whether a color or a tone (sound) is merely an agreeable sensation or whether it is of itself already a beautiful play of sensations and as such brings it about that in an aesthetic judgment we are pleased with its form" (*KU* 324). Kant does mention, most notably, certain kinds of phenomena that attest to the presence of reflection in the reception of the play of aural or visual sensations: beyond the receptivity required for experience of external objects, there would seem to be a special sensibility, precisely that which is lacking in those who are tone-deaf or color-blind. Kant takes such sensibility to suggest the presence of reflective judgment, though not to establish it definitively. Hence, though inclining toward this alternative, Kant leaves the question finally undecided: "If we consider all of this, we may feel compelled to regard sensation of color and tone not as mere sense impressions but as the effect of our judging of the form we find in the play of many sensations" (*KU* 325). He notes explicitly that this indecision also leaves open the question whether music is the art of the beautiful play of sensations or only of agreeable sensations. In the latter case music would need to be declared, at least in part, mere agreeable art, not fine art. But then—one should note—music will, to this extent, take its place among those arts whose purpose is merely entertainment, those that, as Kant earlier described them, "can gratify a party at table, such as telling stories entertainingly, animating the group to open and

lively conversation, or using jest and laughter to induce a certain cheerful tone among them." All music would be, it seems, little different from the *Tafelmusik* that Kant describes as "a strange thing, which is meant to be only an agreeable noise serving to keep the minds in a cheerful mood and which fosters the free flow of conversation between each person and his neighbor, without anyone's paying the slightest attention to the music's composition" (*KU* 305f.).

Yet Kant limits the drift in this direction and the reduction that it would put in force. In his "Comparison of the Aesthetic Value of the Various Fine Arts" (*KU* §53), he turns almost directly from poetry to music in order to declare that, if our concern is with charm and mental agitation, then music is to be ranked immediately after poetry. While this charming and emotion-stirring character does not suffice to accord music any such rank *as a fine art*, it does limit the tendency to reduce it to something like *Tafelmusik*, so that in the end Kant comes to describe its place as lowest among the fine arts and perhaps highest among agreeable arts. Through this double ranking it is as though music were set precisely on the boundary that would separate fine art from agreeable art. Here it would, as it were, weave its web between (fine) art and entertainment, threatening perhaps even to connect them and to erode the very distinction.

Whether music comes down more on one side or on the other seems to depend on whether or not it is bound to poetry. In the *Anthropology* Kant is explicit: "For it is only because music serves as an instrument for poetry that it is a *fine* (not merely agreeable) *art*."[3] Yet the most remarkable elucidation of the connection between poetry and music is that given in the *Critique of Judgment* itself. Here the connection is described not only as one of rank (music coming immediately after poetry) but also as a profound affinity of content. No doubt it is this affinity that ultimately dictates the connection of rank. Kant writes of the proximity of music to poetry, one by which music is closer to poetry than are any of the other linguistic arts. One would suppose that it is because of this proximity that music can be, as Kant says, combined very naturally with poetry. This same proximity is the basis of the charm exercised by music. But what constitutes this proximity? What is the connection between poetry and music? Kant elucidates the connection by returning to the analogy that governed his division of the arts. That which, on the side of speech, corresponds to music is tone; it is in their common tone that

3. *Anthropologie in pragmatischer Hinsicht*, in vol. 7 of *Werke: Akademie Textausgabe* (Berlin: Walter de Gruyter, 1968), 247.

poetry and music meet. What makes this conjunction one of content is the connection *between tone and meaning:* "Every linguistic expression has in its context a tone appropriate to its meaning [*einen Ton . . . , der dem Sinne desselben angemessen ist*]" (*KU* 327). Thus, there is indeed something like music already within language, within poetry. Within language there is another language, a language of tones, a universal language of sensations, as Kant himself calls it, one that, so he says, "every human being can understand." The art of music lets this other language sound outside of poetry and its proper language: "The art of music employs this language all by itself in its full force" (*KU* 328). And—let me add—music may come to supplement poetry or drama precisely because of this connection, precisely because of the music already within poetry or drama.

That music is always already mixed into poetry Kant expresses with utter directness in a discussion in the *Anthropology* in which he proposes, among the linguistic arts, to award the prize to poetry over oratory. This award is justified, he says, because poetry "is also music (singable) and tone."[4]

But one could say also that within poetry there is already something like painting, like the products of the visual arts in all forms. At least one could justify such a declaration if one extended ever so slightly Kant's explicit description of the relation between poetry and painting. I have referred to the description already: whereas in poetry presentations are aroused in the imagination by words, in the visual arts these presentations are cast as actual or illusory objects of sensible intuition. Poetry will always have opened a vision of images that the visual arts can present by themselves in their full force. Poetry will always have already within it something like painting and sculpture, which, like music, can therefore come to supplement it.

But what of the art of color, that other kind that Kant includes among the arts of the play—or the beautiful play—of sensations? Most of the doubts and questions that Kant raises concerning the artistic status of music apply also to the art of color. Most notably, its inclusion as a fine art will be threatened as long as one cannot with certainty declare that there is an element of form in the play of sensations of color. Yet can one not declare such an element present precisely insofar as the art of color coincides—as I have suggested—with painting proper, specifically with the figuration, the design, executed by the painter? Can one not insist indeed

4. Ibid.

that both in art and beyond there is never color without figuration, never sheer sensory matter without form? Least of all, in painting.

The configuration that has thus begun to emerge proves rather different from the division, delimitation, and ranking of the arts that one would have expected the *Critique of Judgment* to produce. It is true that the analogy that Kant puts at the basis of the entire elucidation deploys a certain critical grid and that he leaves the appropriateness of this grid to art generally unquestioned. And yet, if one is attentive to the particular elucidations, one realizes that the deployment of this grid reaches only so far and that an opening to the arts in their specificity is operative throughout. It is as if the deployment of the critical grid brings to light the character of the arts rather than concealing and distorting that character by imposing an alien frame upon it. Or rather, it is as though the specific articulations of the arts come to light both through the grid and despite it. It seems to me that it would not be out of the question to interpret Kant's general cautionary remarks in precisely this connection: the division, the grid, introduced is not to be taken as a definitive theory but as one of a variety of attempts that should be made in order to disclose the arts in their proper identity and their respective rank.

But what of the proper identity of the various arts? Do Kant's elucidations serve to establish the proper identity of each art? Or, on the contrary, do these elucidations, with all the discontinuities, incongruities, and indecision that emerge in them, not serve to disrupt the very concept of proper identity as regards the arts? For some alleged arts end up being suspended at the very boundary of fine art, overlapping into a field that would no longer be that of fine art, while still remaining somehow among the fine arts. Painting, in what one might call the complete sense—in distinction from what Kant calls painting proper and painting in the broad sense—turns out in Kant's elucidation to be literally separated from itself, its alleged proper identity quite dissevered. But at another level it becomes questionable whether any particular art can be complete within itself: for a supplementary structure has proven to be operative in the relation of painting to poetry and, thematized by Kant himself, in the relation of music to poetry. If one is attentive to what Kant's elucidations bring to light, one cannot but begin wondering whether the arts could ever be appropriated to a traditional logical schema or whether another, stranger logic might need to be forged.

And yet, one could perhaps almost have arrived at this point by witnessing with sufficient attentiveness a performance of Shakespeare's *A Midsummer Night's Dream*, by hearing the music that is already within it even before Mendelssohn's music comes to fill it out so exquisitely.

Perhaps almost.

Yet not, I should think, with the clarity that Kant's incisive elucidations provide, Kant's incorruptible clarity, as Heidegger once called it, a clarity "that by no means excludes the questionable and the unstable and that does not feign light where there is darkness."[5]

5. Martin Heidegger, *Die Frage nach dem Ding* (Tübingen: Max Niemeyer, 1962), 42.

Music and Imagination

Though music has a singular capacity to evoke scenes of nature, it is itself most unnatural, most remote from nature.

To be sure, its evocative and ecstatic power can transport the listener into the very heart of nature. Simply hearing a song about nature can often suffice to carry us, in imagination, to a natural scene magically evoked by the song. If someone sings of the lovely sounds of nature, of the softly falling rain, of the babbling brook, of the song of the nightingale, it can be as if we ourselves were there in the countryside listening to nature's own voice. In song, the capacity that words have to evoke images is in play, supplementing what vocal sound alone can achieve. Yet even music without words, without the human voice, purely instrumental music, is capable of evoking natural scenes and of drawing the listeners into those scenes. Though the evocative effect of the second movement of Beethoven's *Sixth Symphony* may be enhanced by the listener's awareness of the title "Scene by the Brook," the music alone suffices to call up the scene and to engage the listener in it.

What is remarkable is that such music achieves its effect by the most unnatural means. In the case of purely instrumental music, even the remnant of naturalness that might be accorded to singing has vanished. In Beethoven's famous Andante, incomparably evocative of nature, there is almost nothing natural. Nearly the entire movement is purely musical without any direct imitation of natural sounds that would be heard at a scene by the brook. The gentle, expansive theme draws the listener to the country scene right away, long before, in the brief coda, flute, oboe, and clarinet come to imitate the songs of birds, of the nightingale, the quail, and the cuckoo. The effectiveness of these imitations of natural sounds depends on the listener's already having been drawn to the scene by the brook by purely musical—that is, artistic rather than natural—means.

>>> <<<

Though there is indeed a kind of music to be heard in nature (nature's song, as it were) and though even in human song there is a vestige of naturalness, the instrumental music that humans compose and perform does not occur simply by nature. Such music is made, is fabricated; it is something artificial, something in which there is always an element of production, something on the side of art rather than nature.

Indeed, among the arts, music is the most unnatural, the most remote from nature. Unlike architectural edifices and works of sculpture, music does not consist of natural things reshaped into artworks by means of human artifice. A musical work is not even an enduring thing like a painting, which not only is borne by a substructure taken ultimately from nature but also—except very recently—depicts a scene consisting of things and persons as they exist—or could or should exist—in a certain relation to nature. Even when, as in poetry, this natural substructure disappears, there remains, as Kant observes, a certain depiction, a vision of a scene produced not by spreading color on a surface but by way of words, a kind of painting within poetry. And though, in song or opera, music may be conjoined with poetry to enhance the force of the vision, music as such—most notably, instrumental music—lacks even this poetic relation to nature. A musical work is merely a sequence of disappearing, self-canceling sounds. The sounds do not come from nature but from highly artificial instruments; thus, as they belong to the musical work, they are not—and are not intended to be—sounds *of* anything. If, in listening to music, one simply passed through the sounds to that which sounds, as one passes through the profiles or visible qualities of an object to the thing itself, one would have missed the point entirely. The sound of a violin is not to be apprehended as disclosing the violin. In music there is merely sound, and, except in overly programmatic music, it is not to be apprehended as the sound of anything. Musical apprehension is in this sense nonintentional. Since the musical work is neither fabricated on the basis of natural things nor a depiction of nature-related things, music is, of all the arts, most remote from nature.

This is why birds have such enormous significance for Kant. Or rather, this is why, as Kant recognizes, the songs of birds are found to be so beautiful. For in the songs of birds, music, which is most remote from nature, is produced from nature, by a purely natural creature. The remoteness of music from nature is what renders the natural production of music all the more conspicuously purposive, that is, beautiful. That nature goes so far

as to make music shows most strikingly nature's fittedness to the human powers capable of apprehending music.

But, putting the birds aside, how does music come to be? It is not a matter of fabricating something from natural materials, and thus one cannot be guided as was Michelangelo when he chipped away pieces of stone in order to let the shape slumbering within the marble emerge or escape. Neither can the composer be guided by a certain vision or idea, since music neither depicts a vision nor represents an idea. If in all art—in all fine art—prescriptions are necessarily lacking by which a work could be created, this lack would seem most extreme in the case of music, since musical composition lacks even the orientation to natural materials and scenes, which, though not sufficient, do provide to other artists a certain guidance. How, then, does the composer create the musical work? How is musical creation possible?

Just imagine. Imagine composing a symphony. Imagine setting out to compose a symphony. The beginning would be, as always, most difficult. There would be nothing there, no sounds, no vision, only—to put it metaphorically—a kind of blank page for still unheard sounds, along with—literally—the blank paper on which the musical work will be inscribed. Just as there are configurations of lines, the staffs, and perhaps other marks on the paper, there are harmonic and rhythmic principles that will frame the musical work. Yet these alone do not produce music. In the most propitious circumstances, one will have been drawn to the blank page by a certain *Stimmung,* by a moodful openness to the arrival of something that might begin to fill the blank page. And yet, how does the music arrive? How can one set down the first note without having already heard the entire symphony through to the end to which, with a certain inevitability, that first note will lead? How does one hear what has not yet sounded, what—still to be composed—cannot yet have sounded? How can one hear in advance? To use Kant's term in a sense that he perhaps would find strange, how can one hear a priori? How is a priori hearing possible? Can one hear with the mind's ear, as—so we are told—one can see with the mind's eye? Would this designation, the mind's ear, also be, as in the other case, a way—metaphorically perhaps—of speaking of imagination, or at least of a certain peculiar operation of what is called imagination? Is it such an operation that the composer must carry out, as, at the opposite pole, listening to a musical work can set the imagination in play?

How, then, does imagination animate music? The *Critique of Judgment* provides enormous—perhaps even incomparable—resources for addressing this question. As I turn, first, to Kant's theory of imagination and, second,

to his conception of music, I will not by any means be in a position to draw
out the full range of resources that Kant's text offers. On the other hand, in
face of certain aporias in Kant's conception of music, I will need to mark a
certain limit and to venture a certain elaboration at that limit.

>>> <<<

Transcendental philosophy displaces the classical philosophical question,
the question "What is . . . ?" (τί ἐστι . . . ?). The directionality of its ques-
tioning is regressive: it questions from the experiences of nature, of beauty,
of freedom back to the powers that make these experiences possible. The
word *power* (*Vermögen*) indicates the intent of the regress: it would deter-
mine, not *what* the powers are, but only what they are powers *of*. Beginning
with experience in the various modalities, which most generally correspond
to the threefold articulation of the critical project, transcendental philoso-
phy takes as its aim the analysis of the operations of the various powers
that make these modalities of experience possible. From the very beginning
of the *Critique of Pure Reason*, the analysis is oriented toward determining
not *what* intuition and understanding, for instance, are as powers of the
soul, but rather what they contribute to the enabling of experience: that, by
intuition, there is immediate relation to objects and that, by understand-
ing, objects are thought and concepts generated. By interrogating the opera-
tions and accomplishments of the powers in relation to experience rather
than pursuing the question of what they are, transcendental philosophy
eludes the performative contradiction of declaring knowledge of the soul
impossible while carrying out a project aimed precisely at such knowledge.
Furthermore, by displacing the classical question, transcendental philoso-
phy interrupts the orientation of philosophical thinking to the ἰδέα, which
corresponds to the directive force that this question, this form of question-
ing, has exercised since Plato. The redetermination that the sense of *idea*
undergoes with Kant presupposes this interruption.

The displacement and interruption seem to be even more decisively
effected in the case of imagination. Though in the first Critique Kant des-
ignates imagination as "a fundamental power of the human soul" (*KrV*
A124), he attests also that it is a power "of which we are only seldom con-
scious" (*KrV* A78/B103). While insisting that the operation of imagina-
tion is continual and indispensable, Kant thus grants that there is only
minimal awareness of this power as such, or even, it seems, of its opera-
tion as such. It is seemingly an operation of which we could easily lose
track, as, to all appearances, Kant himself did when he omitted imagina-
tion entirely from the catalogue of the powers of the mind assembled at

the end of the Introduction to the *Critique of Judgment*. To be sure, in the *Critique of Pure Reason* he offers what seems a comprehensive and forthright definition of imagination, though, as with all powers, the focus is on the operation and accomplishment: "Imagination is the power of representing an object in intuition without its even being present" (*KrV* B151). And yet, even a cursory survey of the operations ascribed to imagination in the Transcendental Analytic—those of synthesis and of schematism, for instance—suffices to show that imagination outstrips the operation to which the apparent definition would confine it. The force of Kant's analyses serves to suspend—or at least to put into question—not only the eidetic unity of imagination but also its operational coherence.

The dispersal is still greater in the *Critique of Judgment*. Here—at least in the Critique of Aesthetic Judgment—the theme of imagination is woven into every strand of the text but in various shades, in various determinations, so various indeed that they threaten the very unity of the word and the concept. Without any pretense of completely disentangling this skein nor even of marking every distinct thread, let me distinguish a series of determinations—six in all—that, minimally speaking, yield what seem the most prominent and decisive shapes that Protean imagination assumes in the third Critique.

The first determination fuses imagination, to a certain extent, with intuition. Kant refers to imagination as a "power of intuition" by which an object is apprehended "in relation to the understanding, as a power of concepts" (*KU* 292). Another passage correlates this apprehensive, intuitive operation with imagination's being "bound to a determinate form" of the object apprehended. In both descriptions, however, the fusion with intuition is limited: imagination exercises this intuitive, apprehensive operation only within judgments of taste, only as reflective apprehension of beautiful objects, not in ordinary cognition of empirical objects. In contrast to the immediate material relation to the object that ordinary experience, that is, empirical cognition, requires, only the apprehension of its form is required in the judgment of taste. It is in this apprehension of the mere form of the object that imagination takes on—or takes over—the role of intuition. In the Introduction to the *Critique of Judgment*, in the very first description of the judgment of taste, Kant uses the phrase *Auffassung der Formen in die Einbildungskraft* (*KU* 190)—thus, not only apprehension of forms *by* the imagination but also their appropriation, transport, translation *into* imagination. In contrast to ordinary empirical intuition, which effects a relation to the object in its materiality, imagination detaches

merely the form of the object, takes up merely the form, takes the form up into itself, and thus lets the material object go its way, remains indifferent to the object, disinterested in it.

Another phrase used in the same context both reaffirms in different terms the description of imagination's apprehensive operation and indicates a significant extension beyond this operation. The phrase, parenthesized following the word *imagination*, portrays imagination as "the power of a priori intuitions" (*KU* 190). The phrase expresses the mixed or intermediate character of imagination, its character as both receptive—hence a power of intuition—and active or spontaneous in its capacity to detach the form from the object and to take the detached form up into itself—hence a power not simply determined by the intuitively given but, to this degree, operating a priori. Yet the phrase also marks an extension of the capacity of imagination, for, in the strict sense, the only intuitions that are a priori are those of space and time. The implication is not only that imagination takes up the form of the object but also that it is capable of deploying or redeploying the space and time in which the object occurs. Though traces of other significant instances of such redeployment can be found, the most explicit discussion ·is found in a passage on the sublime.[1] The passage occurs in the context of Kant's account of the mathematically sublime and, in particular, of the way in which the requisite double operation of imagination is carried out. For in such a judgment, exercised, for instance, with respect to an Egyptian pyramid, imagination must both apprehend the parts successively and comprehend the whole in an instant. What is decisive is the conflict between these two operations, the conflict as regards the condition of time. Kant writes: "Comprehending a multiplicity in a unity, not of thought but rather of intuition, and hence comprehending in one instant what is apprehended successively is a regression that in turn cancels the condition of time in the imagination's progression and makes *simultaneity* intuitable" (*KU* 258f.). By canceling temporal succession and redeploying the time of the intuition of the sublime, redeploying it as simultaneity, the imagination, as Kant says, "does violence to inner sense," for which temporal succession is a condition.

The second determination of imagination with respect to its operation in the judgment of taste is closely connected to its intuitive operation.

1. Since for Kant the sublime proves only marginally significant for art (see *KU* 325), this theme will not otherwise be taken up in the present context. An extensive discussion of the sublime is presented in *Spacings—of Reason and Imagination. In Texts of Kant, Fichte, Hegel* (Chicago: University of Chicago Press, 1987), chap. 4.

It also harks back most explicitly to the determination of imagination as an operation of synthesis, the operation that figures most prominently in the first Critique. Indeed when this operation is mentioned in the third Critique, it is typically in reference to empirical cognition or in marking the difference between the latter and the judgment of taste. Kant describes this operation as the imagination's "activity of combining the manifold" (KU 238). Another passage links this operation explicitly to the intuitive operation, Kant noting that imagination is "for the intuition and the combination" (KU 287). The synthetic operation would, at this level, be integral to the apprehension of form; it would be simply that combining of moments required in order that imagination apprehend the form as a whole.

The third determination introduces an entirely different operation. As the imagination intuits the form of the object, putting synthesis into play such that the form is apprehended as a whole, this power is itself already set in operation. Thus Kant tends to say that this power is brought into operation by the object—in his words, "whenever a given object, by means of the senses, induces the imagination to its activity of combining the manifold" (KU 238). Yet, in turn, according to Kant, "imagination induces the understanding to its activity of providing unity for this manifold in concepts" (KU 238). Clearly, then, the synthetic operation carried out by imagination pertains not only to the apprehension of the form of the object but to its comprehension. And yet—most decisively—in the judgment of taste there is no comprehension, no concept, no cognition. When, in such judgment, the imagination takes up the form as a whole, that form is not then brought under a concept so as, through the understanding, to achieve an empirical cognition of it. In other words, when imagination takes up the form into itself, it does not—as it would in cognition—submit to the understanding; rather, it is set in play and in interplay with the understanding. Kant explains: "The cognitive powers brought into play by this presentation [viz., of the form of the object] are thereby in a free play, because no determinate concept restricts them to a particular rule of cognition" (KU 217). This is, then, the third determination: the operation of imagination as play, indeed as free play.

What counts in this free play is the harmony between the two powers, imagination and understanding. What counts is that precisely in their free play they may prove to have the same accord that would be required in cognition, even though in the judgment of taste there is no cognition. When, through the apprehension of the form of an object, imagination and understanding are, in their free play, set in such an accord, then this accordance is felt with pleasure and the object is determined as beautiful.

Kant refers therefore to the *free lawfulness* of the imagination, the free lawfulness that it displays in the judgment of taste. In such judgment the imagination is not submitted to the laws of understanding, to the categories as they prescribe the unification of the manifold; rather, in the free play to which it is incited by the form apprehended, the imagination turns out to be in accord with these laws. Before an object that is to be determined as beautiful, the imagination proves to be lawful without submitting to the compulsion of laws; it displays a free lawfulness. Kant formulates this operation also in terms of the analysis of schematism developed in the first Critique. He says: "The imagination's freedom consists precisely in its schematizing without a concept" (*KU* 287). This free schematizing is virtually an inversion of the relation sustained between understanding and imagination in empirical cognition: in relation to the beautiful, as Kant says, "the understanding serves the imagination rather than vice versa" (*KU* 242).

Kant offers some indications as to how this free play of imagination is and is not furthered, enlivened. He notes, in particular, that stiff, mathematical-like regularity runs somewhat counter to taste, since it does not for long sustain our contemplation. On the other hand, there are things that lend themselves to unstudied and purposive play by the imagination, things that tempt us to linger in contemplation of them. Yet, except for his critical reference to Marsden's *History of Sumatra,* which describes a pepper garden in the midst of the jungle, Kant offers—at least in this context—only a single example of something beautiful that enlivens the play of imagination, that invites us to linger in imaginative contemplation. Even if a bit apologetically, Kant offers the example of bird song: "Even bird song, which we cannot bring under any rule of music, seems to contain more freedom and hence to offer more to taste than human song, even when this human song is performed according to all the rules of the art of music; because we tire much sooner of a human song if it is repeated often and for long periods" (*KU* 243). The only other examples are of things that are only charming, not beautiful: "the changing shapes of the flames in a fireplace or of a rippling brook: neither of these are beauties, but they still charm the imagination because they sustain its free play" (*KU* 243f.).

The three determinations developed thus far, imagination as intuitive, as synthetic, and as engaging in free play, are geared to the exercise of judgment of taste and to a situation in which the apprehension of the form of an object is what incites the imagination to these operations. In order to develop the further determinations, it is imperative to distinguish

between such a situation and one in which, in Kant's phrase, imagination operates as "the originator of chosen forms of possible intuitions" (KU 240). In the latter situation the imagination no longer simply apprehends the form of an object given to sense; imagination is no longer in this respect receptive, no longer bound to a pre-existent object. Rather, it brings forth the form through its own spontaneity; it produces the object. Even if judgments of taste must be—as Kant always insists—conjoined to such origination, confirming the beauty of the product, the operation of imagination as power of origination surpasses those operations that judgment of taste requires. As a power of origination, imagination is productive and spontaneous. This, then, is the fourth determination: imagination as a productive and spontaneous power of origination. With this determination, Kant's analysis makes the transition from natural beauty to artistic beauty, from the operations in which imagination remains bound to a given object (whether natural or artistic) to an operation in which the freedom, the free play, of imagination is fully actualized.

All the further determinations, especially as they cohere into a single configuration, pertain to the operations of imagination in artistic production. Yet these operations are not entirely restricted to artistic production, and their determinations are, at certain points, carried out in a broader—or, in any case, different—connection. In particular, the fifth in the series of determinations is worked out in connection with the ideal of beauty. In this regard the question concerns models that can be exemplary for taste; it concerns specifically the highest model, the archetype of taste. This archetype is an idea, that of a maximum demanded by reason; and yet it can be set forth, not through concepts, but only through the exhibition or presentation (Darstellung) of an exemplary individual. As an individual adequate to the idea, it is more properly called the *ideal* of the beautiful. Kant declares that we do not possess this ideal but that we strive to bring it forth within ourselves. Because it is to be presented rather than grasped through concepts, it is an ideal of imagination; for, says Kant, "the power of presentation is imagination" (KU 232). Thus, it is through the operation of imagination that we strive to bring forth this ideal, to present it. This, then, is the fifth determination: imagination as the power of presentation (das Vermögen der Darstellung). In relation to the ideal of beauty, this operation of presentation involves various moments: the recall and reproduction of images and shapes, as well as the projection of images upon images so as to arrive at a standard. The operation culminates in giving visible expression to moral ideas; for this, says Kant, "pure ideas of reason must be united with great power of imagination" (KU 235).

Within the broader perspective that unfolds once Kant turns to a con-
sideration of artistic production, the idea of beauty, presented as ideal by
the operation of imagination, converges with the more extensive concep-
tion of aesthetic ideas. Kant observes that there are works of fine art that,
though not lacking in taste, are said to have no spirit (*Geist*). Such dis-
course indicates that spirit is in fact expected to be displayed by works
of art. If indeed spirit is displayed by a work, this in turn indicates the
operation of spirit as animating the production of the work, as the animat-
ing principle in the mind (*das belebende Prinzip im Gemüte*) of the artist.
Spirit is what enlivens, quickens, the mind; it sets the mind in motion in
such a way that thought is stimulated and expanded, extended, beyond its
usual compass. Kant explicitly identifies spirit as "the power of present-
ing *aesthetic ideas* [*das Vermögen der Darstellung* aesthetischer Ideen]"
(*KU* 313). If one recalls that it is imagination that constitutes the power
of presentation as such, then it becomes evident that spirit is none other
than imagination in its specific operation of presenting aesthetic ideas.
Yet, in such presentation, imagination carries out such a decisive advance
that its operation as spirit can legitimately be regarded as still another (the
sixth) determination.

But what is an aesthetic idea and what does its presentation involve?
Kant offers an explicit definition: "By an aesthetic idea I mean a presenta-
tion of the imagination [*Vorstellung der Einbildungskraft*] which prompts
much thought but to which no determinate thought whatsoever, i.e., no
concept, can be adequate, so that no language can fully reach [*erreicht*] it
and render it understandable" (*KU* 314). The definition confirms still more
openly that spirit, in presenting aesthetic ideas, is none other than imagi-
nation. The aesthetic ideas thus presented are characterized as prompting
(*veranlassen*) much thought, that is, as occasioning thought, motivating it,
as bringing it about, calling it forth, evoking it. Yet, almost paradoxically,
such an idea is a presentation to which no determinate thought can be
adequate, with which no concept can entirely match up. It is a presenta-
tion that cannot be grasped, comprehended, encompassed in a concept, a
presentation that *exceeds* every determinate thought. Consequently, it is a
presentation that language cannot fully express, cannot lay out for under-
standing; for what can be fully reached by words—that is, meant by them,
intended through them—are precisely concepts or combinations of con-
cepts. Because aesthetic ideas exceed determinate thought, they also ex-
ceed the expressive—at least denotative—possibilities of language. Hence,
Kant draws a contrast between aesthetic ideas and rational ideas: whereas
an aesthetic idea is a presentation of imagination to which no concept is

adequate, a rational idea is a concept to which no intuition—that is, no presentation of imagination—is adequate. An aesthetic idea is the counterpart or inverse of a rational idea.

In order to describe the way in which imagination presents—that is, produces, creates—aesthetic ideas, Kant puts in play, in a very specific guise, the oppositional relation between art and nature, which in various forms runs throughout his account of art. Productive imagination—he says—creates "another nature out of the material that actual nature gives it" (*KU* 314). Kant explains that in such production imagination proceeds in part analogically, so that the second nature is, to a degree, like the first; and yet, he remarks that it also follows higher principles, principles of reason, and that then it recasts the material of the first nature "into something quite different, namely, into something that surpasses [*übertrifft*] nature" (*KU* 314). Thus, these presentations venture beyond the limits of experience, and so they may appropriately be termed ideas.

Though it belongs to the very character of an aesthetic idea that no concept can be adequate to it, such an idea is always, on the other hand, set forth in conjunction with a concept. In other words, an aesthetic idea is not cast into a remote, independent sphere apart from concepts and from the experience of (first) nature but rather is always paired with a concept and precisely for this reason is always an idea "about" something, an idea "of" something. In order to describe this pairing of idea and concept Kant uses the word *unterlegen*: the aesthetic idea is *set under* the concept. Yet this pairing is decidedly not such that idea and concept are simply matched, for it is precisely the character of an idea that it exceeds every concept. Indeed it is just the *movement of exceeding* that is decisive: set under the concept and exceeding it, the aesthetic idea "aesthetically expands the concept itself in an unlimited way" (*KU* 315). It is as if, set under the concept, the excessive idea stretches the concept beyond what it comprehends, expanding it beyond itself. In this operation imagination is preeminently *creative*; and in its sphere, prompted by this excess, reason is made to think more than can ever be comprehended in the mere concept.

This process by which the mind is animated to think in excess of the concept can also occur, according to Kant, in another, slightly different way. Instead of setting under the concept an aesthetic idea paired with the concept (in the sense of representing it or of being an idea "of" it), imagination may set certain partial presentations next to (alongside) the concept, namely, adjacent presentations (*Nebenvorstellungen*) that express the concept's implications or its kinship with other concepts. Such presentations are called aesthetic attributes—as in the instance in which, to

the concept of the god, there is added Jupiter's eagle with the lightning in its claws. Yet in such cases the effect is the same: such attributes offer "something that prompts the imagination to spread itself over a multitude of kindred presentations that arouse more thought than can be expressed in a concept determined by words" (*KU* 315).

Kant stresses the conjunction of idea and concept: "In a word, an aesthetic idea is a presentation of imagination that is conjoined with a given concept." He continues: it is a presentation "that lets us add to a concept the thought of much that is unnamable [*viel Unnennbares*] but the feeling of which animates our cognitive powers and connects language, which otherwise would be mere letters, with spirit" (*KU* 316). Thus Kant returns to the question of language, but now in another spirit, in its connection with spirit. To be sure, an aesthetic idea exceeds the grasp of language; an idea cannot be reached and rendered understandable by language in its usual logical, denotational function. And yet, it is as though the aesthetic idea had the effect of stretching language beyond these limits, so that it would become a matter, not just of the letter, that is, of what is merely said, but of an animation of language by spirit.

The gift of nature by which nature gives the rule to art, that is, genius as it operates in the artist, consists—Kant declares—in the combination of imagination and understanding set in a certain relation. This relation, on which everything—the very possibility of art—depends, consists of a double exceeding. On the one side, freed of the cognitive bond to understanding, imagination goes beyond the concept and, in Kant's words, supplies "in an unstudied way [*ungesucht*], a wealth of undeveloped material for the understanding that the latter did not take into account in its concept" (*KU* 317). But then, on the other side, understanding takes up this material so as to enliven its own power and to be drawn beyond itself. Thus, genius operates as excess in this play of imagination and understanding; in this operation imagination exceeds the sphere of understanding and thereby draws understanding itself beyond that sphere.

Aesthetic ideas must be not only brought forth but also expressed. Thus, Kant distinguishes explicitly between the discovery of ideas for a given concept (that is, for expanding that concept) *and* the discovery of a way of expressing these ideas so as, in his words, "to communicate to others, as accompanying a concept, the mental attunement [*Gemütsstimmung*] that those ideas possess" (*KU* 317). The latter discovery Kant attributes especially to spirit, and it is this expression that is carried out through the production of works of art. It is for this reason that the entire discussion of the division of the fine arts, of their systematic articulation,

proceeds from the concept of expression, that is, on the basis of the analogy between the arts and the way things are expressed in speech.

Kant's elaboration of the way in which aesthetic ideas come to be expressed thus serves to round out the earlier determination of imagination as the power of presentation. In its allied operations, the imagination both brings forth, creatively produces, aesthetic ideas *and* exhibits them concretely, expresses them through the origination of works of art. Yet, even as it is, in this way, spontaneous and productive, there is need that it also exercise the other operations (intuition, synthesis, free play) that belong to the judgment of taste, thus assuring and confirming the beauty of that which the imagination creates. Hence, in artistic creation all the operations of the imagination—at least as marked in the *Critique of Judgment*—come together. In the work of fine art all these operations converge; in this configuration they are gathered, and a certain unity of imagination is attested.

>>> <<<

The question as to how imagination animates music would seem to be answered, at least at a certain general level, by Kant's theory of imagination. As with all fine art, the creation of the musical work would set in operation the presentation and expression of aesthetic ideas and, in conjunction with the spontaneous production of the work, would require also the operations of intuition, synthesis, and free play that belong to the judgment of taste, which must be exercised to assure the beauty of what is produced. In the discovery and expression of aesthetic ideas, it would not be a matter simply of grasping a concept and then somehow exemplifying that concept in the work, translating the concept, as it were, into the singular work. Because aesthetic ideas are not determinate concepts and because what is primarily operative is creative imagination, the operation consists in a certain intimation, in a kind of hearing in advance that is oriented to the discovery of the idea and of the way, through sounds, of communicating the mental attunement evoked by the idea. Yet this intimation of the idea and of the musical work through which its evocative effect would be conveyed is not carried out independently of concepts and of understanding as the power of concepts. Rather, in Kant's view, the intimation will always have sought out an idea "for a given concept" (*KU* 317), however tacitly conceived the concept might have been; and through the discovery of the idea, imagination will expand the concept, stretching it beyond what is conceived in it, drawing the understanding beyond itself and provoking it to think more than mere words can say. While this operation is thus not a matter of cognition, it is such as to evoke thought, indeed a thought that exceeds what the

cognition allied with experience of nature can accomplish. Though Kant reserves the word *truth* for the latter (see *KrV* A58/B82), a more broadly hermeneutical outlook would tend, quite legitimately, to extend the word to this more expansive thought that can be provoked by the artwork. Then, merely resituating the Kantian analysis within this broader context, one could, in multiple senses, speak of the true sense of art.

In composing a musical work that conveys the sense of the idea, the artist will also have communicated the expansion of thought that the idea evokes. Thus the listener, too, will be provoked to think more than can be conceived and expressed in concepts and mere words. At the same time, in their very movements of exceeding, imagination and understanding must themselves remain in a relation of harmonious free play. The situation must be such that to the listener with sufficiently cultivated taste the musical work will communicate the sense of the idea and evoke expansion of thought precisely as the listener, also exercising judgment of taste, feels with pleasure the accord between his mental powers engendered by the form of the beautiful work.

In the creation of the musical work and in its tasteful, imaginative reception, all the operations of imagination would be gathered—*provided* the musical work is indeed a work of fine art (*schöne Kunst*). Yet Kant is reluctant simply to grant this condition. In the very first reference to music in the *Critique of Judgment*, Kant distinguishes between the merely agreeable sounds of musical instruments and the beauty of a concert. Whereas some like the sound of wind instruments and others the sound of string instruments, so that regarding the agreeable each has his own taste, the beauty of the concert is such for everyone and, in Kant's words, one "speaks of beauty as if it were a property of things" (*KU* 212). In this initial formulation the differentiated terms are presented as being external to one another: on the one hand, agreeable musical sounds, on the other hand, beautiful music. Yet the difference cannot remain external, for music consists precisely of musical sounds; indeed, in a sense, it is nothing other than musical sounds. As Kant comes to think this difference in a more intrinsic way, the question whether music is a fine art will become ever more aporetic.

But even before turning to this first aporia in Kant's theory of music, it is perhaps pertinent to note a peculiar reservation on Kant's part toward music, a reservation that may indeed betoken at a mundane level the limitation that critique ventures to expose in music. Thus, in comparing the aesthetic value of the various arts, Kant writes: "Moreover, music has a certain lack of urbanity about it. For, depending mainly on the character of its instruments, it extends its influence (on the neighborhood) farther than

people wish, and so, as it were, imposes itself on others and hence impairs the freedom of those outside of the musical party" (KU 330). Kant compares the intrusiveness of music to the effect produced when someone pulls a perfumed handkerchief from his pocket and gives those around him a whiff whether they want it or not. Kant adds a note criticizing those who recommend that the singing of hymns be included at family prayer, since they fail to consider the effect on the neighbors. And it is reported that, having been disturbed in his studies, Kant once wrote to the Oberburgermeister of Königsberg suggesting that in the nearby prison the windows be closed during the hymn-singings that the zealous wardens required of the prisoners.

Let us turn now to the two aporias that emerge as Kant develops his conception of music, aporias that represent a certain undecidedness in this conception. It will, I hope, become evident that these aporias attest, not so much to a weakness or failure in Kant's thought, but rather to the force and persistence with which he engages what he ventures to think—in this case, music—even when he is led in directions that are at odds with the broader systematic constraints.

The first aporia, which Kant explicitly acknowledges as such, turns on the question whether music, in a certain respect, is beautiful or merely agreeable. In the preliminary discussion of this question (KU §14), there is a pronounced vacillation, which is suggestive of the aporia that is subsequently formulated as such. Kant begins by observing that most people consider a mere tone such as that of a violin to be beautiful. But, Kant counters, a tone seems to be merely the material of presentation, that is, merely sensation, which is relative to individual taste and deserves only to be called agreeable (angenehm), not beautiful (schön). And yet—thus the vacillation continues—a tone can be called beautiful if it is pure (rein), for the purity of sensation consists in its uniformity, which concerns the form and not simply the material of presentation. There is also the likelihood that in the perception of tone the mind perceives the regular play of impressions, hence the form, so that, again, mere tone could be considered beautiful. Yet, Kant concludes, whatever may be the case with mere tones, what counts in music is the composition (die Komposition); it is the composition that is the proper object of a pure judgment of taste, and hence it is the composition that renders music beautiful rather than merely agreeable. If the tones are pure, then they serve, not so much as an addition to the beauty of the work, but rather to make the form—that is, the composition—more precisely, determinately, and completely intuitable.

In the discussion of the individual arts (KU §51), this aporia becomes explicit. Kant writes: "One cannot say with certainty whether . . . a tone

(sound) [*Ton* (*Klang*)] is merely an agreeable sensation or whether it is of itself already a beautiful play of sensations" (*KU* 324). Yet, having thus posed the aporia, Kant again vacillates somewhat, referring once more, though now more skeptically, to the possibility that perception of mere tones may already involve a formal element. He refers also to the fact that there are people who, with the keenest hearing, are unable to distinguish tones, that is, who are fully receptive to sensations but lack a sense for the form within sensation. Thus, Kant comes very close to resolving the aporia: "If we consider all of this, we may feel compelled to regard sensation of . . . tone not as mere sense impressions, but as the effect of our judging of the form we find in the play of many sensations" (*KU* 325). And yet, again, Kant unsettles the apparent certainty and leaves the question undecided, declaring merely that in the one case music will be wholly a fine art whereas in the other case it will be in part only agreeable art. This, he says, is the only difference that will result from resolving the aporia in one way or the other.

Considering the entire development elaborated around this aporia, one might well suspect that this is a difference that makes no difference for the theory of music and that serves, most significantly perhaps, to indicate the limitation of the systematic distinction between form and material. What could it mean for music to be in part beautiful and in part only agreeable? For the tones do not sound otherwise than within the composition, and, as Kant grants, it is the composition that renders music beautiful. As composition, music is moving form; it is evolving, circling, developing form, form spread out in time. By their mutual relations and continual disappearance, the tones serve, as Kant also grants, to make the form, the composition, intuitable. One could say, then, that music is the intuitable unfolding of form, the audible development of composition; and that tones, which if sounded outside the musical work would be merely agreeable, sound within the work in a way that is inseparable from the compositional beauty of the work. In listening to music, one never simply hears a tone; rather, one hears it in its formal—that is, melodic or harmonic—relation to other tones *and* as its self-canceling sounding serves to unfold the composition itself.

There is a second aporia that bears significantly on Kant's conception of music and that, like the first, harbors a certain undecidedness and works against certain systematic constraints. The second aporia, unlike the first, is never thematized by Kant. It is broached by a conclusion that Kant draws in the course of his discussion (*KU* §16) of the difference be-

tween free beauty and accessory beauty; the aporia emerges when this conclusion is brought to bear on the later discussion of artistic beauty.

In the earlier discussion Kant distinguishes between free beauty, which involves no concept and which is correlative to a pure judgment of taste, *and* accessory or adherent beauty, which involves a concept of what the thing is to be, hence, of its perfection; accessory beauty is correlative to a rational judgment conjoined to a judgment of taste, the purity of the latter being impaired by this conjunction. What is especially pertinent is the way in which Kant situates music with respect to this distinction. Having mentioned several examples of free beauty—many birds, crustaceans, the foliage on borders or wallpaper—he continues: "What one calls fantasias in music (namely, music without a topic), indeed all music without a text [i.e., not set to words], may also be included in the same class" (*KU* 229). Thus Kant regards all purely instrumental music as free (rather than accessory) beauty.

Let us turn now to the discussion of artistic beauty as Kant distinguishes it from natural beauty. Kant explains that judgment of natural beauty as such requires no concept of the thing, of what it is to be. It is otherwise with artistic beauty: "But if the object is given as a product of art and as such is to be declared beautiful, then we must first base it on a concept of what the thing is to be, since art always presupposes a purpose in the cause (and its causality)" (*KU* 311). The aporia is evident: since instrumental music is freely beautiful, involving no concept, it cannot be declared artistically beautiful. But most certainly music cannot be declared a natural beauty, since—except in the very exceptional case of bird songs—music is most remote from nature, most unnatural. It seems, then, that if one adheres rigorously to the conditions Kant has laid down, instrumental music cannot be considered beautiful at all. The only beautiful—that is, artistically beautiful—music is that which is combined with poetry, that which thus, as in song, acquires from poetry the concept requisite for artistic beauty. Kant declares even that music can be combined with poetry "very naturally [*sehr natürlich*]," as if between these two arts there were a bond of nature.

If the second aporia is conjoined with the first, the undecidedness that results assumes the form of an antinomy. For whereas the first aporia declares that music—for the most part, at least—is beautiful, the second aporia declares that instrumental music is not—that is, cannot be—beautiful. Though Kant does not explicitly formulate this antinomy, its effect is evident in the concluding comparative discussion of the arts (*KU* §53). For

here Kant alternates as if between thesis and antithesis: on the one side, he declares music to be next after the highest art, poetry; on the other side, he declares it to have the lowest place among the fine arts or even degrades it to being only the highest among the merely agreeable arts.

Kant indicates with utmost clarity what it is about music that keeps in force its consignment to the lowest place among the arts, that threatens even to degrade it into a merely agreeable—not fine—art. What, in comparison with the other fine arts, music lacks is a well-defined concept. Thus, in the comparison with poetry, Kant writes that music "speaks through nothing but sensations without concepts, so that unlike poetry it leaves us with nothing to meditate about [zum Nachdenken]" (KU 328). Though it impels the mind and is, it seems, more intensely moving than any other art, its conceptual lack necessitates that "in reason's judgment it has less value than any other of the fine arts" (KU 328). In relation to the visual arts, too, Kant stresses music's conceptual impoverishment as well as the transitory character of its product. By contrast, the visual arts "bring about a product that serves the concepts of the understanding as an enduring vehicle, a vehicle that commends itself to these very concepts" (KU 329).

The contrast that Kant begins here to elaborate can also be construed in terms of the operation of imagination. In the case of poetry and the visual arts, the imagination presents and expresses aesthetic ideas that are conjoined with a given concept so as to expand that concept beyond what determinate, conceptual thought can grasp. This operation is aptly illustrated by Kant's example: Jupiter's eagle with the lightning in its claws is an aesthetic attribute that expands indefinitely the concept of the sublimity and majesty of creation. Such ideas of imagination supplement, in their peculiarly aesthetic way, the concept around which, as it were, they are gathered; they prompt more thought than can be comprehended within the determinate concept. In the case of music, on the other hand, the imagination presents and expresses aesthetic ideas without a well-defined concept to which the ideas could be conjoined and in relation to which they would serve to expand thought. Presumably, even in the case of music, the concept would not be totally lacking, for, according to Kant's account, it belongs to the very character of aesthetic ideas to be paired with or set alongside concepts; but what, it seems, is characteristic of music is the relative indeterminacy of whatever concept functions within it.

One could therefore be tempted to conclude that—outside its natural bond with poetry—music expresses little more than free-floating fantasies virtually disconnected from concepts and, because of this disconnection,

virtually lacking even the character of aesthetic ideas. Such could, Kant suggests, provide little more than mere entertainment. And yet, there is a single very remarkable passage in which, as if to rescue music at the very moment when its status as fine art is most endangered, Kant broaches an operation of musical language, an operation of tonal language within language in the sense of speech. He writes: "Every linguistic expression has in its context a tone appropriate to its meaning" (*KU* 327). Kant declares then that music—*Tonkunst*, he calls it, not *Musik*—"employs this language all by itself in its full force" (*KU* 327). Music—instrumental music, in particular—lets this tonal language sound all by itself, lets it sound outside the language in which otherwise it is enclosed. By way of its affect, such a tone, sounding alone, "arouses the idea which in language we express in that tone" (*KU* 327). Yet, most crucially, it can arouse an idea—in the sense of a genuine aesthetic idea paired with or attached to a concept—only because, as a *language* of tones, it is linked to—is evocative of—a concept. Even if this concept remains less determinate than in the other arts, it could suffice nonetheless to secure for music its status as fine art—even if in Kant's text the status of music is left, to the end, it seems, undecided.

The question is whether this indecision hinges merely on the relative indeterminacy of the concept in music and its consequent failure to measure up to the determination of art that Kant formulates in his account of aesthetic ideas; or whether, regarded more broadly, it can be construed as pointing to a fundamental differentiation of music from the other fine arts, a differentiation that, rather than consigning music to an inferior status, would mark a differentiation, even a bifurcation, within the fine arts as such. The question is whether music differs fundamentally from the formative and poetic arts, whether, even though it can be mixed with them, especially with poetry, music animates the mind in a way that is incomparable to the effects of the other fine arts.

꒔꒔

CHAPTER FIVE

Carnation and the Eccentricity of Painting

As to color it seems that Hegel never wavered. From the time of the first cycle of lectures he gave on aesthetics, there is remarkable constancy regarding color, regarding the decisiveness of color for painting. Throughout the entire Berlin period, throughout the four cycles of lectures he presented on aesthetics (1820–21, 1823, 1826, 1828–29), Hegel seems never to have faltered in his view that painting is little else than a matter of color.[1]

Always then he is on the verge of saying: color and nothing but color—that painting is color and nothing but color.

In the first lecture cycle he declares that color is what "first genuinely makes a painter a painter."[2] In the second cycle he is recorded to have said, without qualification: "Color is the element of painting."[3] And in the text that H. G. Hotho composed on the basis of various sources from the various cycles, Hegel is—posthumously—made to say: "It is therefore color, coloring, that makes a painter a painter" (A 2: 213/838).[4] So, then: not just

1. "In the various lecture cycles on aesthetics that he presented in Berlin between 1820/21 and 1828/29, Hegel's remarks on coloring remain remarkably constant" (Bernadette Collenberg, "Hegels Konzeption des Kolorits in den Berliner Vorlesungen über die Philosophie der Kunst," in *Phänomen versus System,* ed. Annemarie Gethmann-Siefert [Bonn: Bouvier Verlag, 1992], 125).

2. G. W. F. Hegel, *Vorlesung über Ästhetik: Berlin 1820/21; Eine Nachschrift,* ed. Helmut Schneider (Frankfurt a.M.: Peter Lang, 1995), 272.

3. Hegel, *Vorlesungen über die Philosophie der Kunst: Berlin 1823,* transcribed by Heinrich Gustav Hotho; vol. 2 of *Vorlesungen: Ausgewählte Nachschriften und Manuskripte,* ed. Annemarie Gethmann-Siefert (Hamburg: Felix Meiner, 1998), 249f. According to this transcription, Hegel also said that color "makes the painter a painter" (ibid., 258).

4. The basis for modern editions of the *Ästhetik* (including Bassenge's) is H. G. Hotho's second edition, published in 1842; the first edition appeared in 1835, only four years after Hegel's death. Hotho's edition, composed from Hegel's notebook (no longer extant) and student transcriptions, conflates the four cycles of lectures and rounds out the diction so as to produce

color (*Farbe*) but also, even primarily, coloring (*Kolorit*) is what constitutes painting, is what makes it painting and makes the painter a painter.

Hegel is, if at all, only slightly less constant about the various consequences of his rigorous orientation of painting to color, about the manifold transformation of the very determination of painting that is brought about by—or at least is coordinate with—his insistence on the all-decisiveness of color and coloring.

The decisiveness of color is especially consequential as regards form and as regards the drawing (*Zeichnung*) that, independently of color, could inscribe form. Hegel's position is that what counts for painting, what accounts almost entirely for it, is not form and drawing but color and coloring. Hegel could hardly have inverted more thoroughly the order laid out in the *Critique of Judgment*. Kant says explicitly that "in painting, . . . drawing [*Zeichnung*] is what is essential"; and that, in drawing, what counts for taste is "what we like because of its form [*was durch seine Form gefällt*]." Color, on the other hand, belongs to mere charm and can, at best, serve only "to make the form intuitable more precisely, determinately, and completely." Color cannot make an object beautiful but rather is usually severely restricted by "the requirement of beautiful form" (*KU* 225f.).

Hegel's inversion of this order has the effect, at least from a Kantian perspective, of reorienting painting to sensation, of granting to sense as such a constitutive function in painting and hence an indispensable role in the judgment of taste that would assess the beauty of a painting. To be sure, Kant opens, even if cautiously, the possibility of according such a function and role to sensation, opens it at two different levels of analysis. In the one instance, this possibility depends on the assumption that in sense perception there is not only sense reception but also, through a reflection intrinsic to sense, an apprehension of the form constituted by the regular play of sensations. In this instance, color would not be a congeries of mere sensations but, says Kant, would "already be the formal determination of the unity of a manifold of these" (*KU* 224). In the other instance, this possibility would be linked to the purity of a simple kind of sensation, to its being uniform and uninterrupted by any other sensation. This very purity would constitute a formal moment within—and yet distinct from—the sensible as such. Such purity, says Kant, "pertains only to form,

what seems a finished text. Recent scholarship has been highly critical of some of Hotho's editorial practices (see Annemarie Gethmann-Siefert, "Ästhetik oder Philosophie der Kunst: Die Nachschriften und Zeugnisse zu Hegels Berliner Vorlesungen," *Hegel-Studien* 26 [1991], 92–110). Some problems created by these practices are discussed below, and some safeguards are put in place by reference to extant transcriptions.

because there we can abstract from the quality of the kind of sensation in question (as to which color . . . is presented)." Kant concludes that it is because of this moment that "all simple colors, insofar as they are pure, are considered beautiful" (*KU* 224). Thus, in both instances Kant's strategy is the same: sense can be regarded as pertinent to beauty only insofar as within sense there is a purely formal moment distinguishable from sense as such, from the mere sense in sense. This same strategy, much more elaborated, is in play in the main analysis of judgments of taste: though with respect to the object of such judgment what is apprehended is sensible, it is a formal sensible, a formal aspect within the sensible presentation of the object; and its apprehension requires accordingly not just sense but also, even primarily, imagination. It is this formal sensible, this sensible form distinguishable from the mere sense in sense, that in the case of something truly beautiful can be brought to display, through the play of imagination, a certain homology with understanding. This homology serves, then, to confirm that this moment of sensible form is independent of the mere sense in sense.

Even when, as on a crystal clear winter day, one marvels at the beauty of the sky and lets one's vision be utterly absorbed in its inexpressible blueness, one would have to grant that the beauty of the sky is completely independent of its color, that as regards its beauty it matters not at all that it is blue. It would be no different if one were enraptured by the glorious colors of a painting. As far as the beauty of the painting is concerned, the colors as such—in distinction from the formal moments that can be disengaged from them—would make no difference.

For Hegel, on the other hand, color makes all the difference, color in its specificity as red, blue, yellow, and in its virtual particularity in the almost unlimited differentiation of shades. These differences are of such subtlety and value and of such decisiveness for painting that they make all the difference. There is nothing in painting that is not produced by color and coloring: "Shape, distance, boundaries, contours, in short all the spatial relations and differences of appearing in space are produced [*hervorgebracht*] in painting only by color" (*A* 2: 186f./810). Hegel marvels at what color can achieve, calls it "incredible [*unglaublich*]." Consider, for example, two men with all the differences between them, each of them a distinct totality in body and in mind: "and yet in a painting this entire difference is reduced to a difference of colors." It is incredible indeed: "Here a color stops and another begins, and by this means everything is there: form, distance, play of features, expression, the most sensible [*das Sinnlichste*] and the most spiritual" (*A* 2: 187/810).

Everything is there, everything, from the most sensible to the most spiritual, from the most sensible of the sensible to the most intelligible of the intelligible. Yet everything whatsoever, across this space of all spaces, is there by means of something eminently sensible, irreducibly sensible.

In particular, form is there, already there, by means of color. Mere coloring will have brought it forth, virtually without need of the drawing that, in drawing as such, would inscribe it.

Everything is there by means of color; that is, color is set there (through coloring), and then, simply as a result, without any further ado, everything else is there, the entire visible spectacle. Everything—color and then everything else—is there. Everything is there in the painting. But what is this *there* of the painting? How, in what manner, is everything there? What is the sense of this presence of sense?

Hegel expresses this sense in a single word. It is one of the most difficult words to translate in Hegel's text, because Hegel's usage of the word is sensitive to its range of different semantic registers. Though this word, *scheinen* (and *Schein*), is not matched in the range of its meanings by *shine* and *shining*, there is every reason to adopt this translation and to tolerate the difference while gradually letting the sense of *shine* expand and accommodate itself to that of *scheinen*. At a certain level there is an abysmality that cannot be avoided, for the sense that is to be expressed in this word is one that turns, that is twisted, in the differentiation intrinsic to the word *sense*. It is a sense that works against sense (against the hegemony of signification) for the sake of sense (the irreducibly sensible). Not surprisingly, Hegel describes it as "in the middle between the immediate sensible and ideal thought" (*A* 1: 48/38). But what is more directly important in rendering *scheinen* and *Schein* as *shine* and *shining* is to avoid identifying *Schein* with *Illusion*. With this identification, in force in Kant's analysis of *transzendentaler Schein*, Hegel breaks decisively, restoring to the word its broad range of senses from illusion to shining to appearance;[5] or rather, he moves from this spread of senses to a precise philosophical determination.

In a painting sense is present otherwise than in nature. Hegel's analysis of such sensible presence is already launched in the Introduction to the *Aesthetics*; at this stage the analysis is completely general and thus

5. Although the word *Illusion* is not missing entirely from the vocabulary of Hegel's lecture cycles (see, for example, the first cycle: *Vorlesung über Ästhetik: Berlin 1820/21*, 274), the group of words based on *scheinen* (*Schein, erscheinen, Erscheinung*, etc.) is, to say the least, predominant.

pertains to the presence of the sensible in all the arts. Hegel begins with the most global differentiation: what is sensible in a work of art is there "only insofar as it is for the human spirit, but not insofar as it exists as sensible for itself" (A 1: 46/36). The presence of what is sensible in a work of art is a presence to spirit, not an independent presence such as things have—or at least are commonly taken to have—in nature. Thus, to determine the sense in which the sensible is present in a work of art, there is required an analysis and differentiation of the various ways in which the sensible can be related to the human spirit, of the ways in which it can *be for* the human spirit. This being-for-spirit is the first, most general determination of the sense of the sensible in art.

Hegel's ensuing analysis shows that the sensible can be related to spirit in various ways. The poorest way is that of mere sensible apprehension, as when, without thinking, one merely listens here and looks around there. For the most part, however, a spiritual being does not simply apprehend the world but also relates itself to things through desire, makes them objects of desire in which, as they are used or consumed, this being achieves a certain self-realization and self-satisfaction. Hegel notes especially that desire requires the things themselves in their sensibly concrete existence, not merely the superficial shining (*den oberflächlichen Schein*) of things. Desire is not satisfied by a mere picture of the animal one would like to eat. And just as a work of art does not satisfy desire, so the proper relation to a work of art is other than desire. Rather than aiming to use or consume the object, one leaves it, if it is an artwork, in its independent existence; and its way of being there sensibly for spirit is such that it is only for the theoretical (not the practical) side of spirit.

Another way in which something can be for spirit is by way of the purely theoretical relation to intelligence. In such a theoretical relation to things, one aims not at consuming them but at knowing them in their universality. Intelligence goes after the universal, seeks to grasp the object in thought, in its concept. But once an object has been grasped in thought, it has thereby been transformed, has become universal. Intelligence will have turned away from the object in its immediate individuality, as which it will be of no further concern. Then it will be the object as intelligible, not as sensible, that will be for spirit; whereas art cherishes the work of art in its immediate sensible character and does not turn it into a universal. Even in the case of the most nearly universal kind of artwork, the linguistic, poetic work, Hegel insists that it is never just a matter of language and concepts, but that there must always be a sensible presence in play, even if only in imagination (*Phantasie, inneres Vorstellen*) (see A 2: 331–34/964–67).

Sensible presence is required in a work of art, is required of a work of art. What is not required is the concrete materiality and empirical completeness that desire, and even mere apprehension, it seems, would demand. Now, in the sphere of art, a mere picture of the animal, which otherwise one would want to eat, completely suffices, even if the picture is of an animal that does not, or even could not, exist, even if it is a picture of an animal that one would never, or even could never, desire to consume. In the artwork the sensible must indeed be present, as, specifically in painting, color and then everything else are sensibly present. And yet, this presence is sensible without being material. Hegel expresses its distinctive character, its distinctive presence, in terms of how it is to appear (*erscheinen*), in terms of the guise in which it appears. It is "to appear only as a surface [*Oberfläche*] and a shining of the sensible [*Schein des Sinnlichen*]" (*A* 1: 48/38). Surface (*Oberfläche*) has here the sense of something sensible that has been detached from materiality, that, as Hegel adds, "is liberated from the scaffolding of its mere materiality."[6] Thus liberated, what appears is not the sensible aspect of something materially existent but rather the shining of the sensible, of a sensible aspect that is, however, not an aspect of a material existent, present with it. The shining appears (*erscheint*); it is not something other than the appearing, but rather the shining is an appearing. There is a shining forth, and in this very shining the appearance or look of something comes forth. And yet, in a sense nothing appears: it is not an appearance or look belonging to—connected to in the sense of standing out from—anything materially existent, and in this sense there is semblance, even illusion, in play in the shining. And yet, in still another sense the shining is an appearance of something, namely, of the sensible, of a sensible aspect (without that aspect being actually connected to, standing out from, anything materially existent). This sensible is what shines, indeed so much so that it is nothing other than the shining. In the artwork this sensible that shines *is* only in and as the shining. One begins to sense how the word *Schein* circulates through all its various senses (shine, look, appearance, seeming, semblance, illusion) and how all differences tend to collapse back into the shining.[7]

6. *Surface* does not have here the specific sense it has in Hegel's discussion of painting as involving the reduction of three-dimensional space to a surface. Hegel maintains the distinction terminologically by using the word *Fläche* instead of *Oberfläche* in the discussion specifically of painting (see *A* 2:181, 183).

7. The decisive role of shining in art is stressed already in the first lecture cycle. Hegel says, for example, that "shining is the most important thing in painting [*die Hauptsache bei der Malerei*]"; and that painting "is directed to shining [*Schein*]" (*Vorlesungen über Ästhe-*

Hegel specifies that because the sensible that shines in art is liberated from materiality, it appears only as the shape, the look, or the sound of things; that is, it appears only to sight and hearing, since the other senses all have to do with materiality in its immediacy. Art, says Hegel, "brings forth only a shadow-world of shapes, sounds, and sights," a "sensible surface" or mere "schemata" (A 1: 49/39). Yet what is most remarkable, especially as regards painting, is what in this context Hegel does not say. What he does not say, what he forgoes saying, is that this shadow-world consists of shadows of materially existent things or even of things that could exist materially. He does not say that the sensible surface images the surface of possibly existent things, nor that the schemata brought forth by art are schemata of such things. To be sure, he does not deny this, and yet, except for the vague reference made when he speaks of "the shape, the look, or the sound of things," the reference beyond remains, at best, merely implicit. This fact is all the more striking if one notes the kind of reference Hegel does make: not outward to things but inward to spirit. Thus: "For these sensible shapes and tones occur in art . . . with the aim, in this shape, of affording satisfaction to higher spiritual interests, since they have the power to call forth from all the depths of consciousness an echo and a resounding in the spirit [einen Anklang und Wiederklang im Geiste]" (A 1: 49/39). The reference is not from the shining to something external, something beyond it, that it would image (as in a relation of image to original), but rather to a certain imaging within, to an echo, which is a kind of sonic image, to a resounding in the depths of consciousness. To the extent that this passage declares the sensible aspect to be of something, it declares it to be an aspect of spirit; in and through the sensible aspect shining forth in art, spirit learns primarily not about things but about itself.

This very striking absence of reference to things can be taken as correlative to Hegel's thoroughgoing critique of the conception of art as imitation (Nachahmung) of nature.[8] Even if one sets aside the purely formal character of the aim expressed in this conception (that what is already there in the external world is to be made a second time), even if one ignores the absence of any objective indication as to what is to be imitated, even then, Hegel insists, this principle that art is to imitate nature is not to be

tik: Berlin 1820/21, 243–44]. In the third cycle he is reported to have been even more direct: "Painting is the art of shining as such" (Hegel, Philosophie der Kunst: Vorlesung von 1826, ed. Annemarie Gethmann-Siefert, Jeong-Im Kwon, and Karsten Berr [Frankfurt a.M.: Suhrkamp, 2005], 206).

8. I have discussed this critique in detail and in relation to the question of the pastness of art in Double Truth (Albany: State University of New York Press, 1995), chap. 10.

accepted. While Hegel recognizes that painting and sculpture have some relation to nature, he stresses that certain other arts quite conspicuously do not imitate nature. Hegel's formulation leaves the cases of painting and sculpture in a certain hypothetical suspension for the sake of declaring, without qualifications, the nonmimetic character of other arts. He says: "For if we look at the various arts, it will be granted at once that, even if *painting* and *sculpture* present [*darstellen*] objects that appear [*erscheinen*] similar to natural ones or whose type is essentially drawn from nature, on the other hand works of *architecture*, which is also one of the *fine* arts, can as little be called imitations of nature as works of *poetry* can" (*A* 1: 54/45). Yet, to say that it is not the aim of artworks to imitate nature is not, Hegel grants, to sever all relations of art to nature. In all the arts, even those most conspicuously nonmimetic, there must be a certain natural basis: "Certainly it is an essential moment of a work of art to have a natural shape as its basis [*Naturgestaltung zur Grundlage*], because it presents [*darstellt*] in the form of external and therefore also natural appearance [*Erscheinung*]" (*A* 1: 55/45). In this passage it is essential to note that Hegel does not say that art presents external, natural appearances or objects; art does not present—that is, imitate—nature but rather only has a certain *natural basis*, which consists in its giving the form of external, natural appearance to what it presents. To the sensible aspect that art lets shine, it gives a certain form, that of external, natural appearances, that which (also) belongs to the appearance of external, natural things. Thus it is that the painter must study what belongs to such appearance: "For painting, e.g., it is an important study to get to know and copy with precision the colors in their relation to one another, the effects of light, reflections, etc., as well as the forms and shapes of objects in their most minute nuances" (*A* 1: 55/45). Yet such study is only preparation for painting, not painting itself. Though indeed painting has a natural basis, taking its form from that of external, natural appearance, what it presents is something other than external, natural objects: "Neither is the naturalness the *rule* nor is the mere imitation of external appearances as external the *aim* of art" (*A* 1: 55/46).

Hegel's concept of artistic presentation is spiritual: what art presents is not the appearance of natural things, but spirit itself, spirit to itself. And yet, art is the *sensible* presentation of spirit. Art is irreducibly sensible, and this is why the painter needs, by way of preparatory studies, to become acquainted with what goes to make up the natural basis, the sensible of painting. Though, to be sure, Hegel mentions in this connection the forms and shapes of objects, what he mentions first is what has to do with color and light: the colors in their relation to one another, the effects of light,

reflections, and so forth. If one adds to this specification the submission of form to color—that is, Hegel's insistence that with color everything is there, including the forms and shapes of objects—then it appears that the study requisite for painters would have primarily to do with color. Even the drawing that the apprentice might learn for the sake of familiarity with forms and shapes would in painting itself be left behind for the sake of a genuinely painterly technique in which forms and shapes would not be formed independently but would emerge from color.

Finally, then, it is color that constitutes the natural basis of painting, that makes the painterly presentation irreducibly sensible. For color in its very decisiveness for painting cannot be reduced to formal moments that would be detachable from the sensible as such. This irreducibility is enforced by the primary role that Hegel accords to shining. It is in the shining of color that the irreducibly sensible basis of painting consists.

>>><<<

Shining lies in the middle between sensible and intelligible. It even establishes the center, which corresponds on the side of presentation to that marked by imagination on the side of artistic creation. Yet, in painting, presentation occurs as the shining of color: it is through the shining of color that everything is there in the painting. In other words, the presentation, centered by the role of shining (common to all arts), is bound to something—namely, color—that is not at all in the middle, not at all centered, but rather lies at the extreme. For color is eminently sensible, irreducibly sensible. In a significant sense it is the most sensible of the sensible means used in the arts. It is true that the stone used by architecture and sculpture has a heaviness and a resistance that the painter's colors do not have; but this heaviness and resistance have more to do with the materiality to which these arts remain attached than with sensibleness as such. And whereas architecture and sculpture have to bring form to bear on the sensible basis (even if, as in sculpture, the form may be prefigured in the stone), painting has only to engage with the sensible basis, to spread its colors on the canvas, and thereby everything—including form—is there.

Thus bound as it is to color, to what lies not at the center but at an extreme, painting is radically off-center. Painting is eccentric.

One will say perhaps that all the arts, as *sensible* presentations, are bound to the side of the sensible and thus are eccentric. Yet with the other arts there are specific determinations that mitigate their decenteredness. As noted already, architecture and sculpture, despite their attachment to the sensible material, have nonetheless to bring form to that material

rather than, as in painting, simply letting it emerge from engagement with the sensible basis. In the case of poetry the mitigation is most striking: poetry is not even bound to a presence of sensibleness but gets along quite well with a sensibleness that is only imagined. Music has a similar tendency insofar as tone is a vanishing moment, a sensible moment that in its very coming to be comes to be annihilated and so vanishes of itself. Already as such more ideal than really subsistent corporeality, tone, says Hegel, gives up even this ideal existence as it comes to sound (see *A* 2: 261/891). Yet, if in the case of music the mitigation seems less decisive, this no doubt is linked to a peculiar inner affinity between music and painting. We shall return to this affinity.

The eccentricity of painting is also marked, if only schematically, in the configuration that arises from the most general divisions of art articulated by Hegel at the outset. This double division of art, its division, on the one side, into the forms of art and, on the other side, into the individual arts, structures the entire *Aesthetics.* It also generates the general dynamics of the work, which is linked to the interrelation between these two sides; it is linked specifically to a certain mutual centering established between the two sides. Reference to such centering is imperative inasmuch as the very axiomatics of eccentricity prescribes that a center must be established in relation to which—that is, in noncoincidence with which— eccentricity is constituted.

There is one centering that is anterior to all others and that lays down the primary axis for all that follows. It is the centering of art as such, of art as a whole: the center of art (*der Mittelpunkt der Kunst*) is the classical form of art (*A* 1: 413/427). Art as such, art as a whole, is centered in the classical form of art. Whatever art or form of art deviates from the classical form is to that extent off-center, eccentric.

But how is it that of the three forms of art—symbolic, classical, and romantic—the classical form is the one in which art as such and as a whole is centered? In the classical form of art the essence of artistic beauty is realized; the perfection of art reaches its very pinnacle. Hegel declares of classical art: "Nothing can be or become more beautiful" (*A* 1: 498/517). Such beauty, such perfection, is achieved in classical art because it is precisely in this form that there is perfect unification of the spiritual and sensible moments that constitute art as such. In classical art spirit acquires a shape entirely adequate to it. In this form of art, spirit is sensibly presented in the most complete manner possible in art as such; it is presented to the most perfect extent that is possible by way of sense. Such is precisely the determination of the classical form of art.

In the mutual centering between forms of art and individual arts, it is sculpture that Hegel centers in the classical form: sculpture, he says, "forms the center of classical art" (*A* 2: 103/718). Centered in classical art, sculpture thereby also gives to classical art its center. Hegel explains how it is that sculpture and the classical form of art are so perfectly matched: "Insofar as in sculpture the spiritual inwardness . . . makes itself at home in the sensuous shape and its external material and both sides are so mutually formed that neither preponderates, sculpture acquires the *classical art-form* as its fundamental type" (*A* 1: 90/85). Sculpture is perfectly matched with classical art because sculpture achieves precisely that most perfect union of spirit and sense that the very determination of the classical form of art prescribes.

At its center, as it is centered in the classical form so as also to give that form its center, sculpture is classical, not only in a structural or systematic sense but also in a historical sense: it is with classical—that is, primarily, Greek—sculpture that the centering occurs. In classical Greek sculpture both the art of sculpture and the classical form of art reach perfection. Since the classical form of art is what, in turn, centers art as such and as a whole, it is in classical Greek sculpture that art as such and as a whole is centered. In a more linear, historical schema, this is to say that in classical Greek sculpture art as such reaches its pinnacle of perfection. In the classical sculpture of the Greek gods, the shining of the sensible is most perfectly suited to present spirit, and spirit is accordingly sensibly presented in the highest degree possible. This is why Hegel says: "Nothing can be or become more beautiful" (*A* 1: 498/517).

That sculpture is centered in the classical form of art and thus attains perfection as classical sculpture does not mean that sculpture is incapable of being realized, if imperfectly, in the other forms. Indeed Hegel discusses at length not only classical sculpture but also symbolic and romantic sculpture. As with all symbolic art, sculpture at the symbolic stage falls short of the unity distinctive of the classical. The spiritual content and the sensible form remain mutually exclusive, not assimilated to each other, and the content remains to that extent indeterminate. Hegel identifies ancient Egyptian sculpture as symbolic and explains that it "has not yet overcome the breach between meaning and shape [*Bedeutung und Gestalt*]" (*A* 2: 161/783).[9] In Egyptian sculpture there is a "lack of inner, creative freedom" and of "the grace and vivacity that result from the properly

9. For his discussion of ancient Egyptian art, Hegel draws on various reports, ranging from passages in Herodotus and in Plato's *Laws* to what he had read in Winckelmann and in

organic sweep of the lines" (A 2: 159f./781f.). Such sculpture falls short of precisely that which sculpture is most properly suited to realize and in its classical form does indeed realize. But then when, as Christian sculpture, it assumes the romantic form, spiritual content and sensible presentation are again sundered, now for the sake of the inwardness withdrawn from external things. Such sculpture has a mode of presentation "that does not so immediately cohere with the material and forms of sculpture" (A 2: 166/788). The unity of spirit and sense at which sculpture by its very nature aims is alien to the romantic form of art.

Yet what about the romantic form of art? How is it that, on the one hand, it can sunder the very unity that classical sculpture achieves and that represents the very pinnacle of what art as such, centered in classical sculpture, can achieve; and yet, on the other hand, it can represent a certain advance beyond the classical form of art? How can a break with the classical form produce anything other than a regression to the imperfection of symbolic art? What artistic advance can there be beyond the consummation of beauty?

Hegel explains how it is that an advance beyond classical perfection is possible: it is because "there is something higher than the beautiful appearance of spirit in its immediate sensible form" (A 1: 499/517). And, in turn, there is something higher because the unity of spirit and sense, which constitutes the beautiful appearance of spirit, is opposed to the true concept of spirit, specifically to the inwardness that belongs to spirit, the inwardness that emerges in the post-Greek, Christian era. The advance of spirit is thus a return to itself from out of external appearance; from being reconciled with external appearance in the classical work of art, spirit comes to be reconciled with itself, with its inwardness, by sundering the classical unity into spirit withdrawn into itself, on the one side, and the external, sensible appearance, on the other side. Yet how is it that this advance of spirit, its withdrawal into the inwardness of subjectivity, still allows the possibility of art and does not instead simply signal the limit and the end of art? How can there be romantic art? This form is possible only because spirit, whatever its inwardness, indeed in its very inwardness, advances into the external and sensible and withdraws from this element back into itself. This advance and withdrawal leave their trace in the sensible, and it is in the presentation of this sensible trace that art finds a way of presenting spirit even in its inwardness, even if without any possibility

Raoul-Rochette's *Cours d'archéologie* to what he had been shown firsthand by Creuzer. See A 2:158/780.

of being adequate to that inwardness. This way of presentation is what defines the romantic form of art.

What romantic art lacks in adequacy it gains in spiritual content. Hegel marks this gain by citing a paradigmatic example, by observing what it is that sculpture lacks and that romantic art gains: sculpture's failure to present subjectivity "is shown externally in the fact that the expression of the soul in its simplicity, namely, the light of the eye, is absent from the sculptures. The supreme works of beautiful sculpture are sightless, and their inwardness does not look out of them as self-knowing interiority in this spiritual concentration that the eye expresses" (A 1: 501/521f.). Hegel marks also another difference: unlike classical sculpture, romantic art does not idealize the external objects that it represents; it does not eliminate what is merely natural and accidental in those objects. Since romantic art no longer takes the sensible object as the embodiment of spirit, it is not adverse to keeping the finite, natural deficiencies and even to letting these serve as traces marking the need and the way for the turn inward. Hegel says: "Romantic art no longer aims at the free vitality of existence with its infinite tranquillity and the immersion of the soul in the corporeal, this *life* as such in its most proper concept; rather it turns its back on this pinnacle of beauty, interweaves its inwardness with the contingency of external forms, and gives unfettered play to the bold lines of what is not beautiful [*des Unschönen*]" (A 1: 507/526f.).

Painting is a romantic art. More precisely, painting is centered in romantic art. Hegel says that he has "placed the center [*Mittelpunkt*] of painting in romantic, Christian art" (A 2: 176/799). This is, he says, "its proper center [*ihr eigentlicher Mittelpunkt*]" (A 2: 179/802). Yet this is to say that with respect to the classical center, with respect to the center of art as such and as a whole, painting is off-center, is eccentric. And yet, its eccentricity as a romantic art is both its defect and its gain, both its limit and, in another regard, its advance beyond the limit. In this respect the situation is much the same as with the eccentricity that belongs to painting by virtue of its radical orientation to color: this latter eccentricity is such as to immerse painting in the most sensible of the sensible, while, precisely thereby, giving it the capacity to let emerge purely from color the entire expanse all the way up to the most intelligible of the intelligible.

In the shining of color that it instigates painting cannot, to be sure, enclose spirit in its outlines, as can sculpture. But what it can do with its coloring is display the traces of spirit turned inward; that is, it can let the inwardness of spirit be expressed, as Hegel says, "in the mirror [*Widerschein*] of externality" (A 1: 179/801f.) and in this manner be presented to

itself in its inwardness—indeed despite its inwardness, which to classical art remains inaccessible, which classical sculpture cannot by its very nature express.

That painting is centered in romantic art and attains as romantic painting its proper perfection does not mean that painting is incapable of a certain realization in classical form. Hegel grants that painting flourished in classical antiquity, and yet he insists that the Greeks and Romans were not able to bring painting to the supreme level to which it was elevated in the Christian Middle Ages and especially in the sixteenth and seventeenth centuries. Hegel stresses the contrast between the "unsurpassable beauty" of ancient sculpture and the relative "backwardness" of their painting: "This backwardness of painting in comparison with sculpture in antiquity is actually to be expected, because the ownmost heart of the Greek outlook [*der eigentlichste Kern der griechischen Anschauung*] corresponds, more than is the case with any other art, precisely with the principle of that which sculpture can somehow achieve" (*A* 2: 177/800). As an essentially romantic art, painting could not reach perfection in the classical setting of antiquity. Its time had not yet come.

>>> <<<

What Hegel says of painting is not independent of what he saw, of what he had seen, most notably in Heidelberg, in Munich, and in Dresden, prior to the first cycle of Berlin lectures on aesthetics and of what he saw on the voyages undertaken during the Berlin period. These voyages were spaced in the intervals between the four lecture cycles on aesthetics. In 1822 he traveled to the Rhineland, visiting Cologne and Aachen, and then on to Flanders and Holland. In 1824 he returned to Dresden and then traveled on to Prague and Vienna. Finally, in 1827, he traveled to Paris, "this capital of the civilized world."[10] The letters written during these travels—mostly to his wife—attest that he saw nearly all the important paintings that were to be seen in the cities he visited.[11] What he said about painting in the successive cycles of lectures on aesthetics did not go unaffected by what he had seen.

10. *Briefe von und an Hegel*, ed. J. Hoffmeister (Hamburg: Felix Meiner Verlag, 1954), 3:183 (no. 559).

11. A brief account of Hegel's travels and of what he mentions having seen in each city visited is given by Stephen Houlgate, "Hegel and the Art of Painting," in *Hegel and Aesthetics*, ed. William Maker (Albany: State University of New York Press, 2000), 61–82; see especially n. 9. For a more extensive account see *Hegel in Berlin: Preussische Kulturpolitik und idealistische Ästhetik: Zum 150. Todestag des Philosophen*, ed. Otto Pöggeler (Berlin: Staatsbibliothek Preussischer Kulturbesitz, 1981), 137–70.

This is not to deny that there are rigorous systematic constraints in the *Aesthetics*. Much of the structure and dynamics of the work is determined by the double division of art as such and as a whole, its division into forms of art and into individual arts. At a certain level of generality these systematic divisions and the configuration of centerings between the two series control much of the movement of the *Aesthetics*. A telling indication of the systematic control is provided by an alteration (indirectly related to these divisions) that occurred in the final cycle of lectures: it has been shown that Hegel's concept of the pastness of art (*Vergangenheitscharakter der Kunst*) was considerably sharpened in the 1828–29 lectures (as testified by the three remaining sets of student notes for this cycle) and that this change corresponds to systematic changes that Hegel made in the relevant sections of the second edition of the *Encyclopedia* (1827).[12]

Critical questions could no doubt be effectively addressed to the systematically controlling divisions of art. Does it suffice to divide art as such into the three forms, symbolic, classical, and romantic? Even if this division does arise as directly as Hegel supposes from the basic determination of art, even if the relations between spiritual content and sensible form that define the three forms of art do "proceed from the idea itself" (*A* 1: 82/75),[13] must one not ask nonetheless whether these forms can suffice otherwise than by enforcing reductionism? Can these forms accommodate an art that, as is perhaps necessary today, is decisively post-Christian, hence post-romantic, and not merely the indefinite protraction of the past form such as Hegel seems to allude to when he says: "One can well hope that art will always rise higher and come to perfection, but . . ." (*A* 1: 110/103). Furthermore, what is to be said, for instance of Japanese art—say, of the seventeenth century? Can the exquisite scrolls, lacquerware, and teabowls of Hon'ami Kōetsu be understood as anything other than an art stalled at the symbolic stage, a judgment that is unlikely to be found satisfactory?

There are questions no less pressing with regard to Hegel's division of art as a whole, indeed first of all the question whether art is a whole with parts consisting of individual arts. Does the logic of whole and parts or of universal and individual suffice for thinking that strange plurality of arts that Jean-Luc Nancy has called the "singular plural of art"?[14] To say noth-

12. See Gethmann-Siefert, "Ästhetik oder Philosophie der Kunst."

13. Such a direct connection is already affirmed in the first cycle of lectures (*Vorlesung über Ästhetik: Berlin 1820/21*, 109–10).

14. Jean-Luc Nancy, *Les Muses* (Paris: Galilée, 1994), 13.

ing of what is omitted from the series of five arts, dance for instance; or of the differentiation in terms of single, simple arts in relation to which others such as opera could be thought only as mixtures or hybrids. One knows from the example of Wagner that the opposite is not inconceivable, that is, to regard opera as the total artwork from which other, so-called individual arts are separated out.

And what about the way in which Hegel links the two divisions, even prior to the mutual centerings? Does the differentiation of the forms of art also provide, as Hegel insists, "the fundamental principle for the articulation and determination of the individual arts"? Are the individual arts "merely the realization" of the general forms of art "in a definite external material" (A 1: 88/82)?

To the extent that the systematic double division of art controls the structure and dynamics of the *Aesthetics*, these questions are especially pertinent. And yet, the division is controlling only at a certain level of generality, and even at this level there are perhaps significant gaps. Especially in the case of painting Hegel is careful to indicate that the limits within which such generalities can legitimately operate are quite narrow. He says: "Because painting has the determination of engaging so unrestrictedly in the sphere of the inward and the particular, there are, to be sure, few generalities that can be said precisely of it, just as there are few definite things that can in general be offered regarding it" (A 2: 190/813). One would suppose that it is precisely at the point where generalities and systematic determinations reach their limit that Hegel's rich firsthand experience of painting begins to become decisive (see A 2: 241/869).

It has been pointed out, for instance, that on the basis of the extensive firsthand knowledge of painting gained through his travels, Hegel came in the final cycle of lectures to recognize a transitional form within painting, which, if not inconsistent with the systematic articulations, could nonetheless hardly have been foreseen on the basis of them. This form, which he found especially in Old German pictures, is characterized by a certain sculptural comprehension of figure: "There the picture does not yet have vitality; the rigidity of marble is still in it."[15]

But there is another, still more remarkable instance.

It is known that on his travels in the 1820s Hegel saw many of the masterpieces of Italian Renaissance painting (even though he never traveled to Italy). For instance, in Dresden in 1820 he saw Raphael's *Sistine Madonna*

15. *Äesthetik nach Prof. Hegel im Winter Semester 1828/29*, Nachschrift by Libelt, cited in Collenberg, "Hegels Konzeption des Kolorits," 126.

as well as several paintings by Correggio. His trip to Paris in 1827 was especially fruitful in this regard. From Paris he wrote to his wife, telling her of the Italian masters whose works he had just seen during two days spent at the Louvre. His excitement is evident: "There is immense wealth, famous items by the noblest masters that one has seen a hundred times in copper engravings: Raphael, Correggio, Leonardo da Vinci, Titian, and so on."[16]

Accordingly, Hegel says in the *Aesthetics:* "What has Raphael or indeed any other of the great Italian masters not made of the Madonna and the Christ-child! What depth of feeling, what spiritual life, what intimacy and abundance, what majesty and gentleness, what a human heart [*Gemüt*], though one wholly penetrated by the divine spirit, speaks to us out of every feature!" (*A* 2: 177f./800). Especially in the case of Raphael, Hegel recognizes a certain decidedly classical moment. Along with the artist's "supreme spiritual feeling for religious subjects" and his "affectionate attention to natural appearances in the whole vitality of their color and form," there is also displayed in Raphael's work a "sense for the beauty of antiquity," a "great admiration for the ideal beauty of the ancients" (*A* 2: 252/881). Yet this sense and admiration for classical art did not lead Raphael simply to imitate, adopt, or use the forms that had been so perfectly realized in Greek sculpture. Rather, says Hegel, "he took up only in general the principle of their free beauty" and let this classicism penetrate and determine his painting, giving it an "open and serene clarity and thoroughness of presentation" (*A* 2: 252/881). What Hegel finds, most remarkably, is that Raphael infused into romantic painting a moment of the classical form, that he did so without regressing to the rigidity of the Old German painters, without simply mixing classical and romantic. Rather—and this is what is most remarkable—he infused into romantic painting a certain classical style, a certain moment modeled on but detached from the classical form, and precisely thereby he brought romantic painting to, as Hegel says, "the pinnacle of perfection" (*A* 2: 252f./881). In the end Raphael's painting is neither simply romantic nor simply classical nor simply a blending of romantic and classical, but something quite other, a painting that brought the classicism of the ancients back into the very heart of romantic painting in a way that, from systematic considerations, could not have been foreseen.

>>><<<

Painting cannot capture spirit, cannot contain it within the confines of the canvas as sculpture does in a shaped block of marble. Painting does not

16. *Briefe,* 3:187 (no. 560).

enclose spirit in a sensible external object in the sense of making the object such that precisely in its sensible presence it presents spirit openly and without reserve. Painting does not present spirit openly and without reserve: whereas what one sees in viewing a work of sculpture is a presentation directly of spirit in its proper bodily form, a painting neither presents spirit directly nor sets before the viewer an image in which spirit would itself, as such, be presented. Painting does not, then, supply a merely two-dimensional image of what sculpture presents in its full three-dimensional spatiality. Rather, the two arts are more radically heterogeneous: whereas in sculpture spirit is openly and directly presented, made visible in the work of sculpture, what is made visible in painting is only the withdrawal of spirit from the sensible and external, its retreat into itself, its turn into its own inwardness. What painting makes visible is the escape of spirit from visibility, from confinement within the visible.

Even to speak of the content of painting can be misleading inasmuch as the word may suggest a plenitude that has only to be brought into sensible form in order thereby to be directly presented as such. To be sure, Hegel does not therefore abandon the language of content and form, perhaps because it seems essential for retaining the connections with the more general determinations of art; the result is that Hegel's formulations, precisely when they address the heterogeneity of painting, tend to be twisted into a shape in which they say something rather different from what they would say in a classical discourse. Here in still another respect it is a matter of the eccentricity of painting: for painting is set apart from the classical center, from classical sculpture in which art as such is centered, set apart from the center at which art would directly present spirit as such, set at a point where only the escape, the flight of spirit, is to be presented.

Yet despite the torsion to which it exposes his discourse, Hegel continues to speak of the content of painting. This content, he says, is spiritual inwardness (*die geistige Innerlichkeit*). Yet for painting it is not a matter of directly presenting this inwardness as such, of presenting, for instance, an image of it. For it cannot be presented as such; rather, it "can come to appear [*zum Vorschein kommen*] in the external only as retreating out of it into itself" (*A* 2: 182/805). Thus, as a romantic and eccentric art, painting can only trace the withdrawal of spirit from the external and sensible, making spirit appear in its very disappearance, making it visible precisely as it escapes visibility. Or rather, more precisely, painting makes visible the traces that spirit leaves in the sensible exterior as it withdraws into its inwardness.

How, then, does painting make these traces visible? How does it make them visible as traces of spirit in its retreat? How does painting present

the *traces as traces* and not as a plenitude in which spirit would be enclosed and thus directly offered to vision? Painting can accomplish such a presentation by virtue of a reduction that belongs to its very constitution as painting, not therefore by the painter's painting in a certain way rather than another but rather in and through the very inception of painting as such. As its very condition, painting enforces a reduction of the real sensible appearance to mere shining. More precisely, by reducing three-dimensional spatiality to the two dimensions of a surface, painting effects an *Aufhebung* in which the canceling of the real sensible appearance is paired with a transformation of its visibility into pure shining (see *A* 2: 18/625f.). Deprived of its status as an existent object, the surface that remains has therefore the character of being only *for spirit*. It is to this extent inwardized (*verinnerlicht*), not in the sense of being totally assimilated to spirit in its inwardness, but in the sense of being made to bear an indelible reference back to spirit. In this way what comes to appear on the surface as mere shining becomes also a trace pointing back to spirit in its retreat; and, as painted, the trace is presented as a trace. Painting presents spirit not as circumscribed or imaged there on the painted surface, but only by way of the traces that from that surface point back to spirit in its retreat.

By bringing one back to oneself, the painted traces awaken feeling, disclose inward spirit, subjectivity, to itself in the mode of feeling. Short-circuiting this route to self-disclosure, Hegel characterizes painting simply as "the shining forth of the inwardness concentrated in itself [*das Hervorscheinen des in sich konzentrierten Inneren*]" (*A* 2: 173/795)—almost as if in a painting one were given a direct vision of one's own spirit. One suspects that a certain counterthrust by the language of content and form is here in play, as it is unmistakably in another passage in which Hegel says, "Certainly painting brings the inward [*das Innere*] before our intuition in the form of external objectivity, but its proper content, which it expresses, is affective subjectivity" (*A* 2: 181/804). Yet what painting sets directly before our vision is not inward spirit or affective subjectivity but rather only a painted surface with vector traces capable of awakening affection and thus prompting an affective disclosure of the inward spirit to itself. Here one sees how Hegel's discourse hovers or twists between, on the one side, a language of content with its conception of art as presenting content and, on the other side, a language more in accordance with the heterogeneity, the eccentricity, of painting. Or rather, to be more precise philologically, the discourse of the *Aesthetics* can be said to be spaced between these two alternatives. Whether the alternation is a result of Hotho's editorial prac-

tices, whether, for instance, it was Hotho rather than Hegel himself who introduced the language of content into the text; also whether this alternation may be only a result of the various lecture cycles having been conflated and so may mark Hegel's development of a more radical conception in the later cycles; and finally whether the language of content might, also or instead, have been introduced by others who prepared transcriptions of Hegel's lectures—probably none of these questions can be answered with complete certainty, considering the way the text was composed and the limited manuscript resources now available for decomposing it.[17]

The painter paints only traces. And yet, what he gains thereby is immeasurable. For there is almost no limit—perhaps no limit at all—to what can serve as a trace of spirit in its retreat. Individual affective subjectivity can enter into relation with the entire range of things, any of which can become traces turning subjectivity affectively into itself. Therefore, says Hegel, "it is possible for the painter to bring within the sphere of his presentations a wealth of objects that remain inaccessible to sculpture" (A 2: 180/803). The contrast is decisive: the only object that, as in classical sculpture, can directly present spirit is the human form, the form of the human body, whereas there is almost no limit—perhaps none at all—to what objects can serve as shining traces of spirit's retreat. Hegel enumerates, beginning with the whole range of religious topics and continuing with "external nature, everything human down to the most fleeting aspects of situations and characters." He concludes: "Each and all of these can win a place here," that is, in painting (A 2: 180/803). Then, as if to underline that a virtually unlimited range is to be accorded to painting, to underline, in particular, that painting is not limited to elevated, religious matters, he adds: "For there belongs to subjectivity also the particular, the arbitrary, and the accidental in human interests and needs, and these therefore equally press to be taken up [in painting]" (A 2: 180/803).

As indeed they had been in seventeenth-century Dutch painting.

Hegel's interest in Dutch painting antedates the travels in the 1820s. In Heidelberg he saw the Boisserée collection of works by Dutch painters,[18] and his acquaintance with such painting was broadened by what he was then able to see in Berlin. Yet what was most significant in this regard was his travel in 1822, which took him to Flanders and the Netherlands: to Antwerp, then on through Dordrecht, Rotterdam, Delft, to Den Haag; from there he traveled on through Haarlem to Amsterdam, the "queen of

17. See Gethmann-Siefert, "Ästhetik oder Philosophie der Kunst."
18. Pöggeler, ed., Hegel in Berlin, 232.

the sea." These travels allowed Hegel to see works by Wouwerman, van
Dyck, Rembrandt, and many others; it is known, for instance, that in Am-
sterdam he saw Rembrandt's *Night Watch*.[19]

Hegel was struck by the "utterly living absorption in the *worldly* and
the everyday" exemplified in Dutch painting (*A* 2: 255/884). Hegel draws a
connection to the movement away from the Catholic Church, as well as to
the more general outlook of the Dutch, who, having expelled the Spanish
and having reclaimed much of their land from the sea, experienced a "joy
and exuberance in their own sense that for all this they have their own
activity to thank" (*A* 1: 170/169). Hegel clearly sensed this outlook in the
people and in their painting, that they had moved from the old religious
piety "to joy in the worldly as such, in the objects and particular appear-
ances of nature, in domestic life in its respectability, cheerfulness, and
quiet seclusion, as well as in national celebrations, festivals, and proces-
sions, country dances, and the enjoyment and exuberances of consecra-
tions" (*A* 2: 256/885). It is to the scenes of peasant life that fill so many
Dutch canvases that Hegel applies the expression "the Sunday of life" (*A* 2:
257/887).

What is perhaps most remarkable and most consequential is the way
in which Hegel's recognition and legitimation of Dutch painting had the
effect of reinforcing a theoretical tendency already at work in the *Aesthet-
ics*. Specifically, Hegel is led to introduce into painting at large a bifurca-
tion into two extremes. At one extreme, the chief thing is the profundity
of the subject matter, the religious and moral seriousness of the presenta-
tion. At the other extreme, the subject matter consists of objects that in
themselves are insignificant, and what counts is the subjective skill for
presenting the particularities of actual things. Suggesting that this divi-
sion lies in the very concept of painting, Hegel stresses that it is a bifurca-
tion that is not to be brought under a supervenient unity: "one could even
say that the two sides are not, in a uniform development, to be unified,
but that each must become on its own account [*für sich*] independent" (*A*
2: 188/811). Hegel links this two-sidedness to the fact that painting has
two means of presentation, by way of shape and by way of color, hence,
on the one side, in a way that gives primacy to the ideal and the plas-
tic and, on the other side, in a way that favors the immediate particular-
ity of actual things. He concludes that there are, correspondingly, two
kinds of painting: "The one presents the ideal, the essence of which is

19. Ibid., 148–52. Hegel mentions these three painters by name in the *Aesthetics*, indeed
in the context of a discussion of the general Dutch outlook (1:170/169).

universality; the other presents the individual in its close particularity" (*A* 2: 188/811).

In Hegel's account of this bifurcation of painting, that is, of these two quite nonunifiable kinds of painting, it is significant that he relies on a duality in painting's means of presentation and uses this duality as a basis for deriving the two kinds. The duality of means consists of shape ("the forms of spatial delimitation") and color. Whereas shape and form tend toward the ideal and universal, that is, toward the intelligible, color immerses the painter in the very sense of sense. Hence, in the former case, painting presents "the substantial, the objects of religious faith, great historical events, the most preeminent individuals"; in the latter case, "it has to free and to release into independence the particularity that otherwise remains merely incidental, the surroundings, and the background" (*A* 2: 188f./812). However, what Hegel does not explicitly mention in this connection is that the two means of presentation neither have the same status nor are entirely independent. Rather, it is by means of *color* that everything is there—*including shape*. This primacy of color entails that even in the kind of painting that is occupied with shape and thus is oriented to the ideal and universal the painter is nonetheless engaged with color precisely as the means by which shape is made to emerge. In being occupied with shape, painting would not dispense with its engagement with color but would rather only not be immersed to the same degree in color. The engagement with color is thus what connects the two otherwise nonunifiable kinds of painting, which therefore are differentiated by the extent to which color either is limited by an occupation with shape or is pursued more freely and more for its own sake.

The paradigms of these two kinds are Italian Renaissance painting and seventeenth-century Dutch painting. Broaching the example of Raphael, Hegel refers to the substantial, lofty subject matter for the sake of which "the overwhelming skill in the painter's art is forced back as something still less essential" (*A* 2: 188/812)—that is, the painter's handling of color, his coloring (*Kolorit*), is limited by the aim of presenting a substantial subject matter. Thus, Hegel draws a remarkable comparison between Raphael and the Dutch painters: "So, for example, Raphael's cartoons are of inestimable value and they display every excellence of conception, although Raphael himself in his completed paintings—whatever mastery he may have achieved in drawing [*Zeichnung*], in the purity of his ideal yet thoroughly living and individual shapes, in composition, and in coloring— is certainly surpassed by the Dutch masters in coloring, in landscapes, etc." (*A* 2: 188/812).

Also clearly in play here is the difference between content and trace—that is, between a content, which, in order to present spirit, must itself be preeminently spiritual, "substantial," as Hegel calls it, and a trace, which can be made to present spirit in retreat regardless of its content. In a sense, then, the most radical strain in this already fracturing account is that which leads on to a painting in which content ceases to matter at all. Hegel situates this even more extreme painting at what he calls "the extreme of appearance itself as such." His description of what happens in painting at this point is one of the most remarkable passages in the entire *Aesthetics*, and though Hegel no doubt had Dutch painting primarily in view here, one cannot but marvel at how the description could, almost more appropriately, serve as a description of Impressionist painting: it is the point "where content does not matter [*gleichgültig . . . wird*] and where the chief interest lies in the artistic production of shining [*das künstlerische Scheinenmachen*]. With supreme art we see fixed the most transient shinings of the sky, of the time of day, of the lighting of the forest, the shinings and reflections of clouds, waves, seas, streams, the shimmering and gleaming of wine in a glass, a flash of the eye, a momentary look or smile, etc." (*A* 2: 189/812).[20]

What Hegel came to see, what the Dutch masters brought him to see more clearly, was that painting veers off from the classical center in a direction in which the shining of the sensible becomes ever more its concern, the shining of the sensible in its very sensibleness and not as the direct sensible presentation of spiritual content. To be sure, alongside this most eccentric painting, Hegel retains another kind, a kind that, though not without a certain eccentricity, retains a certain orientation to the classical; it is not insignificant in this regard that Hegel takes Raphael to have brought painting—or rather, it seems, this one of two kinds—to its pinna-

20. A transcription of the 1826 lecture cycle contains a passage that explicitly connects, on the one hand, the indifference of content and a predominant interest in shining with, on the other hand, the inwardness of painting, that is, the inwardness of spirit that is in and as itself unpresentable but that nonetheless painting is to present. This interest in shining Hegel calls—presumably because of the indifference to content—an abstract interest. The passage reads: "Because of its inwardness, painting is the art of shining as such; it arouses an interest in this shining, an abstract interest, which asserts itself still more. The content becomes more or less indifferent, since it is something particular, and the shining gains predominance" (*Philosophie der Kunst oder Ästhetik: Nach Hegel im Sommer 1826*, Nachschrift von Kehler, cited in Collenberg, "Hegels Konzeption des Kolorits," 154). In the Pfordten transcription of this same cycle, the corresponding passage reads: "Painting is the art of shining as such and the inwardness in the shining, this [is its primary] interest; insofar as the content has particularity in itself, the content becomes in itself indifferent, but because it is a particular, mere shining as such, the latter gains predominance (*Philosophie der Kunst: Vorlesung von 1826*, 206).

cle by infusing into it a moment, even though a highly original moment, of classical form. It is almost as though the bifurcation of painting fractures it into *one kind* that, for all its originality as a romantic art, remains turned back toward classical form and sculpture-like presentation by way of content *and another kind* that, indifferent to content, sets its sights on the shining of the sensible in its utmost sensibleness, tracing in the very sense of sense the retreat of spirit.

>>> <<<

How, then, does the painter paint the traces of spirit in retreat? How does he let these traces shine forth as sensible traces of the very withdrawal of spirit from the sensible? The painter does so by the same means always used, by spreading color across a surface, by coloring. Here coloring (*Kolorit*) is not a matter of adding color (*Kolorierung*) to a shape already outlined by drawing.[21] Rather, it is by means of coloring that everything is there and that, specifically, the traces of spirit are there. Clearly, then, trace is to be understood here neither as line nor as outline nor as a configuration of lines. Traces are not drawn but painted; they are not even primarily the product of a kind of drawing that emerges from color, not linear moments on the colored surface. As such, they are not specifically linear at all, for what they trace is not an outline of spirit but the withdrawal of spirit from every outline within which one would presume directly to present it as such. Like everything else in painting, these traces that are the primary moments of the painter's art are forms of color and interplays of color. These the painter lays out in such a way that they become vectors indicating—though not in the strictest sense presenting—spirit in its escape from artistic presentation. There is of course no saying how the painter finds this way, in any case not by any general rule but only through imagination and his own individual sense of color.[22] It is entirely a matter of coloring.

In this matter of coloring, the Dutch painters excel. Yet alongside them, as also "masters of the tones of color," Hegel places the Venetians, preeminently Titian.[23] In the *Aesthetics*, in the context of his description

21. See Collenberg, "Hegels Konzeption des Kolorits," 127.

22. According to Hotho's transcription of the 1823 lecture cycle, Hegel says: "Coloring is the peculiar characteristic [*das Eigentümliche*] of every master; a moment of the productive imagination of the artist" (*Vorlesungen über die Philosophie der Kunst: Berlin 1823*, 260). The formulation is expanded but also modified somewhat in the published text of the *Aesthetics*: "The sense of color must be a characteristic of the artist, a peculiar way of looking at and conceiving the tones of color that exist, as well as an essential side of the reproductive imagination and invention (2: 222/849).

23. *Vorlesung über Ästhetik: Berlin 1820/21*, 272; also *Vorlesungen über die Philosophie der Kunst: Berlin 1823*, 258.

of how Raphael reached the pinnacle of perfection in painting, Hegel says that Titian was still greater "in the wealth of natural liveliness, in the illuminating luster, in the warmth and force of the coloring" (A 2: 253/881f.). It is known from the letter cited above that Hegel saw some works by Titian when he visited the Louvre in 1827.[24] Most likely he had seen other works by Titian much earlier, since the 1820–21 lecture cycle includes a discussion of the Venetian master as a portrait painter who "stresses the features of liveliness to such an extent that the picture seems to move."[25]

In the *Aesthetics* the detailed discussion of color comes in a section entitled "More Detailed Determinations of the Sensible Material." In this section Hegel extends—indeed to the limit—what had been developed in a more general way in the earlier section entitled "The Sensible Material of Painting," namely and above all, that, in painting, it is by means of color that everything is there. However, if regarded against the background of the earlier, general account, the more detailed one seems to be organized in an odd way. For rather than addressing straightaway the all-determining role of color in painting, the section is divided into three subsections: the first two subsections are quite brief but then are followed by what seems a disproportionately long subsection on color. The first subsection addresses linear perspective as a means for introducing depth and hence a semblance of three dimensions.[26] The second subsection addresses drawing (*Zeichnung*) and declares quite oddly: "It is drawing alone that provides the distance of objects from one another and also their individual shape" (A 2: 212/838). What is perhaps most odd is the conflict between this declaration, by which drawing would be retained as an essential, independent moment in painting alongside coloring, and the assertion which concludes the subsection and brings the entire matter back to the position laid out in the initial discussion of the sensible material of painting. For Hegel concludes the subsection on drawing by depriving it—contrary to what he has just said—of any essential, independent role in painting: painting's "proper task is coloring [*Färbung*], so that in genuine painting, distance and shape win their proper presentation only through differences of color and emerge [precisely] therein" (A 2: 212f./838).

Both the sharpness of the conflict and the emphasis that the *Aesthetics* otherwise places on the all-determining role of color strongly suggest

24. See note 16.
25. *Vorlesung über Ästhetik: Berlin 1820/21*, 265.
26. In the 1820–21 cycle Hegel says: "Mere geometrical perspective is quite mechanical and not difficult." He then goes on to discuss atmospheric perspective (*Luftperspektive*) and to describe how this is produced by the handling of colors (ibid., 274).

that the text is here corrupt, that is, that in editing it Hotho inserted material that runs counter to what Hegel otherwise and repeatedly says. Especially through the work of Gethmann-Siefert, it has been shown that Hotho's editorial practice went well beyond merely conflating the various cycles and sources and rounding out the diction to give it the smoothness and elegance of a finished text. It has become clear that Hotho added considerable material that most likely did not come from any of the sources at his disposal, material that presumably he thought would improve, or at least positively supplement, what Hegel had presented in the lecture cycles. In some cases this material is contrary to anything Hegel could conceivably have intended. For example, according to Gethmann-Siefert: "So in the edition [prepared by Hotho] there is a worked-out theory of natural beauty, whereas in the lectures Hegel always mentions natural beauty only as a negative foil for his own proper intention of putting the beauty of art, thus the beauty 'reborn from spirit,' at the center."[27] It thus turns out that Hotho's additions to Hegel's lectures do, at least in some significant cases, substantially modify what Hegel said; or, as in the present case concerning the sensible material of painting, such additions may set Hegel's text at odds with itself. For the two initial subsections, on linear perspective and drawing, were almost certainly added by Hotho; they do not occur in any of the extant transcriptions of Hegel's lectures. Their addition serves of course—were it not for that final, conflicting sentence—to obscure the all-decisive role that Hegel gives to color and the correlative devaluing of drawing. By adding the two initial subsections, Hotho, it seems, tried—unsuccessfully—to blend into Hegel's text an alien, classical-academic conception by which the sensible material of painting consists of linear perspective, drawing, and color.[28]

Contrary to this conception, Hegel considers painting entirely a matter of color: it is color, coloring, that makes a painter a painter. It is by way of color that everything in a painting is there: shape, distance, boundaries, contours, that is, all the differentiating spatial relations that emerge on the painted surface. In turn, indeed in the very briefest formula: "It is only by the use of color that painting brings the soulful to its properly living appearance" (A 2: 213/839).

In the section "More Detailed Determinations of the Sensible Material" (specifically, in the long, third subsection, which properly constitutes the section as a whole) Hegel broaches a series of discussions of ways in

27. Pöggeler, ed., *Hegel in Berlin*, 183.
28. See Collenberg, "Hegels Konzeption des Kolorits," 138–40.

which color and coloring function in painting. He details the way in which the coloring of light and dark determines foreground and background, as well as the contours, the proper appearance of shape as sensible shape. He identifies red, blue, and yellow as fundamental colors, each bearing a certain symbolism; and he describes all other colors as shades or shadings (*Schattierung*) of these. He speaks of the completeness with which the colors must appear in painting, declaring that no fundamental color should be missing entirely, that this completeness provides the basis for the harmony of colors in painting. He explains also how atmospheric perspective (*Luftperspektive*) is constituted by the dampening of color tones so that the contrast of light and shadow is sharpest in the foreground and as objects recede they become more colorless so that the opposition of light and shadow is progressively lost.

It is, in a word, incredible what color can achieve in all these and other related respects. And yet, there is one achievement that surpasses these and all others and that brings coloring to its highest point, its culmination, its pinnacle. Hegel marks this pinnacle, identifies what it is that painting must paint, what it is that must be made to emerge from coloring, in order to reach this culmination: "The most difficult thing in coloring [*Färbung*], the ideal, as it were, the pinnacle of coloring [*der Gipfel des Kolorits*], is *carnation* [*Inkarnat*], the color tone of human flesh" (A 2: 220/846).[29] Since painting is entirely a matter of color and coloring, Hegel can equally well say that painting reaches its culmination in painting carnation. At least for one of the two kinds of painting, carnation would constitute the culmination, namely, for the painting that favors the immediate particularity of actual things and that pursues color more freely and more for its own sake. And yet, in discussing carnation Hegel does not broach at all the fracturing of painting as such into two kinds, and it seems that he takes carnation to constitute the pinnacle of painting as such, even if—as one would presumably have to say—in one kind it is hedged in somewhat by the aim of presenting a substantial subject matter. In this connection it is not insignificant who, in Hegel's view, has brought the painting of human flesh to the very highest point, to the pinnacle of the pinnacle: "The greatest master in this art was Titian."[30] Of all the painters whom Hegel mentions, Titian is the one who would seem perhaps least enclosable in merely one

29. "The most difficult object with regard to color is the human body" (*Philosophie der Kunst: Vorlesung von 1826*, 214).

30. *Philosophie der Kunst, 1826*, Nachschrift by Griesheim, cited in Collenberg, "Hegels Konzeption des Kolorits," 159. Exactly the same statement is found in the Pfordten transcription (*Philosophie der Kunst: Vorlesung von 1826*, 215).

of the two kinds of painting, the one who most nearly succeeds in bridging the two nonunifiable extremes. Yet however this may be, there can be no question but that Titian did indeed excel in painting human flesh.

Carnation is what it is most difficult to color, most difficult to paint, for it unites all other colors wonderfully in itself without letting any particular color predominate.[31] Even the youthful and healthy red of the cheeks is no exception: though it is pure carmine (the 1820–21 cycle says, pure red [reines Roth])[32] without a stitch of blue, violet, or yellow, this red, says Hegel, "is only a hint, or rather a shimmer, which seems to press outward from within and then shades off unnoticeably into the rest of the flesh color" (A 2: 220/846). In this way and in this sense, even the red of the cheeks is united with the other colors rather than predominating. More typically the union of flesh colors appears thus: "Through the transparent yellow of the skin there shines the red of the arteries and the blue of the veins, and into the light and dark and the other manifold shinings and reflections there come tones as well of gray, brownish, and even greenish" (A 2: 220/846). Hegel observes that this shining together, this shining into one another (Ineinander von Scheinen) is lusterless (glanzlos); this means that the luminosity of flesh is not such as would be produced by something else shining upon it, hence giving it luster, but rather is a luminosity animated and ensouled from within. It is this shining through from within that is most difficult to present. Hegel draws a comparison: "One could compare this to a lake in the light of the evening [im Abend-schein] where one sees both the shapes mirrored in it and at the same time the clear depth and special character of the water" (A 2: 220/846). Hegel

31. Collenberg has traced the background of this view of carnation in Diderot's *Essay on Painting*, which was translated by Goethe and was well known both to Schelling and to Hegel. The *Essay* is cited by Hegel: "Whoever has attained the feel of flesh has already gone far" (A 2: 220/847). Already in Schelling's *Philosophie der Kunst* carnation is identified as "the highest task of coloring," and flesh is described as "the true chaos of all colors and thus as similar to none in particular, but rather as the most indissoluble and most beautiful mixture of all." On the other hand, Schelling is prevented from reaching the radical consequences to which Hegel is led, because he fails to accord color the all-determining role given it by Hegel. Pairing color with the senses and drawing with the understanding, Schelling takes drawing as that by which painting has the status of art. For Schelling what is decisive is the orientation of painting not to the sensible but rather to "a sublime beauty beyond all sensibleness." See Collenberg, "Hegels Konzeption des Kolorits," 107–9. According to the Pfordten transcription, Hegel mentions the Diderot essay in the 1826 cycle and explicitly identifies carnation as "a mixture of all colors" (*Philosophie der Kunst: Vorlesung von 1826*, 214). Hotho's transcription of the 1823 cycle records Hegel as saying that in carnation all colors "are wonderfully combined" (*Vorlesungen über die Philosophie der Kunst: Berlin 1823*, 260).

32. *Vorlesung über Ästhetik: Berlin 1820/21*, 275.

draws also a series of contrasts: the luster of metal shines and reflects, precious stones are transparent and flashing, and yet in both cases there is no shining of one color through another as there is in flesh. With the skin of animals (hair, feathers, wool, etc.) there is in each part an independent color and so only a variety of colors, not an interpenetration such as occurs with human flesh. Hegel suggests that the color of a bunch of grapes or of a rose comes nearest to the distinctive shining of colors in human flesh, but even these fall short of the shining of inner animation characteristic of the colors of human flesh. Hegel observes that for presenting the lusterless shining of flesh colors through one another, oil painting, with its capacity for layering, has proved most suitable.

Suppose that now a broader perspective is taken on carnation as the pinnacle of coloring and hence also of painting (even, it seems, of painting as such). Three points need then to be mentioned. The first pertains to a question regarding the primacy Hegel accords to carnation, a question regarding his taking it precisely as what is most difficult and as what constitutes the pinnacle of painting. The question is: Why carnation and not rather the eye? Even aside from the question of technical difficulty, if painting shares the task of all art, that of giving a sensible presentation of spirit, would this task not be still more perfectly achieved in painting the human eye than in painting flesh? Consider what Hegel says of the eye: "But if we ask in which particular organ the whole soul appears as soul, we will at once name the eye; for in the eye the soul is concentrated, and the soul does not merely see through it but is also seen in it" (A 1: 155f./153). Why, then, is it not in painting the human eye that painting would most perfectly present the soul, the inward spirit? Why would painting not reach its pinnacle in painting the eye? Hegel does not say. But presumably it is because painting is determined by the task of presenting spirit precisely in its retreat from sensible presentation. One might suppose, then, that in the eye the soul shows itself too directly, shows itself more in its entrance into the sensible than in its retreat from sensibleness. In contrast, the peculiar luminosity of flesh, its lusterless shining from within, makes it ideal for presenting in painting the withdrawn human spirit. In human flesh, taken up into painting, one sees not the soul itself as in the seeing eye, but rather a trace of spirit in its retreat.

The second point concerns a peculiar connection or analogy that Hegel draws later in his lectures. In the discussion of music, he speaks of the human voice, says that it is the perfect instrument because it unites the character of wind and string instruments. He continues: "Just as we saw, in the case of the color of the human skin, that, as an ideal unity, it con-

tains the rest of the colors and therefore is the most perfect color, so the human voice contains the ideal totality of sound, which is only spread out among the other instruments in their particular differences. Consequently it is the perfection of sound." And just as, in painting, the human soul sees itself traced in human flesh, so, says Hegel, "in song the soul rings out from its own body" (A 2: 291/922). Such, at least, is the affinity between painting and music.

The third point concerns the connection between carnation and the eccentricity of painting. Already in the radical orientation of painting to color, Hegel broaches its eccentricity. By its engagement in the most sensible of the sensible, painting is enabled eccentrically to present the entire span from the most sensible to the most intelligible. Because it sides so eccentrically with color, painting is also set apart from the classical center of art as such, and, itself retreating from any direct presentation of spirit, it sets its sights instead on the traces of spirit in retreat. In its engagement, then, with carnation, all of painting's eccentricities come into play and reach indeed their culmination. Engaged with the coloring of human flesh, painting intensifies its orientation to sense and, forgoing the dream of presenting spirit directly as such, veers off from the classical center toward the most perfect sensible traces of spirit in retreat, the color of human flesh.

>>> <<<

With carnation, painting comes to the limit of what can be achieved by means of color—to the limit, not in the sense of limitation, but rather as the bound where something becomes fully that of which its determination makes it capable, the point (in Hegel's metaphorics) that represents its pinnacle of perfection.

And yet, though with carnation painting comes to its limit, there is—oddly enough, eccentrically enough—a beyond of this limit, a painting that goes beyond this limit. This passage beyond the limit is foreshadowed and indeed prepared by Hegel's identification of a kind of painting in which, as with at least some Dutch painting, content no longer matters and the chief interest lies in the artistic production of shining. This is the point where painting becomes more concerned with the shining of the sensible, with, as Hegel calls it, "the play of the shining of colors [das Spiel des Farbenscheins]" (A 2: 211/836), than with the presentation of lofty spiritual content. Nonetheless, at the limit, with the painting of carnation, the preoccupation with pure shining comes to serve for tracing the traces by which spirit in its retreat is presented.

But there is a beyond where painting's divergence away from content

toward pure shining is renewed in such a way that the very determination of painting, which prescribes the limit, begins to mutate. Hegel's name for this beyond is "the magical effect of coloring" (*Magie in der Wirkung des Kolorits*). Here is how he describes the magic: "In general, it may be said that the magic consists in so handling all the colors that what emerges is an inherently objectless play of shining, which forms the extreme hovering summit of coloring, an interpenetration [*Ineinander*] of colors, a shining of reflections that shine in other shinings and become so fine, so fleeting, so soulful that they begin to pass over into the sphere of music" (*A* 2: 221/848).

Here, then, the object disappears from painting, is dissolved into the play of shinings. Here, then, the extreme hovering summit of coloring is reached, even beyond the pinnacle of carnation. The mutation that then comes into play, there beyond the limit of the determination of painting, attests to the profound affinity between painting and music. It attests equally to an openness of Hegel's thought to the future of painting.

Soundings

W hat sounds in music? What is sounded? What is music other than sound? Is it anything other than a sequence of sounds, of sounds sounding? Or does something also sound through it? Is something conveyed through the sounds that sound in it, as the look of a beautiful landscape may be conveyed through the colors of a painting or as, among the Greeks, a god could be made to appear through sculpted marble? On the one hand, the indisputably powerful effect of music would seem to attest to some such conveyance. How could music affect us so profoundly if in the end it were nothing but the mere sounding of a sequence of sounds? Yet, on the other hand, there is nothing beyond music that its sounding would serve to present, nothing comparable to the landscape that the painting spreads before our eyes or to the figure of the god that the sculptor lets emerge from the marble.

Yet if music conveys nothing to us, could it be that music conveys us to something, that it carries us along, or rather draws us into a depth that we otherwise seldom fathom? Do the sounds of music serve to sound this depth, to take its measure, to let it resound? If the essence of music is to be determined as such a double sounding, everything will depend on the character of the depth that would be sounded by the sounds of music.

Hegel has no doubt but that the depth sounded by music is that of the self. In his words, most directly, "music makes the inner life resound in tones" (*A* 2: 310/941). Yet it is not as though the inner life would otherwise go entirely unsounded, as if this depth required the advent of music in order to announce itself at all. States of the soul and feelings have natural forms of expression, as in a cry of pain, a sigh, a laugh. Yet in order to become music, these natural forms must be stripped of their wildness and crudeness and the feelings expressed must be linked to specific,

determinate tones and relations between tones. Only in this way can the transition from nature to art, from natural outcry to music, be made. To be sure, Hegel does mention, precisely in this connection, the songs of birds, their delight as they put themselves forth in their songs. Nonetheless, Hegel will not allow these creatures with their songs to cross the threshold from nature to art. Though perhaps belied by his repeated, significant reference to bird songs, Hegel's insistence that there is no natural music is an index of the distance he takes from the *Critique of Judgment*, from its celebration of natural beauty.

>>> <<<

Hegel was considerably less knowledgeable about music than he was, for instance, about painting. He readily admitted that his knowledge of musical theory and his acquaintance with the great musical works were limited and that limits were thereby prescribed for his philosophical treatment of music. At the outset of his account of music in the *Aesthetics*, he observes that one cannot enter into the particulars about music without running into technical matters concerning different instruments, different keys, etc.; and confessing that he is little versed in these matters, he excuses himself in advance for restricting his treatment to the more general points. Later in his account he reiterates his limitations in this regard, observing that a thorough treatment "would require a more exact knowledge of the rules of composition and a far wider acquaintance with the greatest musical works" than he possesses (*A* 2: 299/930). On the other hand, one should not make too much of Hegel's disclaimer, considering the extended discussion of harmonic intervals, scales, overtones, and so forth found in the relevant sections of the *Encyclopedia.*[1] Indeed Hegel's caustic comments about the theoretical insufficiencies of many practicing musicians could lead one to suppose that Hegel knew considerably more about musical theory than he took most musicians to know.

Hegel was also not a musician, not even an amateur. There is no evidence that he was practiced in any form of musical performance. Nonetheless, it is known that already at the time of his residence in Nuremberg he owned a piano; and during the Berlin period he is known to have held music evenings at his home.[2] Contemporary observers in Berlin report that after his lectures Hegel could often be seen hurrying over to the nearby

1. G. W. F. Hegel, *Enzyklopädie der philosophischen Wissenschaften im Grundrisse (1830)*. Zweiter Teil: Die Naturphilosophie, vol. 9 of *Werke in zwanzig Bänden* (Frankfurt a.M.: Suhrkamp, 1970), §§299–302. See especially the long *Zusatz* to §301.

2. See Pöggeler, ed., *Hegel in Berlin*, 240.

opera house; it is known also that he regularly attended concert performances. In Berlin he was personally acquainted with a number of prominent musical figures, including the most famous German singers. Above all, Hegel was enthusiastic for the soprano Anna Milder-Hauptmann, who is known to have been a guest in Hegel's home and who, in turn, extended her hospitality to Hegel. Milder-Hauptmann was especially celebrated for her roles in Gluck's operas, and it seems that Hegel never missed a performance.[3] The very positive estimation of Gluck's operas that Hegel expresses in the *Aesthetics* (see A 2: 315f./947) is perhaps not unrelated to his enjoyment of these performances.

It seems that it was in fact Milder-Hauptmann who recommended the Italian opera in Vienna when Hegel set out on his trip to the Austrian capital in 1824. Hegel's enthusiasm for the bel canto style of singing that he heard in Vienna seems to have been boundless. In a letter to his wife he writes: "There is no idleness in the singing and bringing forth of sounds, no mere recitation of lines, but rather the entire person is there in it. The singers . . . generate and invent expression and coloration out of themselves. They are artists, composers as much as the one who set the opera to music."[4] Hegel's discovery of Rossini, in particular, made such an impression that he never faltered thereafter in his praise of Italian opera. His descriptions suggest that the performance he saw of *The Barber of Seville* was quite extraordinary. It seems that even Mozart's *Marriage of Figaro*, which Hegel saw two days later, paled somewhat by comparison, Hegel observing that "the Italian voices did not seem to have as many opportunities in this more restrained music to display those brilliant feats that are so sweet to hear."[5] As to Rossini, what Hegel admires most is that the music is preeminently for the voice. Having seen, the very next day, still another Rossini opera (*Corradino*), Hegel writes to his wife: "Now I completely understand why Rossini's music is reviled in Germany, especially in Berlin. For just as satin is only for ladies and *paté de foie gras* only for gourmets, so *this* music is created only for Italian voices. It is not for the music as such but for the singing *per se* that everything has been created. Music, having validity for itself, can also be performed on the violin, on

3. Ibid., 87.

4. Hegel, *Briefe*, 3:56 (no. 479).

5. Ibid., 3:61 (no. 481). Rumor had it that Hegel actually preferred *The Barber of Seville* (which he calls Rossini's *Figaro*) over *The Marriage of Figaro*. Hegel is reported to have said that *The Barber of Seville* first conveyed to him a concept of comic opera (see Annemarie Gethmann-Siefert, "Das 'Moderne' Gesamtkunstwerk: Die Oper," in *Phänomen versus System*, *Hegel-Studien*, Beiheft 34 [Bonn: Bouvier Verlag, 1992], 179f.).

the piano, etc., but Rossini's music has meaning only as sung."[6] Hegel had another opportunity to see a fine performance of Rossini when he traveled to Paris in 1827 and attended a production of *Semiramide* at the Italian theater. Again his report to his wife is enthusiastic: "The opera was excellent in every respect, a performance as distinguished as the music was marvelous."[7]

Despite the enthusiasm with which Hegel attended musical and operatic performances, his acquaintance with the great musical works was, as he acknowledged, limited. This limitation is borne out if one considers the musical references given in the *Aesthetics*, and even more so if, from a textual-critical standpoint, one differentiates between Hegel's actual lectures (as preserved in transcriptions) and the text published by Hotho after Hegel's death. Yet what is most remarkable about Hegel's musical references is the fact that there is no mention whatsoever of Beethoven, neither in the lecture transcriptions nor in the published text of the *Aesthetics*. While it is true that by the time Hegel visited Vienna, Rossini had become much more the fashion, Beethoven continued nonetheless to be regarded throughout the European musical culture—and by younger composers such as Schubert and Schumann—as the greatest living composer. Furthermore, when Hegel arrived in Vienna in September 1824, he would almost certainly have heard reports about the great concert that had taken place at the Kärntnertor Theater only four months earlier, the concert on May 7 at which the premier of Beethoven's Ninth Symphony was given. Whether Hegel actually heard any of Beethoven's music while in Vienna is uncertain, as the composer's name is not mentioned in any of the letters Hegel wrote during his stay in the city. Hegel is silent too about Schubert, who was also active in Vienna at the time of Hegel's visit. Had Hegel heard and taken to heart the final movement of the Ninth Symphony or some of the many songs that Schubert composed to poems by Schiller, then perhaps he would not have been so insistent on the inappropriateness of Schiller's poetry for being set to music.[8]

6. Hegel, *Briefe*, 3:64 (no. 481).

7. Ibid., 3:195 (no. 564).

8. In the published text of the *Aesthetics* it is said that "Schiller's poems . . . prove very awkward and useless for musical composition" (A 2: 271/901). The same criticism is found already in the 1820–21 cycle of the lectures. Referring to the need for operatic poetry to be, as in Italian opera, somewhat mediocre (*mittelmässig*), Hegel says: "For the same reason very few of Schiller's poems are suitable for [musical] accompaniment" (Hegel, *Vorlesungen über Ästhetik: Berlin 1820/21*, 281).

Hegel's taste in opera sometimes tended toward the banal and currently fashionable, especially following his discovery of Italian opera during his visit to Vienna. Even Hegel's son Karl expressed reservations about his father's musical preferences, and in his published recollections about his father's musical interests he felt obliged to remain completely silent about Hegel's enthusiasm for Rossini, stressing instead his father's liking for Gluck's operas.[9]

Yet Hotho played a much greater role in shaping what came to be communicated to posterity regarding Hegel's musical preferences and indeed regarding his philosophical approach to music. For Hotho had considerable expertise as regards music: he was active for many years as music editor for Cotta's *Morgenblatt* and in this capacity exercised considerable influence on the musical culture of Berlin. Since he was therefore very much in his element when it came to questions concerning music, it would likely have seemed self-evident to him that in preparing for publication the portion of Hegel's lectures dealing with music he should take it upon himself to compensate for the deficiencies that, because of Hegel's lack of expertise, remained in the lectures. Thus seeking to improve on his teacher, Hotho produced a text that, especially in the account of music, deviates considerably from Hegel's own lectures.[10] Not only did Hotho fill out Hegel's statements and reformulate them more elegantly, but he also corrected Hegel's questionable musical taste by placing the emphasis on classical works by Mozart, Gluck, and Haydn. In addition, he realigned Hegel's account of music so as to force it to cohere with the system, effacing what traces there might have been of musical discoveries capable of challenging the systematic constraints. One sign of this realignment is the account, inserted at the very beginning, of the relation of music to all the other arts, an account not found in the lecture transcriptions. Another sign of Hotho's intervention is the sudden switch to first-person forms, as when the text, engaging in a discussion of musical instruments, continues: "I recall, for instance, that in my youth a virtuoso on the guitar had composed great battle music in a tasteless way for this trivial instrument" (A 2: 325/957). Not only the first-person form but also the very tone of the passage is foreign to Hegel's lectures.

What Hotho seems to have found especially difficult to understand or accept was Hegel's enthusiasm for Italian opera. To be sure, he did not suppress entirely Hegel's admiration for Rossini, which was probably so widely

9. See Gethmann-Siefert, "Das 'Moderne' Gesamtkunstwerk," 176.
10. See ibid., 186, 198.

known that Hotho could have suppressed it only at the cost of discrediting his editorial practices. And so, instead, in a typical instance he begins with some positive generalities (perhaps taken from the lectures themselves), for instance, that Rossini's music is "full of feeling and genius, piercing the mind and heart," contrary to the belief that it is "a mere tickling of the ear," a suspicion Hotho raises by its very mention. Then comes explicit qualification: "even if it does not have to do with the sort of character-ization beloved of our strict German musical intellect." Then comes still another reservation: "For it is true that all too often Rossini is unfaithful to his texts and with his free melodies soars over all the heights" (A 2: 317/949). Thus there is praise, to be sure, but not without several injections of poison, the contribution almost certainly of Hotho. Listen, by contrast, to Hegel himself in another of the letters from Vienna: "But with the Ital-ians the sound is immediately free of longing, and the genuine ringing of naturalness is ignited and in full swing from the first moment. The first sound is freedom and passion. From the first tone they go at it blissfully with a free soul. The divine furor is at bottom a melodic stream that fills us with delight, penetrating and freeing every situation."[11]

Whatever deficiencies Hotho found in Hegel's musical taste, there was certainly no deficiency of contact with music and musicians during the Berlin period. Indeed there was one eminent, though still very young, composer with whom Hegel had considerable personal contact. Felix Men-delssohn actually attended the 1828–29 cycle of Hegel's lectures on the philosophy of art; furthermore Mendelssohn produced a transcription of the lectures in which reportedly he added some polemically humorous re-marks of his own, especially concerning Hegel's thesis about the pastness of art.[12] It was at this time that Mendelssohn conducted the momentous performances of Bach's *St. Matthew Passion* at the Singakademie in Ber-lin, performances that not only revived this previously neglected master-piece but indeed proved to be a turning point in the nineteenth-century revival of Bach's music at large. At both performances, on March 11 and 21, 1829, Hegel was present along with other such prominent guests as Schleiermacher, Droysen, and Heine.[13] Hegel also is known to have taken part in the social festivities associated with the performances.[14] In the *Aesthetics* there is a remark (presumably from Hegel himself) that, though

11. Hegel, *Briefe*, 3:71 (no. 483).
12. Gethmann-Siefert, "Das 'Moderne' Gesamtkunstwerk," 170f.
13. See Pöggeler, ed., *Hegel in Berlin*, 91.
14. Gethmann-Siefert, "Das 'Moderne' Gesamtkunstwerk," 172.

probably preceding these historic performances, pays tribute to Bach and to the revival of his music: Hegel describes him as "a master whose grand, truly Protestant, robust, and yet, as it were, learned genius we have come only in recent times to admire completely" (A 2: 318/950).

One might imagine Hegel listening intently to the *St. Matthew Passion* as Mendelssohn conducted it in the Singakademie in Berlin. Hegel might well have had the text in hand, reading along in a kind of silent, interior enactment of what he heard. Yet he would not have been unresponsive to the place in which the performances were staged. The Singakademie was distinctively classical in its design. Its main facade resembled that of a Greek temple; its four columns were topped with Corinthian capitals upon which a typical entablature rested. Listening to the performance in this setting, Hegel might—one could imagine—have set about musing on the profound affinity between architecture and music that he had described in some detail in his lectures. One aspect of this affinity lies in the externality of form and content that architecture and music have in common. Just as in architecture the content cannot be made to command entirely the shape that is fashioned, so that architecture falls short of the classical unity achieved in sculpture; so in music as a romantic art this unity has been dissolved and the artwork itself remains apart from the inner life it would present. Hence, just as architecture surrounds the statue of the god with its proper columns, walls, and entablature, so music, expressing the element of feeling, accompanies a text or thoughts that, as determinate content, are not contained in the music.[15] In short, as architecture surrounds the god with his temple, so music surrounds enunciated spiritual ideas with melodious sounds expressive of feeling. Furthermore, both architecture and music produce their form, not from what exists (as in the more nearly mimetic arts of sculpture and painting), but rather by inventing them in accord with certain quantitative proportions, in one case, those pertaining to the laws of gravity and symmetry, in the other case, those pertaining to the harmonic laws of sound, the regularity of the beat, and the symmetry of rhythm. Hegel even draws a specific comparison between the columns of temples and the bar or beat as it functions in music

15. The treatment of the affinity between architecture and music is not found solely in the published text of the *Aesthetics*. Though it is only briefly introduced in the 1820–21 cycle (*Vorlesungen über Ästhetik: Berlin 1820/21*, 283), it does occur in the Hotho transcription of the 1823 cycle, as in this passage: "Music is similar to architecture in that it does not have its content in itself, and as architecture calls for a god, so does the subjectivity of music call for a text, thoughts, representations, which as determinate content are not in it" (*Vorlesungen über die Philosophie der Kunst: Berlin 1823*, 270).

(see *A* 2: 284/915). Thus he regards music as pairing the most profound feeling with the most rigorous mathematical laws. When these two moments are separated and music is freed of emotional expression, then, according to the *Aesthetics*, it acquires an architectonic character and becomes a musically regular building of tones (*Tongebäude*) (*A* 2: 264/894). As Hegel listened to Bach's great work there in the Singakademie, he might well have marveled that it was Bach's rare genius to have succeeded in creating a magnificent edifice of sounds that, precisely as such, expressed the most profound feelings.

One might imagine Hegel interrupting these musings in order to recall that, for all the affinity, the fact remains that architecture and music move in quite opposite realms, architecture remaining bound to heavy, visible matter, whereas music with its soulful tones liberates itself from space and matter. And yet, one could imagine how the musings might resume as Hegel—continuing to listen intently to Mendelssohn's performance of Bach's great work—transported himself in imagination from the temple-like Singakademie to a magnificent Gothic cathedral, drawing perhaps on his memory of the great cathedral in Cologne, which, less than two years before, he had visited for the second time on his return trip from Paris. He might then have wondered whether, in such instances, a deeper affinity between architecture and music would not outweigh the apparent opposition between their realms. The affinity would lie in the commitment to verticality, to elevation. For as music elevates the soul and lets it soar upward, so it is with a Gothic cathedral: everything is constructed or contrived so as to deprive the stone of its massive heaviness and draw one's vision upward. As the *Aesthetics* declares: "There is no other architecture that with such enormous and heavy masses of stone . . . preserved nonetheless so completely the character of lightness and grace" (*A* 2: 82/696). In the Gothic cathedral stone is deprived of its heaviness and made to soar.[16]

One might imagine Hegel entering the Cologne cathedral at the moment when Bach's Toccata and Fugue in D Minor begins to sound from the organ. Then, perhaps even more than at the historic performance in Berlin, he would have been struck by the profound affinity between architecture and music. Perhaps, too, he would have been set to musing on the interweaving of vision and audition that is indispensable for sensing this affinity. For he could not but have sensed how both the somber interiority of the sacred space and the upward thrust of the pillars and arches are matched by the walls of echoing sound intersecting at ever varying

16. See my analysis in *Stone* (Bloomington: Indiana University Press, 1994), 61–69.

harmonic angles and the manifold tonalities ascending from the depths as those depths, too, continue to sound.

>>><<<

While music possesses an affinity in depth with architecture, the art to which it is most contiguous is painting. For this reason Hegel's account of music begins with the transition from painting to music.[17] Indeed the contiguity is almost such that no transition is needed. For there is a certain development in painting that almost turns it into music. Hegel calls this development "the magic of color"; it occurs at the point where shining becomes so prominent that the object begins to disappear and there remain only the compoundings of shinings, which are no longer tied even to figure. The objectivity of the painting's surface undergoes reduction to an objectless, figureless play of the shinings of color. While such surfaces "begin to pass over into the sphere of music" (A 2: 221/848), they remain nonetheless spatial; they continue to persist as surfaces over against the spectator. Thus, while beginning to pass over into the sphere of music, they stop short of the threshold. Passage over this threshold requires something else.

Music comes about only with the obliteration of such surface. From one point of view, the transition merely extends the reduction already effected in passing from sculpture to painting; whereas the previous passage required reduction from three spatial dimensions to two, now it is required that these two remaining dimensions, surface as such, be effaced. Yet, from another point of view, this passage is entirely different, for its effect is to eliminate spatiality as such. Once the spatiality of the artwork is entirely eliminated, then the work is no longer anything persisting over against the subject but is itself drawn back into subjectivity. This withdrawal into subjectivity brings to completion what with painting was already initiated: whereas in painting there remains a self-reposing, persistent object, a surface on which subjective inwardness is obliquely presented by way of traces of its withdrawal from objectivity, in music this surface disappears, and even that by which subjective inwardness would be presented is itself withdrawn into subjectivity. Thus, it can be said that music "even in its objectivity remains *subjective*" (A 2: 260/889).

Yet this passage by which music comes about is no simple negation, no mere cancelation leaving nothing behind. At this point in the text

17. Such a beginning is found not only in the text of the *Aesthetics* but also in both the Hotho transcription of the 1823 cycle (*Vorlesungen über die Philosophie der Kunst: Berlin 1823*, 262) and the Kehler transcription of the 1826 cycle. See Gethmann-Siefert, "Das 'Moderne' Gesamtkunstwerk," 191).

the word *Aufhebung* becomes prominent, for the pertinent operation is precisely that which this speculative word names. In the passage from painting to music, spatial objectivity is both canceled as such and preserved as canceled. With the advent of music something remains over against subjectivity; something is preserved in the place previously occupied by the painted surface, even though this place is stripped of its spatiality as such and retains only the character of being over against subjectivity. What comes to occupy this residual place, if only in being immediately displaced, is just music itself.

The *Aufhebung* through which this placement-displacement comes about is described as follows: "The *Aufhebung* of the spatial therefore consists here only in the fact that a determinate sensible material gives up its peaceful separateness, turns to movement, yet *so* vibrates [*erzittert*] in itself that every part of the cohering body not only changes its place but also strives to replace itself in its former position. The result of this oscillating vibration is *tone* [*Ton*], the material of music" (*A* 2: 160f./890). What the placement-displacement leaves in its wake is tone. Yet, in the most succinct formulation, "Tone is to be considered only in its way of sounding."[18] Hence, what is produced by the *Aufhebung* of spatial objectivity, by the placement-displacement that it sets off, is sounding.

The other theoretical sense thus comes into play. Hearing is more ideal than sight, less directly linked to existing things to be apprehended in their independence. Whereas sight reveals how things look, apprehends their form and so discloses to some extent what they are, hearing is geared only to how things sound when they are struck or when they are made to vibrate. Thus it is that as existent surfaces with their stable forms give way to internally vibrating things hearing comes to replace sight.

What counts especially is the instability, the outcome of the double negativity. The first negativity is that by which every part of the object is displaced, this displacement being itself, in turn, negated by the striving of these parts to replace themselves in their original place. The operation of this double negativity is the internal vibration, the sheer instability itself that results in the sounding tone. In the formulation from the *Aesthetics:* "Since, furthermore, the negativity into which the vibrating material here enters is, on one side, an *Aufheben* of the spatial condition, which is itself again *aufgehoben* by the reaction of the body, therefore the

18. "Der Ton kommt nur als solcher in Betracht, nach der Weise seines Klanges" (*Vorlesungen über Ästhetik: Berlin 1820/21*, 278).

expression of this double negation, namely, tone, is an externality that in its coming-to-be is annihilated again by its very existence and disappears of itself" (A 2: 261/890).

Yet the double negation and the sheer instability it releases cannot be entirely disengaged from the cohering body, from the spatial object. For tone can be produced only from such an object, only by setting such a thing vibrating. In fact, in the parallel and more elaborate treatment of sound that Hegel gives in the second part of the *Encyclopedia*, he explicitly links the quality of the sound produced to the character of the vibrating body: "The purity or impurity of sound proper [*des eigentlichen Klanges*] and its distinction from mere noise . . . is bound up with the homogeneity of the vibrating body and also with its specific cohesion."[19] Furthermore, Hegel observes that because the vibration is a determinate negation of the specific forms of cohesion of the object and thus has these as its content, the sounds produced are also specified accordingly; and thus it is that the various musical instruments have their characteristic sound and timbre. As to the precise relation between the vibration of the object and the tone that sounds from it, there are passages that virtually identify these—as, for instance, the following from the *Encyclopedia:* "Sound proper is the reverberation [*Der eigentliche Klang ist das Nachhallen*], this unhindered inner vibration of a body, which is freely determined by the nature of its cohesion."[20] Thus music sounds from an instrument, from the vibrating strings of a violin or from the vibrating air column of a wind instrument or from the passage of breath across the vocal cords of a singer. Music sounds from these instruments so intimately, in a way so thoroughly bound up with the instrument, that there is hardly a difference between the vibration of the instrument and the tone that sounds from it. And yet, in sounding, the tone relinquishes entirely its objective existence and soars beyond the instrument by which it has been produced. No sooner does it sound than it disappears. As soon as it sounds for a subject, it is already gone and can only resound within the subject.

Not only is tone thus a vanishing moment, but it is also wholly abstract. In this connection the *Aesthetics* draws a distinction between, on the one hand, the way in which stone and color, the materials of sculpture and painting, respectively, can be given forms taken from the world of objects, thus portraying such objects in their enormous variety of forms; and,

19. Hegel, *Enzyklopädie*, §300, Remark.
20. Ibid., §300, *Zusatz.*

on the other hand, the incapacity of tone to be treated in this manner. To put it more directly, sculpture and painting are to some extent mimetic arts, whereas music is quite nonmimetic. Since music cannot portray objects, what remains for it to express is only the object-free inner life, abstract subjectivity, the self entirely empty of further content. In the formulation given in the *Aesthetics*: "Consequently the chief task of music consists in letting resound [*wiederklingen*] not the objective world itself, but, on the contrary, the way in which the innermost self is moved in its subjectivity and spirituality" (*A* 2:261/891).

According to this account there is nothing beyond music that its sounding would serve to present, nothing like the landscape evoked by the painter or the god called forth by the sculptor. Conveying nothing to us, music conveys us to ourselves, draws us into our own subjective depth, lets that depth resound and thereby be sounded. The sheer instability of tone as it momentarily hovers almost nowhere is indicative that, lacking any stability of its own, it is borne by the inner subjective life. As soon as a tone sounds, it vanishes, and the impression (*Eindruck*) made by it is inscribed not at the point where it is sounded but rather within. In the silence that supervenes as it is swept away, the tone goes on sounding (*nachklingen*) only in the depth of the soul.

At this point three sets of questions need to be formulated. They are questions that seek to confront Hegel's account with the actuality of music and thereby to mark—if still in the form of questions—certain limits of that account.

Without contesting the fleeting character of tone or the abstractness of music compared to painting and sculpture, there is need nonetheless to consider whether music is indeed so thoroughly assimilated to subjective interiority as Hegel maintains.[21] Is music in every instance so thoroughly nonmimetic that it can present nothing other than empty subjectivity? Leaving aside for the moment the forms such as song in which music is allied with poetry, focusing on purely instrumental music, even setting aside instances in which mere imitation of natural sounds such as bird songs are introduced into music, is there not still good reason to grant to music the power to present certain things in the world, even if in a way incomparable to those of painting and sculpture? How could Hegel have

21. In addition to the account in the *Aesthetics*, the following excerpted passage occurs in the transcription of the first (1820–21) cycle of Hegel's lectures: "The most abstract, most formal interiority . . . is the proper place of music" (*Vorlesungen über Ästhetik: Berlin 1820/21*, 279). In a transcription of the third cycle, the following passage occurs: "Tone is the externalization of abstract inwardness" (*Philosophie der Kunst: Vorlesung vom 1826*, 216).

overlooked this power of music if he had heard the second movement of Beethoven's *Pastoral Symphony*, which, long before the bird songs enter near the end of the movement, will already have transported the attentive listener to the "Scene by the Brook," indeed will have done so by purely musical means. There are comparable examples from the Italian composers whom Hegel so admired, the storm, for instance, in Rossini's overture to *William Tell*. And though its expressive means goes beyond most, if not all, of the music of Hegel's time, there is perhaps no more convincing example of a musical presentation of nature than Debussy's *La Mer*. While it may be true that such works evoke natural phenomena by detouring, as it were, through subjectivity, that is, by evoking the very feelings that such a natural scene would evoke, still such music does succeed in presenting a natural scene rather than withdrawing entirely into resonant interiority.

A second question concerns the spatiality of music. The reduction of space is what both effects the transition from painting to music and, depriving music of place, prepares its assimilation to subjectivity. To be sure, it is acknowledged in the *Aesthetics* that the sounding is to an extent distinct from subjectivity: there is reference to "the beginning of a distinction between the enjoying subject and the objective work," which derives from the fact that the artwork "in its actually sounding tones acquires a sensible existence different from interiority." Yet this sensible existence is said to be purely transitory or ephemeral (*vergänglich*) (*A* 2: 275/905). Still, without contesting the instability of the sounding, it is relevant to observe that the sounding comes from somewhere, from the place where the instrument that produces it is located; and one might insist that this place retains a certain pertinence even after the tone that sounds there has passed. For the musical tones must at least traverse the space between the sounding instrument and the listener. Yet, as it traverses this space, it will also spread throughout the surrounding space; and especially if that space is enclosed, the musical tones will reverberate, echo, resound, in a way that will add something to the tone produced by the instrument. In this resonating supplement a certain spatiality will become audible. Many composers have recognized the spatiality that in this way accrues to music and have sought to utilize this character to enhance their music: as in Gabrieli's antiphonal Canzoni, composed to be performed in San Marco Basilica in Venice, in which musicians are stationed at several different locations in such a way that the interplay between the differently spatialized musical tones can be incorporated into the very conception of the work. It is precisely this spatiality of music that prompts us to speak of

edifices of sounds, a figure that points to a still deeper affinity between architecture and music.

 A third set of questions brings the other two together. If the abstract subjectivity that music presents is not mere emptiness but rather, by its very indeterminateness, a broader, virtually unlimited opening onto the world, then it would seem that music's presentational capacity could be accounted for without, on the other hand, reducing the difference that sets music apart from painting and sculpture. Is it, then, in such a fashion—and not as mere emptiness—that the abstract subjectivity presented in music is to be understood? Furthermore, is it because music presents such an opening onto the world that spatiality flows back—in a distinctive form—into music itself? For much of the language used in speaking of music—oriented especially by the difference between high and low tones—suggests that music itself engages in a certain imitation of spatial figures.

>>> <<<

The freedom that music enjoys is both distinctive and dangerous, setting music apart from the other arts while also exposing it to a unique threat of degeneration. Because music is released from all bonds to existent objects and their typical configurations, because, except as a vanishing moment, tone is nothing other than subjective, what counts for music is the proximity to inner life; to music, as to subjectivity, there belongs a tendency to detach itself from every determinate content. Or rather, to express it with the proper directionality, music can turn above and beyond any given content, soaring above everything that would bind it to determinateness. It is to this capacity for flight beyond content that Hegel refers in saying, according to a transcription of the 1823 cycle, that music is "for itself without content."[22] Furthermore, there is an appropriateness in representing this movement beyond content as a peculiar verticality, as a matter of flight beyond, of soaring beyond, every determinateness. Indeed it will turn out that this representation is more analogical than simply metaphorical.

 The escape from content can become a flight of musical phantasy, which is itself an almost paradoxical hybrid, bound in its very freedom to the rigorous mathematical laws of musical form. The exercise of such phantasy can develop in such a way that liberation from restriction becomes virtually an end in itself, as, moving in a sphere where inventiveness and law, freedom and necessity, are almost perfectly blended, the composer develops and interweaves themes and counterthemes virtually

 22. "Für sich selbst inhaltslos." The phrase occurs in Hotho's transcription of the 1823 cycle (*Vorlesungen über die Philosophie der Kunst: Berlin 1823*, 265).

without restriction, following up with his inventiveness the tonal possibilities delineated by the manifold of harmonic principles.

Yet when this tendency goes unchecked, it threatens to render music "completely spiritless,"[23] hence "empty, meaningless" (A 2: 271/902). Since spiritual content and expression is required for art as such, the overdevelopment of music in this direction broaches the danger that what is produced will cease altogether to be art, that it will degenerate into a mere display of skillfulness in handling the purely musical element, a kind of musician's music incapable of appealing to the general human interest in art. In the *Aesthetics* there is the suggestion that recent music has tended toward such overdevelopment, that it has retreated into the purely musical element, and that thereby it "has lost its power over the whole inner life" (A 2: 269/899). Yet, even if this devaluation of recent music is indeed the verdict of Hegel himself[24] rather than an interpolation by Hotho, there is not the slightest indication as to which composers he might have had in mind. Rossini is almost the only composer Hegel mentions who could be considered contemporary, and his letters attest unmistakably to his admiration for Rossini. Even in those passages of the *Aesthetics* where other composers are mentioned by name, there is evidence of interpolations by Hotho,[25] though most of those included could hardly be considered recent. On the other hand, a century later, such overdevelopment of the purely musical element and the consequent restrictedness of appeal would become, in the view of many critics, the source of a profound crisis in music, one that, despite recent mutations and innovations, continues to determine much of our musical landscape.

To prevent music from succumbing to this threat, it would not suffice merely to limit the extent of the composer's development and interweaving of themes, figures, or motifs. Such a limit could not but prove in the final analysis arbitrary; and the insistence on such a limit could not but be countered by the observation that some of the very greatest composers, Bach, for example, were masters of contrapuntal inventiveness. What is required, rather, is that music not retreat into the purely musical element, that it not become isolated in a sphere that no longer admits the possibility of such spiritual presentation as constitutes the very essence

23. *Vorlesungen über Ästhetik: Berlin 1820/21*, 288.

24. There are passages in the transcriptions that would support this supposition, for instance the following from the 1820–21 cycle: "Especially in recent times music has become more independent; but what is natural is the music that accompanies song. To the extent that music becomes more independent, it loses its power over the mind" (ibid., 281).

25. See Gethmann-Siefert, "Das 'Moderne' Gesamtkunstwerk," 196.

of art as such. What is required is that music remain appropriately dis-
closive, that it remain, in its proper way, sensible presentation of spirit.
Its proper way to present spirit is by way of tones, by the configuring
of tones in accord with the formal principles of music; and spirit in the
guise in which music, as a romantic art, would present it is the inward-
ness of subjectivity.

A passage in the *Aesthetics* addresses this requirement quite precisely:
the proper task of music is to present spiritually a certain content, not as
this content occurs in consciousness in the form of a general idea, not as
a determinate external shape either present to intuition or made to ap-
pear by art, but rather "in the way in which it becomes vital [*lebendig*] in
the sphere of subjective inwardness" (*A* 2: 272/902). Thus, while tending
to detach itself from all content, music has precisely as its task to adhere
to a certain content so as to present it. This content to which music is to
retain a certain bond is neither a general idea nor an external shape. It is,
rather, the inner life itself, the inner life as such without further content,
simply in its vitality (*Lebendigkeit*). Hence, the *Aesthetics* describes the
task of music, considering it, first of all, quite independently of whether,
as in song, it is allied with words and hence with ideas: "The difficult task
assigned to music is to let this intrinsically veiled life and energy resound
[*wiederklingen*] for itself in tones" (*A* 2: 272/902). At the most undifferen-
tiated level, music presents spirit in its inwardness as such, presents it by
way of the sounding of tones. Thus, the *Aesthetics* explicitly identifies the
content of musical expression as the inner life (*das Innere*) and its form
as the purely transitory tones (see *A* 2: 275/906). What is decisive is that
the sounding of tones lets the inward spirit resound in such a way that it
is sounded in its depth. Through this complex of soundings, the inward
spirit is presented, disclosed, as such.

As observed above, both the *Aesthetics* and the *Encyclopedia* seek to
demonstrate that the sounding of tones originates from the vibration of a
cohesive material. Indeed, even though the tones are capable of soaring be-
yond the material instrument that produces them, they are so closely al-
lied to the vibratory motion that they are virtually indistinguishable from
it and in fact in at least the one relevant passage cited above are identified
with this motion. One could, then, extend this identity to the receptive
side, even though it must be acknowledged that such an extension is not
explicitly marked in the relevant texts. Then, to say that the sounding of
tones lets the inward spirit resound would mean that this inner life is set
vibrating by the tones, or rather that the very reception of the tones is at

once the energizing of inner life, whose movement, analogous to that of the vibrating instrument, takes the form of feeling.[26]

Such is, then, the task of music at the most undifferentiated level. Yet, while music as such does not present spirit in the form of a general idea, music can—and readily does—come to be allied with words and ideas; indeed, as song it is always already allied with words and ideas. When this happens, then, according to the *Aesthetics*, music adds to these words and ideas, indeed redoubles them, casting them in another guise: for the task is "to immerse the ideas into this element"—that is, the element of music at the undifferentiated level—"in order to bring them forth anew for feeling" (*A* 2: 272/902). Far from superseding the soundings of music as such, the words and ideas are set to music, immersed in its soundings in such a way that they too begin to sound musically.

Although he sets aside the ancient tales about the all-powerfulness of music, Hegel grants that the power of music is elemental (*elementarisch*); and in order to account for this elemental power, he ventures an analysis of the connection between subjectivity and time, which he takes as the universal element of music.[27] At the undifferentiated level at which Hegel situates the initial account of music as it resonates in the inner life as feeling, there is as yet no separation between the inner feeling and an objective felt content. While at this level subjectivity is thus a unity, its unity is one not of subsistence, of mere perdurance, but rather of active self-unification. What happens in this process is that the subject makes itself its object, then cancels this objectivity in its otherness from the subject, and so, recovering itself in this other, affirms its subjective unity. Yet, since nothing really objective is yet distinguished from the subject, there is no concrete determinate other from which, in recovering itself, the subject can become determinate. Thus its self-identity remains abstract and empty; it remains undifferentiated feeling.

What is decisive is that the same process is at the core of time. The juxtaposition of things in space, their three-dimensionality, is obliterated and drawn together into a point of time, into a *now*. But this point of time

26. In the philosophy of subjective spirit, Hegel describes the feeling soul in its immediacy as being set in vibration (*durchzittert*) (*Enzyklopädie*, §405).

27. All these themes are found already in the 1820–21 cycle. According to the transcription, Hegel speaks of "the elemental power of music" and of "the connection of music with time" that results from the *Aufheben* of the spatial. He refers also to Orpheus, observing that the civilizing effect of this legendary figure could not have been achieved "merely through tones" (*Vorlesungen über Ästhetik: Berlin 1820/21*, 279f.).

proves at once to be its own negation: as soon as this *now* is, it ceases to be and passes into another *now*. No true unity is established between the first *now* and the second *now*, for time is pure externality, that is, every *now* is outside every other *now*. Nonetheless, as with the undifferentiated feeling subject, a certain abstract, empty unity results, for the *now* always remains the same in its alteration. It is always now, every point of time is a *now*, and, regarded merely as points of time, the *nows* are entirely undifferentiated. Thus, in the case of time, as in that of subjectivity, there is the same process: an empty positing of itself as other and then a canceling of this otherness such that unity is restored. Furthermore, there is nothing that subsists in and through this process, nothing substantial; hence, in both cases there is nothing but the process, the very same process. Thus, not only does the subject prove to be in time, but, more fundamentally, the subject turns out to coincide with time; at this undifferentiated level of feeling, subjectivity is, like time itself, nothing but the positing of itself as other and the *Aufhebung* of this otherness. In the words of the *Aesthetics:* "The I is in time, and time is the being of the subject itself." Because of this identity and because time is the very element of tone, "tone penetrates the self, grips it in its barest existence, and sets the I . . . in motion" (*A* 2: 277/908)—presumably, granted the extension ventured above, a vibratory motion in which the subject is displaced into its other only to return to itself, vibrating like the strings of a violin. Thus it is that music has elemental power.

One could say, then, that music is elemental, not by disclosing something elemental in nature, but rather by penetrating to the depths of the self so as to let the elemental within us resound. Yet, if account were taken also of the distinctive spatiality of music, hence of a certain intervening or interpolation of a spatial moment within the operation of time and of the sounding of tones in time—as in the case of a tone that continues to echo after it has ceased actually sounding—then the question would be whether in sounding the elemental depths of the self music might also offer an intimation, however remote, of the elemental in nature.

>>> <<<

Sounding is momentary. Even if a tone is extended in and through an echo, it soon vanishes. Unless it is sounded anew, it is replaced by silence. For this reason a musical composition requires repeated reproduction, or rather a musical work *is* only in being produced anew. Music requires performance. Furthermore, performance is not mere repetition, as if there were an original that had only to be repeatedly instantiated. Rather, the performer must animate the musical work, must lend his own inner life to the work. Such is, as the *Aesthetics* says, the deeper significance behind the necessity of

performance: in performance "the expression must be the direct communication of a *living subject*, who puts into it the entirety of his own inner life" (*A* 2: 279/909).[28]

Sounding requires instruments capable of producing pure tones. Only one instrument is provided directly by nature: the human voice. All other instruments must be fabricated. Unlike the preparation of materials required in such arts as sculpture and painting, the fabrication of musical instruments is, for the most part, a complex process. In this respect music is—aside from song—the least natural art, the art that requires for its very means the most thorough transformation of natural materials of the most diverse sorts, wind instruments being fashioned from wood or metal shaped into a tube, strings being made from catgut or metal, percussion instruments from all manner of materials.

But the freest and most complete instrument, also the most natural, is the human voice. Its completeness stems from the fact that it combines the character of wind instruments and of string instruments: for the voice is breath flowing across the vocal cords. Most remarkably, the *Aesthetics* posits a perfect parallel between carnation and the human voice: just as the color of human skin (according to the analysis given in connection with painting) contains all the colors and so is the most complete color, so likewise "the human voice contains the ideal totality of soundings, which is merely spread out among the other instruments in their particular differences" (*A* 2: 291/922).[29] It is for this reason that the human voice blends most easily and most beautifully with other instruments. And yet, if in this respect music reaches its perfection in the human voice, it also undergoes a decisive displacement. For, in song, words and hence the ideas signified by those words are added to music. Even though, dipped in the element of music, the words and ideas are redoubled, nonetheless they draw music beyond the sphere in which its sounding presents and sounds the depths of undifferentiated inner life, that is, beyond the sphere of music simply as such. When music becomes song—and this it will of course always already have become—there is added to its subjectiveness the objective subsistence engendered by words and ideas.[30]

28. According to a transcription of the third cycle, Hegel says that in singing, in particular, "the soul of the performing artist is more freely elevated; it is the free soul of the individual that one sees there before one's eyes" (*Philosophie der Kunst: Vorlesung von 1826*, 222).

29. This analysis is also found in the Pfordten transcription (ibid., 218f.).

30. Referring to the Kehler transcription of the 1826 cycle of lectures, Gethmann-Siefert notes that the advent of song both bestows on music an objective subsistence and draws it beyond the mere art of tones ("Das 'Moderne' Gesamtkunstwerk," 189).

When music lets the inner life resound, there is a doubling, for in resounding it resounds *for itself*. While, on the one hand, the advent of song drives music beyond the pure sounding of inner life, it is, on the other hand, in the human voice that this doubling is most perfectly enacted. In the words of the *Aesthetics*: "At the same time, the human voice can apprehend itself as the tones of the soul itself, as the sound that the inner life has in its own nature for the expression of itself, an expression that it regulates directly. . . . In song the soul sounds forth [*herausklingt*] from its own body" (*A* 2: 291/922). As the soul sounds forth, it hears itself immediately, and in that audition there is an immediate resounding that sounds the depths of the soul. To be sure, in playing an instrument, one hears the sounds produced, and, as with all music, those sounds resound in one's interiority. But there is lacking the immediacy that occurs when, as always in song, one hears oneself singing.

In music—and most immediately in song—the inner life sounds forth for itself. In this doubling, this apprehension of itself, it finds satisfaction. However, this satisfaction occurs only insofar as one does not simply remain immersed in the feeling that music engenders, in the passions and phantasies that pour forth in tones. In the words of the *Aesthetics*: "Music should lift the soul above this feeling in which it is immersed, make it hover [*schweben*] above its content, and so form for it a region where a withdrawal from this immersion, the pure feeling of itself, can occur unhindered" (*A* 2: 308f./940).[31] In the end everything depends on this elevation through which one comes to hover in the pure feeling of oneself, hearing oneself resound in a manner comparable to "pure light's

31. There is a parallel passage in the transcription of the 1820–21 cycle of lectures. Hegel speaks of how music arouses passions and expresses particular joys, sufferings, etc. Then he continues: "but at the same time the soul should lift itself into regions where it withdraws itself from this particularity." Music "does not merely draw us into this feeling, but rather the soul should rise above this, enjoy itself. It is the character of great music that it does not stream forth desiringly in a Bacchic manner but rather in such a way that the mind is also in itself soulful [*seelig*], like a bird in the air" (*Vorlesungen über Ästhetik: Berlin 1820/21*, 289f.). It should be noted that in the text of the *Aesthetics* the description of this uplifting music is followed by a passage observing that music cannot rest content with such purity but must advance to the expression of the particularities of concrete inner life (*A* 2: 309f./940f.). However, in the transcription of the 1820–21 lectures, the entire account of music concludes with the description of such pure music and makes no reference whatsoever to the need of an advance beyond it. Whether the insistence on this advance originated from Hegel himself or was interpolated by Hotho in order to "round out" Hegel's account is uncertain. In any case, even in the text of the *Aesthetics*, there is an indication of a still further advance that, formulated in terms of melody, leads to the preservation, within the particularization, of pure melody, which corresponds to the uplifting music described earlier and which in the later passage is designated as "the bearing and unifying soul" of music (*A* 2: 317/948).

vision of itself" (A 2: 309/940). That moment within music that engenders such elevation, letting one soar into the region of the pure feeling of self, constitutes the genuine song in a musical work.[32] For, above all, it is song, in which one hears oneself singing, that allows one to hover above in the pure delight of its sounding. As "the bird on the bough or the lark in the air sings cheerfully and touchingly just for the sake of singing" (A 2: 309/940).

32. See also *Vorlesungen über Ästhetik: Berlin 1820/21*, 289f.

Preposterous Ascents:
On Comedy and Philosophy

> And those things do best please me
> That befall prepost'rously.
> —Puck, *A Midsummer Night's Dream*

Almost as if while absent from the scene, almost as if suspended above it, almost as if simulating the ancient comedic image of the philosopher and letting it mutate as it does in the history of philosophy, I will venture to release here an engagement between comedy and philosophy, to let such an engagement be enacted, translated repeatedly from text to scene, and played out on those scenes, set forth before our almost detached vision. Such an enactment will require, in the first of its four segments, letting comedy address philosophy, exhibiting a moment of comedy as it, in its own way and with the economy proper to drama, engages a philosophical discourse. In the second segment philosophy will, in turn, be brought to address comedy with the generality proper to philosophy and with a different, more analytical, more extended economy. Yet it is imperative, whatever its claim to autonomy, that the philosophical account not remain simply detached in its generality but that it be confronted with comic drama and thus compelled to prove itself while also perhaps being brought to bear on possibilities of comedy that it will only have intimated. Yet comedy not only can address—and be addressed by—philosophy but also can inhere as a moment within philosophy; the third segment will display in certain exemplary philosophical texts how comedy belongs to philosophy. The final segment will reverse this inherence and show how it can also happen that philosophy belongs to comedy, that a properly philosophical discourse—and not just its ludicrous double—can come to function in the texture of a comedy.

>>>><<<

First Segment.

It would not be out of the question to construe the scene of Bottom's soliloquy, in Act 4 of *A Midsummer Night's Dream*, as a kind of comedy on philosophy, as a ludicrous parody of philosophical discourse. Prior to this scene Bottom, in his translated condition, doted on by the fairy queen, had announced, with typical malapropism:

I have an exposition of sleep come upon me.
(*D* 4.1.38)

As, then, Bottom was sleeping in Titania's flowery bed, at first in her arms and then after her awakening, loathed by her, Puck finally removed the ass head from him. It is when Bottom then awakens to discover that his fellow mechanicals have abandoned him that he delivers his soliloquy. The deed itself, a soliloquy intoned by such a preposterous character as Nick Bottom the weaver, already broaches comedy.

 I have had a most rare vision.
I have had a dream, past the wit of man to say what
dream it was. Man is but an ass if he go about to
expound this dream.
(*D* 4.1.203–6)

Yet it is only as he continues that this weaver turned visionary, just relieved of his ass head, comes to articulate—or rather, to disarticulate—a discourse on sensibility:

 The eye of
man hath not heard, the ear of man hath not seen,
man's hand is not able to taste, his tongue to conceive,
nor his heart to report, what my dream was.
(*D* 4.1.209–12)

As he resolves to have inscribed and set to music this dream that surpasses all the senses, this supersensuous dream, this dream even, perhaps, of the supersensuous, he bestows on his dream a title that, beneath it, opens an abyss. Bottom's declaration of this title forms the climax of his comical, parodically philosophical soliloquy:

I
will get Peter Quince to write a ballad of this
dream: it shall be called "Bottom's Dream," because
it hath no bottom.
(D 4.1.212–15)

Bottom concludes by promising to sing it at the end of the play that the
mechanicals are to perform before the Duke, indeed at the most tragic mo-
ment of the play, that of Thisbe's death. Yet both this promise and the
connection with tragedy dissolve into thin air, or rather into the laughter
and jollity with which, without Bottom's having sung any such ballad, the
play within the play is received and the play itself moves toward its end.

>>> <<<

Second Segment.
Such comedy of philosophy has its counterpart from the side of phi-
losophy. As such comedy comes, in its own way, by parodic enactment, to
bear on philosophy, so, taking distance, philosophy poses to comedy the
question that, stopping comedy in its tracks, silencing the laughter, is, on
the other hand, proper to philosophy, the question τί ἐστι?, the question of
what comedy is. Yet the distance must be limited, the theoretical remove
mediated by experience, if the question is to be pursued concretely.

Thus it is not insignificant that the author of the most comprehensive
of all philosophical discourses on art was also an avid theatergoer. Dur-
ing his years in Berlin, the years in which he presented the four cycles
of lectures on the philosophy of art, Hegel is known to have frequented
the theater. Also, during his extensive travels in the 1820s, he had the op-
portunity to attend performances by some of the best theater companies
of the time. From the letters that he wrote to his wife during his visit to
Paris in 1827, we know that Hegel saw a great many plays while there and
that he was especially impressed by what he saw of Molière (for instance,
Tartuffe) and of Shakespeare. At the time of Hegel's visit, the actor Charles
Kemble and his English company from Covent Garden were performing at
the Odéon Theatre. In a letter dated September 19, 1827, Hegel writes to
his wife about a performance of *Othello* he had seen the day before. He
contrasts the performance with the performances of Shakespeare seen in
Germany and observes that "what is most striking are the frequently aris-
ing, deeply persistent, slowly solemn or even growling tones and speech—
like the growling of a lion or tiger." Hegel notes that "much of this comes
from the nature of the English language." Yet he adds: "I understood most

of it, since I read along word for word in my little book." [1] Though he found the English company's performances of Shakespeare provocative, Hegel did not entirely endorse them. Thus a couple of days later he reports having seen *Romeo and Juliet* performed by the same English company. Hegel is especially critical of Kemble's portrayal of Romeo: "I have now seen English rage in its entire splendor. The way they botch Shakespeare is wondrous." [2] From the account that Hegel goes on to give, it is clear that he was intimately familiar with the play.

Like others of his generation in Germany, Hegel held Shakespeare in the highest esteem. Near the end of the *Aesthetics* he declares that there is "scarcely any other dramatic poet who can be compared with Shakespeare"; and noting that the English are masterly at presenting characters who are fully developed human individuals, Hegel adds: "and above them all Shakespeare stands at an almost unapproachable height" (A 2: 577f./1127f.). In the *Aesthetics* hardly any other poet figures more prominently than Shakespeare, and Hegel discusses and cites from many of the plays, especially the tragedies and the histories. There is also reference to Shakespearean comedy, Hegel observing, for instance, that in contrast to the work of certain contemporary dramatists, "Shakespeare had great and deep humor" (A 1: 289/295). Most significantly, at the very end of his discussion of drama, hence at the very end of the *Aesthetics* itself, Hegel notes that the modern world has developed a type of comedy that, as he says, "is genuinely comic and poetic" and that parallels in the modern world what Aristophanes achieved among the ancients. As a "brilliant example" he names Shakespeare yet forgoes characterizing such comedy more specifically.

Philosophy of art neither begins at the beginning nor does it, in the end, quite return to the beginning. As it begins, there are presuppositions that lie outside the discipline, so that in taking up the concept of art it can only do so, as Hegel says, "lemmatically" (A 1: 35/24). This lemmatic character comes into play not only at the beginning, in the elaboration of the concept of the beautiful and of art in general, but also at various junctures in the course of the *Aesthetics* when Hegel turns to the determination of a particular form of art. In the case of dramatic poetry the concepts presupposed are those of substance and subject in the specific forms in which, in their harmony, they determine the essence of true action. The moment of substance is the basis of the mundane actualization of the divine as

1. *Briefe*, 3:190 (no. 562).
2. Ibid., 3:192.

the genuine content of individual character and aim; over against this stands the moment of subjectivity in its unfettered self-determination and freedom.

In drama, as in every artwork, what is essential is that the true as such, in its absoluteness, be sensuously presented. In drama the sensuous presentation is double, taking place both through the action and scene beheld by the spectators and through the inward representations evoked by the poetry itself and coalescing harmoniously with what is beheld on stage. Yet the presentation can, as Hegel observes, take two very different forms depending on whether the dominant moment in the presentation is the substantive basis or the freedom of subjectivity, which apart from the substantive basis can only assume the form of subjective caprice, folly, or perversity. If substance dominates, then the drama is tragic; if subjectivity is dominant, then the result is comedy. In tragedy different moments belonging to the substance of ethical life come, when actualized, into opposition and collision; through the tragic resolution of the conflict, through the destruction of the one-sided individuals, the eternal substance of things emerges victorious, conveying a sense of reconciliation and of eternal justice. In comedy, on the other hand, it is subjectivity in its unlimited assurance that retains the upper hand. In comedy, as in tragedy, there is collapse, dissolution; but in comedy the dissolution occurs in laughter, the characters dissolving everything including themselves in laughter, precisely thereby assuring the persistence of their own self-assured subjectivity.

What counts primarily in comedy, as in tragedy, is the relation of the drama to the substantial. Whereas tragedy is immersed in the substantial and issues in its restoration, it is precisely the lack of substance or the empty pretense of substance that determines comedy. Because there is only lack or pretense of substance, the characters in comedy cannot achieve any substantial aims; their efforts are bound to fail, and as everything around them collapses they become laughable. Yet characters are truly comic and comedy genuinely occurs only when the self-assurance is so boundless that, with utter lightheartedness, they can blissfully bear the frustration of all aims and the collapse of every achievement.

Hegel outlines two basic kinds of situations that can serve for comical action.[3]

3. Hegel mentions also a third kind based on external circumstances but leaves it entirely unelaborated.

The first kind corresponds to lack of substance. The typical situation is one in which both the characters and their aims are entirely without substance and in which, as a result, nothing can be accomplished. The situation is one in which trivial and narrow-minded aims are undertaken with a show of great seriousness and/or elaborate preparations; yet precisely because the aim is totally lacking in substance, the failure to achieve it is not the ruin of those who ventured it, but, on the contrary, they can, as Hegel says, "surmount this disaster with cheerfulness undisturbed" (A 2: 553/1201).

Comedies based on such a situation are not hard to find, but in Shakespeare's plays there is perhaps no more perfect example than the scenes in *Much Ado about Nothing* that involve Dogberry and his sidekick Verges. Dogberry is a constable, and he and Verges first appear in a scene in which they are assembling the watchmen for the evening and giving them their charge. That these two are considerably less than substantial characters is signaled by their slightly ludicrous names[4] as well as by their malapropisms, for instance inadvertently using the word *salvation* when what is meant is exactly the opposite, *damnation*. Complimenting one member of the watch for his fitness to serve, Dogberry declares:

> You are thought here to be the most senseless
> and fit man . . . —
> (M 3.3.22–23)

and he urges this man to comprehend—he means to say "apprehend"—all vagrants. Indeed the instructions that with a show of great seriousness Dogberry conveys to the men of the watch amounts to patent nonsense; it is indeed, one could say, much ado about nothing. When one of the men asks what they should do if an apprehended vagrant refuses to stand, that is, to halt, Dogberry replies:

> Why then, take no note of him, but let him go, and
> presently call the rest of the watch together, and
> thank God you are rid of a knave.
> (M 3.3.28–30)

4. *Dogberry* refers to the fruit of the dogwood shrub. *Verges*, contracted from *Verjuice*, refers to the acid juice of green, unripe fruit.

That his aim of instructing the watch is utterly without substance be-
comes all the more evident when, shortly before he and Verges leave the
men to themselves, he declares:

> for indeed the watch ought
> to offend no man, and it is an offence to stay a man
> against his will.
> (M 3.3.78–80)

For then, wishing the men adieu, he says, quite to the contrary:

> Be vigilant, I beseech you.
> (M 3.3.92)

What's more, he remains blissfully untouched by the nonsense he utters,
boundlessly self-assured as he advises the watch:

> Ha, ah ha! Well, masters, good night: and there
> be any matter of weight chances, call up me[.]
> (M 3.3.82–83)

Dogberry and Verges are no different in the later scene when, after two
rogues have in fact been apprehended, they appear before Leonato, gover-
nor of Messina, to inform him of the rogues. Yet in the later scene their
show is not only of great seriousness but also, even more, one of elaborate
preparation, in the form of inability to get to the point; their ludicrous de-
ferral is precisely what, in this scene, propels the comedy forward. As the
scene begins, Leonato asks that they be brief. Their responses are totally
vacuous until, urged on by Leonato, Dogberry launches into a ludicrous
apology for his sidekick:

> Goodman Verges, sir, speaks a little off the
> matter: an old man, sir, and his wits are not so
> blunt as, God help, I would desire they were, but, in
> faith, honest as the skin between his brows.
> (M 3.5.9–12)

It is not long before Leonato informs them that they are tedious. Then,
after still more irrelevancies, he says impatiently:

I would fain know what you have to say.
(M 3.5.28)

Verges touches obliquely on the message, but then Dogberry picks up again his tedious apology:

A good old man, sir, he will be talking; as they
say, 'When the age is in, the wit is out,' God help us,
it is a world to see! Well said, I' faith, neighbour
Verges; well, God's a good man, and two men ride
of a horse, one must ride behind.
(M 3.5.32–36)

On and on he babbles until, out of patience, Leonato prepares to leave. Only as he is leaving does Dogberry put aside the digressions, the interminable preparations, though too late to achieve their goal of having the rogues examined by Leonato. Yet in true comic fashion, Dogberry and Verges are boundlessly self-assured as, told by Leonato to examine the rogues themselves, they set off to do so:

Dogberry. We are now to examination these men.
Verges. And we must do it wisely.
Dogberry. We will spare for no wit, I warrant you[.]
(M 3.5.55–57)

There is another kind of situation that, by Hegel's account, can serve for comical action. This second kind of comedy involves a situation in which there is not simply lack of substance, as with the first kind, but rather a pretense or show of substance, even an aim perhaps that is not simply insubstantial. Such comedy turns, then, on the incapacity of the characters to achieve the aim, on the inevitable downfall coupled with their own unbounded lightheartedness, which allows them to remain self-assured above all that collapses around them. Though Hegel describes the situation of such comedy as the converse of that which produces the first kind, it proves in fact to be a more complex situation, one capable of generating a more manifold and developed comedy, even perhaps just that type of comedy to which Hegel, referring to Shakespeare, accords the honor of paralleling in the modern world what Aristophanes achieved among the ancients.

Among Shakespeare's plays there is perhaps none that more thoroughly exemplifies such a comedic situation and the dramatic possibili-

ties it opens up than *A Midsummer Night's Dream*, preeminently the scenes involving Bottom and his fellow mechanicals. The situation required for this kind of comedy must be, according to Hegel, one in which the characters plume themselves on their substantial quality, in which they give themselves airs of being substantial characters. This is precisely the bearing exemplified by Bottom from the very beginning of the play. When, in Act I, the mechanicals assemble at Quince's house to be assigned their parts and given their scripts, Bottom's first action, in response to Quince's query as to whether all are there, is to tell Quince, with utter self-confidence, how things ought to be done:

> You were best to call them generally, man by man,
> according to the scrip.
> (D 1.2.2–3)

That he is giving himself airs, not like someone who knows that in fact he is otherwise but with full confidence that he is just as substantial as he gives himself airs of being, is hinted at by the malapropism, the first of many, in this case his saying *generally* while meaning *individually*. Once Quince identifies the play they are to perform as "The most lamentable comedy, and most cruel death of Pyramus and Thisbe," he instructs Bottom that he, Nick Bottom, is to play Pyramus. Bottom launches into a speech about all the tears the audience will shed if he plays the ill-fated lover. As he goes on to speak of his preference for playing Ercles—that is, Hercules, a role notorious for ranting—his speech mutates into a performance of just this ranting role:

> The raging rocks,
> And shivering shocks,
> Shall break the locks
> Of prison-gates;
> And Phibbus' car
> Shall shine from far
> And make and mar
> The foolish fates.
> (D 1.2.27–34)

Then, his performance finished, he adds:

> This was lofty.
> (D 1.2.35)

As casting continues, Bottom's unknowing pretense propels the comedy. When Quince instructs Flute that he is to play Thisbe, Bottom exclaims—contrary to all possibility—that he could play Thisbe too. He launches into performing the part "in a monstrous little voice," addressing Pyramus and thereby demonstrating—unintentionally no doubt—the impossibility of playing both roles at once. Then, again, when Quince casts Snug as the lion, Bottom wants to play the lion too, promising that he will roar furiously or, if that would frighten the ladies, that he would roar as if he were a dove or a nightingale. At this point Quince tells him sternly:

> You can play no part but Pyramus[.]
> (D 1.2.79)

And Bottom, self-confident as ever, replies:

> Well, I will undertake it.
> (D 1.2.83)

Yet it is not only in his own eyes that Bottom is an actor of real substance. Peter Quince and the others too have such regard for him, as is evident later in the play after they have returned from the woods and are lamenting that, since Bottom cannot be found, the play cannot go forward. In the words of Quince himself:

> You have not a man in all Athens
> able to discharge Pyramus but he.
> (D 4.2.7–8)

Yet even the others too Quince describes—at the initial gathering at his house—as those who are

> thought fit through all Athens to play in our interlude
> before the Duke and the Duchess, on his
> wedding-day at night.
> (D 1.2.5–7)

Day and night are not of course the only things that will get comically mixed up in the course of the play.

With Bottom and the others there is, then, a kind of vanity of substantiality, a vanity of being substantial actors, the only ones through all of

Athens fit to perform the play before Duke Theseus and his soon-to-be Duchess Hippolyta in their wedding celebration. Yet, regardless of how fit or unfit they may prove to be for their new role of playing roles—for they are of course not actors but

> Hard-handed men that work in Athens here,
> which never labour'd in their minds till now
> (D 5.1.72–73)

—their aim is serious and is undertaken in earnest. What they aim to do, to entertain the Duke and Duchess at the wedding festivities, is something substantial. This substantiality is underscored, in precisely the terms suited to these hard-handed working men, namely, in terms of money, when, lamenting that the play cannot go forward without Bottom, they speculate that Bottom will have lost being paid sixpence a day for playing Pyramus. If their aim fails to be realized, if in the end their efforts only bring about the collapse of the entire undertaking, it will not have been because the aim was insubstantial.

Rather, it will have been, in Hegel's words, because "as instruments for accomplishing something substantial their characters are the precise opposite of what is required" (A 2: 553/1201). No matter how earnestly such individuals set about to achieve the substantial goal, their very character proves, by virtue of what it is, not to be on the level of such goals; indeed their character proves to be at the pole opposite the spiritual, ideal content that would be realized in the accomplishment of a genuinely substantial goal. In contrast to every action or work by which the spiritual would be actualized in the mundane, these characters and their deeds are simply mundane and mundanely simple. Hegel writes that "the comical therefore plays its part more in people of lower standing, tied to the present and to what is actual" (A 2: 571/1220f.); and though Shakespearean comedy is not limited to the low life, the comedic character of A Midsummer Night's Dream relies primarily on these "hempen homespuns," as Puck calls them,

> A crew of patches, rude mechanicals,
> That work for bread upon Athenian stalls[.]
> (D 3.2.9–10)

Comedy, says Hegel, has its place largely in characters "who are what they are once and for all, who cannot be or will anything different, and,

though incapable of any genuine pathos, have not the least doubt about what they are and what they are doing" (A 2: 571/1221). Such simple self-identity and self-assurance could not be more perfectly exemplified than in Bottom and his fellow mechanicals. Each of them is indeed who he is. Each of them remains who he is even when he plays some role in "Pyramus and Thisbe," and this naive simplicity is perhaps the most significant factor in rendering the play-within-the-play so comical both as such, that is, to us as spectators, but also to those within the play who watch it, Theseus and his party. For instance, when Snug the joiner comes on stage as Lion, half his face will—provided he follows Bottom's instructions—be seen through the lion fell; and as if that were not enough to make it evident that he is Snug and not a lion, he has to inform the audience of his identity, telling them that he is Snug the joiner.

Such simple self-identity also serves to enhance the comical effect of Bottom with the ass head. For along with the preposterous mix-up of top and bottom, there is a thorough persistence of character. Even though his fellow mechanicals are frightened out of their wits, Quince exclaiming:

Bless thee, Bottom, bless thee! Thou art
translated[;]
(D 3.1.113–14)

even though they are so astonished that they cannot even name what they see on Bottom's head but must leave it to Bottom himself to utter the word:

I see their knavery: this is to make an ass of me[;]
(D 3.1.115)

still, Bottom with the ass head is still just Bottom and, when offered music by Titania, still wants to hear the tongs and the bones. At least he is almost just still Bottom—almost, one best say, because without the ass head he would perhaps not have come to deliver his soliloquy on sensibility.

The simple identity of the mechanicals is indicated even by their names, by the fact that their names say exactly who they are, say their trades, the trades to which they have stuck up to now, having never labored in their minds till now. Thus the proper name belonging to Bottom the weaver is also the common name of the object on which weavers wound their skeins of yarn. Quince the carpenter is named after quines, wooden wedges used by carpenters. The name of Snug the joiner means

compact, close-fitting, tight. Flute the bellows-mender is named after the fluted bellows used for church organs. Snout is a tinker, a mender of household utensils such as kettles, and his name means nozzle or spout. The name of Starveling the tailor refers to the proverbial thinness of tailors.

In their simple self-identity, the mechanicals are oblivious to the translations or transpositions that imagination effects in the theater. They have no sense for the imaginative transferals by which actors become the characters they play and the audience regards them, not as the individuals they actually are, but as characters in the drama. This obliviousness is especially evident when, gathered in the woods outside Athens, they discuss how they will perform the play they have come there to rehearse. On the one hand, they fear that the audience will take what is seen on stage as real rather than as something merely enacted. Bottom launches the discussion:

> There are things in this comedy of Pyramus and
> Thisbe that will never please. First, Pyramus must
> draw a sword to kill himself; which the ladies
> cannot abide.
> (D 3.1.8–11)

Starveling is ready to leave the killing out, but Bottom proposes instead that Quince write him a prologue explaining that Pyramus is not really killed and—here asserting his simple self-identity—that he Pyramus is not Pyramus but Bottom the weaver. Though in fact Quince says no such thing in the Prologue he actually presents when they perform the play, Bottom asserts his identity in other ways too, for instance by speaking at one point entirely out of character, informing Theseus that a certain phrase is in fact Thisbe's cue (see 5.1.182–83); though he is indeed playing Pyramus, Bottom is still Bottom and is prepared, with the slightest prompting, to make this evident.

The next subject of their concern is the lion, Bottom saying:

> to
> bring in (God shield us!) a lion among ladies is a
> most dreadful thing[.]
> (D 3.1.28–30)

Snout suggests another prologue, but Bottom's solution is that half Snug's face be visible and that he tell the audience who he is, for, like all the others, he is who he is and only who he is.

On the other hand, the mechanicals, in their simple self-identity, think that the audience will not be able to imagine anything not actually seen on stage, that everything must, in its simple self-identity, be actually present on stage. They are puzzled, in particular, about moonlight, about how it can be brought into the room, made actually present there, and about the wall that separates Pyramus and Thisbe, Snout exclaiming:

You can never bring in a wall.
(D 3.1.61)

For these characters it is an incalculable advance when finally they reach the decision to present or signify moonshine and wall.

The ineptness of such simple characters for performing the play is what propels the comedy, especially in the scene in which they are rehearsing in the woods. Malapropisms abound: *odorous* becomes *odious*, and *Ninus' tomb* becomes—both here and in the actual performance—*Ninny's tomb*, *ninny* being a synonym of *fool*. Flute especially plays—in his ineptness—the fool, speaking all his lines at once, advancing to a line addressing Pyramus directly by name before Pyramus has even reappeared on stage. Even when, later, with Bottom's return, the mechanicals prepare to set out for the palace to perform their play, the last-minute instructions given them by Bottom are indicative of how utterly untheatrical they remain. They are told to get new strings for their beards; Thisbe is to have clean linen, and the one who is to play Lion must not pare his nails. Bottom concludes:

And most
dear actors, eat no onions nor garlic, for we are to
utter sweet breath; and I do not doubt but to hear
them say, it is a sweet comedy. No more words.
Away! Go away!
(D 4.2.39–43)

Yet with all this ineptness—to say nothing else yet about the bungling of the performance itself—the mechanicals, above all, Bottom, remain boundlessly self-assured and lighthearted. Hegel writes that the characters in comedy, while being simply what they are, "reveal themselves as being of a higher nature in that they are not seriously bound to the finitude in which they are engaged but rather are raised above it and remain firm in themselves and secure in face of failure and loss" (A 2: 571/1221). No doubt, whatever the case may be with the performance, Bottom and the others are

raised above it and remain firm and secure in themselves. In fact, the mo-
ment the performance is over, Bottom, who as Pyramus has stabbed him-
self and died, stands up and offers some commentary to the audience. As
Flute, who as Thisbe is also dead, also rises, Bottom immediately offers
the audience the choice of an epilogue, which they decline, or a Bergomask
dance. Two of the mechanicals dance the dance, and then all are gone.

The question is whether, as Hegel's account would have it, this comic
elevation occurs, in this case, in face of failure and loss. Though comedy
may in many cases end, as Hegel says, with the downfall of the whole
finite sphere, with the collapse of the very thing at which the characters
aimed in their all too inept efforts, is this indeed the way *A Midsummer
Night's Dream* ends? Or, more specifically, is it the way the comedic se-
quence involving the mechanicals ends?

These characters are no doubt inept, insufficient for their aim of pre-
senting the play with which to entertain Theseus and his party on the eve-
ning of their weddings. And yet, the performance of the play does in fact
entertain Theseus and his party. When Quince presents the Prologue with
such confused punctuation that it makes either no sense or the wrong
sense, it elicits a series of amused remarks from the audience. And what
could be more amusing, especially when one sees it performed (as do those
in the play who are watching the performance), than Snout, playing Wall,
stretching out his fingers to represent the chink through which Pyramus
would look? It is likewise when Starveling appears carrying a lantern to
present the moon; again a series of amused and amusing comments by
Theseus and his party are elicited and testify that they are indeed being
entertained. Again, when Pyramus stabs himself and exclaims:

Now die, die, die, die, die[,]
(D 5.1.295)

and then dies, Theseus's retort is indicative:

With the help of a surgeon he might yet recover,
and prove an ass.
(D 5.1.298–99)

As the performance is about to begin, Theseus remarks:

Our sport shall be to take what they mistake[.]
(D 5.1.90)

And at the end, when the mechanicals have just left for good, he declares:

> This palpable-gross play hath well beguil'd
> The heavy gait of night.
> (D 5.1.353–54)

Because the mechanicals aimed to entertain Theseus and his party by performing the play, their very failure, their utter ineptness in performing it, turns into success. Though the play has the character of a tragedy, lover and beloved stabbing themselves to death, the complete bungling of the performance turns it into a comedy, so that it proves to be, as Theseus was informed at the outset, tragic mirth, merry and tragical—or, as Quince, unknowingly no doubt, first identified it: lamentable comedy. Or even, as Bottom hoped to hear: a sweet comedy.

Yet, above all, even when it would be most tragic, it is comedy. Because the comedy ends in comedy, in a comedy within the comedy, there is no downfall of the finite sphere, no collapse of what was aimed at, and the elevation of the comedic characters is not effected in face of failure and loss.

It is rather a purely comic elevation.

The question is whether it is just such pure comedy that Hegel envisages at the very end of the *Aesthetics* when he writes of a type of comedy in which the keynote lies in such features as exuberance, high spirit, and foolishness. Is it just such pure comedy, comedy issuing in comedy, that Hegel regards—or that one could regard—as accomplishing in the modern world what Aristophanes achieved among the ancients—perhaps even as accomplishing something never quite achieved among the ancients?

>>> <<<

Third Segment.

Comedy brings drama to its end. Indeed it brings about the dissolution of art as such. Comedy produces this result not simply as it itself expires, but rather at the moment when it reaches its pinnacle. This moment constitutes the end of the *Aesthetics* and is expressed by Hegel with utter succinctness: "Yet on this pinnacle [*Gipfel*] comedy leads at the same time to the dissolution of art as such" (A 2: 585/1236).

This dissolution is, in a sense, already under way in romantic art as such, and it is precisely in the wake of romantic art that it comes to completion. Romantic art already goes beyond what art as such can achieve: in this form of art, spirit has withdrawn from the ideal unification with the objective and the sensible that was achieved in the classical form of art,

above all, in classical sculpture. Though in romantic art there remains a moment of sensible externality, this moment no longer serves as an adequate external embodiment of spirit; what is now essential is that it provides a locus where the withdrawal of spirit from everything external can be traced. Yet, since art is nothing other than the sensible presentation of spirit, this withdrawal of spirit from sensible exteriority becomes, at the limit, its withdrawal from art as such. Thus, in Hegel's words: "In this way romantic art is the self-transcendence of art, but within its own sphere and in the form of art itself" (A 1: 87/80).

This self-transcendence enters its final phase with poetry, with which, as Hegel says, "art itself begins at the same time to dissolve and acquires for philosophical knowing its point of transition to religious representation as such as well as to the prose of scientific thought" (A 2: 335/968). Because poetry relies entirely on phantasy, because the images that are essential to it are those within, those of inner representation, everything external and sensible becomes unessential, at best only a secondary reinforcement of the images evoked within by poetry. Even in the case of dramatic poetry, everything external and sensible remains quite secondary, including the entire theatrical character that belongs to such poetry. What counts in drama is the inner world of images evoked by the poetic words, not the enactment of the drama on stage, not the visible spectacle of characters audibly sounding the words and mimetically embodying the actions. Entertaining this account momentarily, noting how little significance it accords to the theatrical character of drama, one readily thinks— perhaps with some amusement—of Hegel himself at the Odéon Theatre in Paris, watching a production of *Othello*, or rather, perhaps not watching so closely the scenes unfolding before his eyes, since, as he attests, he read along word for word in his little book.

With poetry, which "speaks to inner phantasy" (A 2: 336/969), the self-withdrawal of spirit from what is external and sensible is intensified to such an extent that all bonds to a specific content and a particular form of art are severed, poetry becoming, as Hegel says, the universal art. This very universality, which gives poetry a certain superiority among the arts, prepares art for its dissolution and for its passage into philosophy.

The withdrawal of spirit from external sensible presentation, initiated with romantic art as such and intensified in poetry, reaches its culmination, its pinnacle, in comedy. For in comedy there remains only withdrawal, only the collapse into detached subjectivity. In comedy even the traces of withdrawal, which romantic art and in a certain way even other forms of poetry retained, are dissolved in the laughter and jollity of the

preposterously ascensional subjectivity. Precisely as it reaches this pin-
nacle, art as such is dissolved.

Effecting in its very fulfillment the dissolution of art as such, comedy
does not simply vanish, but rather, detached from its character as art, it
passes into philosophy. Thereby comedy comes to belong to philosophy,
becomes—in whatever guise it assumes—inherent in philosophy. But how
does it belong to philosophy? How is there, within philosophy as such, a mo-
ment of comedy? At what points in its enactment does philosophy run the
risk of evoking laughter? At what junctures must the philosopher endure
the eruption of laughter? Is the laugher only to be endured? Or can the phi-
losopher perhaps join in, sharing the laughter and playing out the comedy?

No instance is more notorious than that introduced at the very center of
the *Theaetetus*. As in many other passages in this dialogue, this particular
discourse stages a scene on which something comes to be shown; in this
case it is allegedly shown what a philosopher is. The philosopher who is
summoned to appear on this scene is Thales, who makes his appearance
at just the moment when he becomes comical and evokes the derisive
laughter of the one looking on: "As Thales was studying the stars . . .
and looking up, he fell into a well, and a graceful and elegant Thracian
servant girl is said to have jeered at him, that in his eagerness to know
the things in the heaven he was unaware of the things in front of him and
at his feet" (*Theaet.* 174a). Thus the philosopher is presented as prepos-
terously ascensional, as casting his vision above while stumbling about
in the world around him here below, inviting the derision that common
sense with its servant girls directs at him. To the extent that the philoso-
pher remains purely ascensional, he is a comical figure; he cannot but play
a role, unwittingly, in a comedy.

Yet Thales is not the only philosopher who makes an appearance in the
Theaetetus. Not only is there Socrates himself, who presents the comic
scene and who does so in such a way as to mark its limits as a presenta-
tion of the philosopher; but also there is the young Theaetetus, the bril-
liant mathematician who, through interrogation of the flow of perceptual
things, is brought to wonder and thus is drawn into the beginning of phi-
losophy. The limits of philosophical ascendancy are also indicated by the
dramatic structure of the dialogue as a whole: to Thales' ascendancy as de-
picted at the center of the dialogue there is counterposed, both at the begin-
ning and at the end, a descent (κατάβασις), the narrator Euclides having
gone down to the harbor where he met the dying Theaetetus and then, at
the end, Socrates going off to hear the indictment that will lead to his trial
and death. Everything depends on appropriately conjoining the two op-

posed directionalities, on sustaining the upward vision while nonetheless affirming, even in one's very bearing, all that draws us back earthward. One who, like Thales, is oblivious to the latter and so falls involuntarily into a well will be, for those who look on, a comical character.

Although, in this specific regard, the overall structure of the *Republic* is similar, the account of philosophical ascendancy in the central Books is conspicuously conjoined with a descensional movement. The prisoner who escapes from the cave and makes his way upward so as finally to turn his vision heavenward submits also to the necessity of returning to the cave. Thus he is not a comical character in the way that the Thales of the *Theaetetus* is comical. And yet, he too would incur laughter: if he had to compete with the other prisoners in making predictions and judgments about the shadows passing by on the inner wall of the cave, then, at least until his eyes again grew accustomed to the darkness, he would be laughed at by the others for having gone up only to come back with his eyes ruined (see *Rep.* 517a). Returning to the cave, he would be blind—momentarily at least—to what is to be seen there, though not, like Thales, oblivious to it; on the contrary, he would have come to realize what the shadows in truth are, to recognize the images *as* images. Nonetheless, he would display a certain comical aspect as, with his eyes filled with light, he returned to the darkness.

Comedy would continue to belong to philosophy not only in the descent but also in the prisoner's movement upward out of the cave. For the eyes are also disturbed by the passage from darkness to light: as the prisoner turns his vision toward the cave entrance and then, making his way upward, steps out into the daylight and even casts his vision upward finally at the heaven, he will be "dazzled by the greater brilliance" (*Rep.* 518a–b). Blinded by the excess of light, he will be laughable, though Socrates remarks that such laughing would be itself less laughable than laughing at someone who returns from light to darkness. For those who might laugh at the dazzled escapee as he stumbles into the daylight would also themselves have escaped into the brightness of the region above and thus would comprehend the laughable phenomenon; whereas those who, within the cave, laugh at the returnee would have no such comprehension and in their foolishness would be themselves more laughable.

Thus comedy belongs to philosophy, not as a counterforce capable of overturning philosophy into comedy, but rather as a guise that philosophy may take on in its most demanding passages, a guise linked to the temporary blindness that may be incurred in such passages. Thus comedy may always, in any such passage, break out in philosophy.

What is remarkable is that in the Platonic dialogues comedy does not so much just break out but rather comes, at certain junctures, to be played out, thus regaining, through the dialogue form, its dramatic character. The comedies in the dialogues are played out alongside more rigorously dialectical passages and often are intimately linked to them in such a way as to show something that bears significantly on the dialectical passages. For instance, in the dialectical exercise near the beginning of the *Sophist*, the Stranger sets out to catch the sophist in the web of λόγος by means of the method of division. After five such catches, he sets out again, but in his sixth attempt he ends up delimiting the sophist as one who practices cross-questioning (ἔλεγχος). The Stranger's elaboration of what this practice involves tips the balance to the side of comedy: this would-be sophist "questions people about the things about which they think they are saying something when they are really saying nothing. He easily discovers that their opinions are like those of men who wander. . . . The process of freeing them from their opinions affords the greatest pleasure to the listeners and the most lasting benefit to those who are subjected to it" (*Soph.* 230b–c). Here the climax of the comedy occurs—as so often in comic drama—at the moment when the mistaken identity comes to light: though the Stranger went fishing for a sophist, the sophist who turned up in his net turned out to be not a sophist but a philosopher, indeed none other than Socrates. This comedic moment in the dialogue serves to bring something to light. By playing out the comedy within the search for the sophist, the Stranger brings to light the proximity of philosophy to sophistry, that is, the difficulty of establishing the distinction with a rigor capable of preventing all mixing of sophistry into philosophy.[5]

Thus the comedies within a dialogue serve to illuminate what is in question in the dialogue. If indeed they evoke laughter and mirth, these moments of jollity are not simply for their own sake but are submitted to the overall task of making something manifest; the laughter and mirth are evoked in such a way that, in and through them, a certain concealment or dissimulation is dissolved. A typical structure can be discerned in many of the dialogical comedies. At the moment the comedy is launched, there is a kind of abstracting from something essential; that is, something is disregarded that cannot ultimately be disregarded. This disregarding is in effect a way of enacting the temporary blindness that accompanies both

5. See my discussion in *Being and Logos: Reading the Platonic Dialogues*, 3rd ed. (Bloomington: Indiana University Press, 1996), 472–78.

the ascensional and the descensional passages of philosophy. On this basis the comedy is then played out to the point where the play itself shows dramatically that what the players sought to disregard cannot in the end be disregarded, that it inevitably returns to the scene as the comedy reaches its climax. One of the most transparent examples of such Platonic comedy is found in Book 5 of the *Republic:* here what is disregarded is eros, corporeality, sexual difference; the comedy played out by Socrates and Glaucon serves to bring to light the impossibility of excluding these moments of human being from a consideration of the polis and of the soul. This dramatically effected insight is what leads into the long digression on philosophy, which then effects the appropriation of this insight and which constitutes the core of the *Republic.* In this instance comedy proves to belong so intimately to philosophy that the playing out of the comedy is what first draws the philosopher into the discourse.[6]

It is remarkable that among the dialogues there are few that are richer in comedy than the *Phaedo.* It is as if the manifest relation of this dialogue to tragedy[7] made it all the more imperative to lighten it with the quiet merriment of some moments of comedy. An explicit indication regarding these moments is given at the very outset of the dialogue when Phaedo, who narrates the events of the dialogue, mentions that those who were gathered in Socrates' prison cell on his last day were "sometimes laughing, sometimes weeping" (*Phaedo* 59a). From those with even the slightest dramatic perceptiveness, laughter would no doubt have been evoked, for, despite—if not indeed because of—the proximity to tragedy, comedies abound in this dialogue and are played out to the point where their character as comedy becomes apparent and the disclosive return of what had been disregarded is accomplished. A single example will perhaps suffice to illustrate the subtlety and brilliance of the comic drama within this dialogue.

The comedy is enunciated by Socrates. Yet, in speaking, Socrates plays the ventriloquist, lending his voice to others who are not present. These others, the actual characters in the comedy who play it out by being lent the voice of Socrates, are called by Socrates the "true-born philosophers." The word γνησίως ("true-born") can mean either belonging to the true race or legitimate (as opposed to bastard—νόθος).

The comedy occurs within the context of Socrates' declaration that philosophers devote themselves to nothing but dying and being dead.

6. See ibid., 371–78.

7. On the relation of the *Phaedo* to tragedy, see my discussion in *Platonic Legacies* (Albany: State University of New York Press, 2004), chap. 8.

When Socrates voices this declaration, Simmias's response (so Phaedo reports) is to laugh and then to swear about his laughing. He says: "By Zeus, Socrates, right now I'm not much for laughing, but you did make me laugh" (*Phaedo* 64a–b). So, not only does he laugh, but he calls attention to his laughing, adding emphasis by swearing. As a result the word *laugh* (γελάω) occurs three times in the course of two short sentences. Could one doubt that the performance of a comedy is being prepared?

Simmias and his companion Cebes are from Thebes, which at the time was a haven for the Pythagoreans who had been driven out of Southern Italy. There is no mistaking their Pythagorean preconceptions. Also there is no mistaking the fact that Socrates speaks to these conceptions as he goes on to describe death as the separation or deliverance of the soul from the body. His very diction sounds Pythagorean as he continues by speaking of the two respects in which the philosopher strives for separation of soul from body and hence pursues death, wants to be dead. The first respect is pleasure. Whether it is a matter of the pleasures of food or drink or love-making or other servicings of the body, the philosopher—so it seems—stands apart, striving to purify himself from bodily pleasure. Turning away from pleasures, the philosopher—for instance, Socrates himself—keeps turned to the soul. The question is whether it is indeed so, whether the philosopher Socrates does in deed stand apart from the body, whether he cultivates obliviousness to the pleasures of the body. The fact that, at the age of seventy, Socrates has a very young son, who was there at the scene with his mother Xanthippe earlier in the dialogue, as well as two other somewhat older sons could make one wonder how consistently the philosopher stands apart from the pleasures of love-making.

The other respect in which the philosopher strives for separation of soul from body is in the attainment of thoughtfulness (φρόνησις), for it appears that in this regard the body is merely an impediment. Socrates says: "So when . . . does the soul get in touch with truth? For when it attempts to look at something along with the body, it's clear that then it's deceived by it" (*Phaedo* 65b). Simmias responds: "What you say is true." Yet the reflexive complication is evident: if the soul is deceived by the body and held apart from truth, then how can this very assertion—by the embodied Socrates—be made? What about *its* truth and Socrates' body? How can it be clear—and be said to be clear—to someone embodied that the body prevents us from ever achieving clarity? And how can Simmias—also embodied—recognize that what Socrates says is truth?

Socrates sounds almost rhapsodic as he goes on to tell of the soul bidding farewell to the body in order to realize its striving for being itself.

Though speaking in interrogatives rather than assertions, he comes to re-iterate his song of the soul unencumbered by the body. Again, in almost the same words, Simmias responds: "Extraordinary how truly you speak, Socrates!" (*Phaedo* 66a). Socrates then repeats the performative contra-diction that Simmias has again committed; yet what is striking is that, instead of making the self-referential assertion himself, Socrates mutates into a ventriloquist and puts it in the mouths of others not present at the scene, the so-called true-born philosophers.

Thus the comedy begins as Socrates, introducing the true-born phi-losophers, remarks that "they would say something like the following to one another." From this point on, the words are those of the true-born phi-losophers, ventriloquized by Socrates.

Here is what, first of all, they would say: "It looks like there's a short-cut that brings us to this conclusion—that as long as we have the body accompanying the discourse in our investigation, and our soul is smushed together with this sort of evil, we'll never, ever sufficiently attain what we desire. And this, we affirm, is the truth" (*Phaedo* 66b). It should be noted that by lending them his voice Socrates literally lets them speak with-out being *bodily present*. This is—comically—appropriate, since for them truth would require not being bodily present, not being born, or at least thoroughly undoing the having been born on the part of these "true-born philosophers."

Something else that Socrates puts into the mouths of these "true-born philosophers" is that the body "fills us up with erotic loves and with de-sires." Indeed Socrates makes these "true-born philosophers" speak so passionately—as they extend their diatribe against the body—that one could almost fail to notice that it would hardly be possible to be a lover of wisdom, a philosopher, without being filled with eros and that desiring the truth would require being filled with desire. One could almost fail to notice this, were it not that Socrates has the "true-born philosophers" themselves reveal it: "and this is where it's really pointed out to us that if we're ever going to know anything purely, we've got to free ourselves from the body and behold things themselves with the soul itself. And then, as it seems, the thoughtfulness we desire and whose lovers we claim to be will be ours" (*Phaedo* 66d–e). In unmistakably Orphic-Pythagorean tones, they conclude on the note of purification, resolving to purify themselves from the body until the god himself will release them. Yet, as the comedy comes to an end, all that from which they would purify themselves—all that which had been comically disregarded—has returned to the scene: above all, eros, desire, and the body.

>>> <<<

Fourth Segment.

Once comedy passes into philosophy, it not only may inhere as a moment in philosophy but also may be played out, as in the comedies that abound in the Platonic dialogues. In the latter case the comedy in philosophy regains its dramatic character: it is no longer merely a moment corresponding to the blindness of passage between light and darkness but comes to be enacted with a certain independence, conjoining word and deed otherwise than in dialectic. Thus it turns out that, having passed into philosophy, comedy not only does not vanish but indeed takes shape again within philosophy and, set apart from dialectic as well as from other moments of the dialogues, tends toward independence and virtual detachment. Comedy as such reappears on the scene, as if it had itself been the subject of comedy.

Thus it is to be expected that the most profound comedies—those that arise from the depth of blindness—would retain decisive philosophical moments, that philosophy would prove to belong to such comedies.

In *A Midsummer Night's Dream* the mechanicals are presented in their simple self-identity, which is expressed in their proper names and in what they say and do. As the drama folds back upon itself through the discourse on drama in which the mechanicals engage, their simple self-identity is reflected in the allegiance they profess to undivided presence. For them presentation means and requires being-present: if something is presented (for instance, a lion), it will—they suppose—be taken to be present; and in order for something to be presented (for instance, a wall), it must—they suppose—actually be present.

Yet the comic sequence involving the mechanicals is not simply a presentation of this view. Rather, in and around the enunciation of this view, there is played out in the play the exceeding of the self-identity and presence that this view puts forth as primary. The opening of the scene in which the mechanicals rehearse their play effects already a violation of the simple identity of undivided presence and broaches a translation across a space of difference. Quince is speaking:

Pat, pat; and here's a marvellous convenient place
for our rehearsal. This green plot shall be our stage,
this hawthorn-brake our tiring-house[.]
(*D* 3.1.2–4)

As the rehearsal and the discussion that accompanies it proceed, difference crops up everywhere. For instance even to foresee, as they do, that

the ladies might fail to distinguish the presentation of a lion from the actual presence of such a creature, they must translate themselves into their audience-to-be and into the future in which the performance will be held.

Yet the most decisive and explicit philosophical moment lies in the decision that the mechanicals reach to engage in signifying. Initially they are concerned that the audience will not be able to imagine anything not actually seen on stage; they suppose, in other words, that whatever is to be presented must be actually present on stage. Thus there is the question of how moonlight can be brought into the room, made actually present there. Having ascertained that the moon will in fact shine on the night of the performance, Bottom—in thoroughly mechanical fashion—proposes that they leave the window open and let the moon shine in. But Quince, assuming the guise of playwright, has a better solution:

> Ay; or else one must come in with a bush of thorns
> and a lantern, and say he comes to disfigure or to
> present the person of Moonshine.
> (D 3.1.55–57)[8]

Instead of moonlight being simply, actually present, it will be presented. It will be represented by something present that refers to it. It will be presented in the figure of something else (someone with a bush of thorns and a lantern). It will be figured—or, as Quince says, disfigured, his malapropism declaring what all advocates of presence would maintain, that all representation is disfiguring.

The same question arises concerning the wall through which Pyramus and Thisbe communicate. In this case there is no other solution, for, as Snout observes:

> You can never bring in a wall. What say you,
> Bottom?
> (D 3.1.61–62)

Bottom proposes the solution:

8. The ineptness of the mechanicals in representing or signifying is shown when Starveling, representing Moonshine in the performance of the play, announces that his lantern presents the moon while he appears as the man in the moon. This regression in the very operation of signifying prompts Theseus to jest that the man should be in the lantern if he is to be the man in the moon (see D 5.1.235–39). The conflation of Moonshine with the man in the moon is also operative in the attribute given to Moonshine: that he carries a bush of thorns corresponds to the legend that the man in the moon had been placed there for gathering firewood on Sunday.

Some man or other must present Wall; and let him
have some plaster, or some loam, or some rough-
cast about him, to signify wall; and let him hold his
fingers thus, and through that cranny shall Pyramus
and Thisbe whisper.
(D 3.1.63–67)

The presentation of moonshine and wall is indeed what receives dra-
matic emphasis. When, in the final Act, the mechanicals perform their
play before Theseus and his party, the figures of moonshine and wall pro-
voke the most commentary from the audience. It should also be noted that
in order to incorporate the signifying of moonshine and of wall as well as
the Prologue, the play (within the play) has itself to be skewed: whereas
Quince's initial instructions were that Starveling was to play Thisbe's
mother, that Snout was to take the role of Pyramus's father, and that he
Quince would play Thisbe's father, it turns out that when they perform
the play all the parents are left out. Starveling is recast as the figure signi-
fying moonshine, Snout assumes the role of the figure representing wall,
while Quince's only role is to present the Prologue, in which he explains
to the audience that

This man, with lime and rough-cast, doth present
Wall,
(D 5.1.130–31)

and that

This man, with lantern, dog, and bush of thorn,
Presenteth Moonshine[.]
(D 5.1.134–35)

Thus the signifying operations (along with Quince's signifying of these
signifyings) replace the mere presentation of those related by nature, by
kinship, to the main characters Pyramus and Thisbe. This replacement
furthers, at another level, the undermining of allegedly self-identical pres-
ence that is under way throughout the play. By means of this moment
within the drama, this dissemination of presence that delivers it over to
operations of signification, the comedy carries out—in its own way, in the
way proper to comedy—the very move that belongs to the proper begin-
ning of philosophy.

The Promise of Art

Promise concerns the future. A promise, made now, sets forth a pledge into the future. What has been pledged comes toward us from the future, its coming sustained by the promise. Yet a promise may be announced without having been made by anyone, without anyone having promised. Then the promise has the character of a prospect offered from out of the future. Then the promise is more akin to hope than to certainty or even likelihood. There is the promise that something will advance toward us from out of the future, perhaps even something transfigured and transfiguring, something renewed and renewing, opening up unheard-of possibilities. Such would be the promise of art, its double promise, the promise of a transfiguring renewal sufficient to engender works quite unprecedented in their bearing.

Thus the promise of art concerns the way in which its future may take shape. It concerns the future of the work of art—that is, the prospect that this future will take shape in such a manner that art might remain decisive in its bearing on still reserved happenings and on this future itself.

This is, then, my proper theme: the future of the work of art. This formulation is of course almost a citation, reproducing, as it does, the title of Heidegger's celebrated essay with only one alteration, though, to be sure, this alteration of one word enacts, at least by way of allusion, the entire series of turns that I will be concerned to carry out. These turns have to do both with reorienting the essay to the future and with marking certain of its limits, as Heidegger himself, in an exemplary way, marked certain decisive limits in Hegel's and Nietzsche's thinking about art. By taking into account the way in which Heidegger's essay is set against the background of his engagement with Hegel and Nietzsche regarding the future of art, the futurity to which the essay is devoted can be made more evident

and certain limits concerning, above all, the sense of sense can be marked more incisively. In this manner I will attempt to chart a way of engaging art philosophically that takes a certain distance from Heidegger, not by pretending that his way can simply be abandoned, but rather by resituating thought at the limits so as to trace the mutations that these limits produce, mutations that may eventually transform the entire landscape across which this way runs.

In the question of the future of the work of art, future is not to be simply opposed to origin; it is to be taken neither as the symmetrical opposite of origin nor as opposite to origin in some more oblique fashion. Even if origin could be identified as a certain constitutive past, it would still turn out to be as much intertwined with the future as opposed to it; for the past, sufficiently understood, proves to be that which comes to meet us from out of the future. Still more significantly, the origin, if properly understood, is, according to Heidegger, that which determines the future; it is, for him, that which could first open for art a future. Whether this unilateral determination can be sustained is a question that will have to be addressed later—not, however, in order to set origin and future apart, but rather to compound their mutual implication.

>>><<<

The promise of a transfiguring advancing toward us from out of the future is attested by the famous lines, often cited by Heidegger, from Hölderlin's late hymn "Patmos":

Wo aber Gefahr ist, wächst
Das Rettende auch.[1]

In this paradoxical conjunction or reversal, that which would save promises to emerge in utmost proximity to the very danger it would allay; its promise would sound from the very midst of what endangers, and the poet, receptive to the promise, has as his vocation merely to wrap the promise in song so as to hand it down. As both thinker and poet, Hölderlin sought both to think the reversal promised and to bequeath it in his own poetic work. That work was clouded by the madness that overcame him upon his fateful return from the south of France, and its measure is still, it seems, lacking.

>>><<<

1. "But where danger is, / That which saves also grows" (Friedrich Hölderlin, "Patmos," in vol. 1 of *Sämtliche Werke und Briefe*, 379).

With Hegel, despite all he shares with Hölderlin,[2] it is quite otherwise as regards the promise and future of art.

Though Hölderlin remains always on the horizon, it is of utmost consequence that in *The Origin of the Work of Art* Heidegger poses the question of the future of art in relation to Hegel's foreclosing of this future, that is, in response to Hegel's thesis that art is a thing of the past (*ein Vergangenes*). For Hegel the pastness of art follows almost directly from the general determination of art as such. If, as with Hegel, art is determined as the sensible presentation of truth, then the further inference to its pastness requires only that truth be shown to exceed the possibility of sensible presentation. If, in the course of development of truth, it comes to surpass the possibility of being adequately presented in a sensible configuration, if, beyond a certain point in its development, it proves to exceed every possible sensible form, then this point will mark the limit of art and will delimit the past to which art, even in the future, will remain consigned. In a certain respect this limit is posited from the moment truth is comprehended as the intelligible over against the sensible, which, as the very character of the opposition prescribes, can never entirely measure up to the intelligible. And yet, with the Greeks this limit is only posited abstractly, while, on the other hand, truth, comprehended as the divine in the form of the Olympian panoply, proves eminently susceptible to presentation in Greek sculpture. In the classical sculptures of the Greek gods, the sensible proves perfectly suited to present the spiritual; for this reason classical sculpture represents the very pinnacle of perfection of the classical form of art; here spirit and its sensible presentation, truth and artwork, are perfectly matched.

Yet the limit does not remain merely abstract and ineffective. Rather, there comes about, as Hegel says, "a deeper comprehension of truth which is no longer so akin and friendly to sense as to be capable of being taken up and expressed in this medium in an appropriate way" (*A* 1: 21/10). Hegel refers to the Christian view of truth, to which an inwardness of spirit belongs that is unknown to the ancients and is inexpressible as such in the sensible; he refers also to the modern development of reason in which emerges the demand for a universality that no longer relies on sensible

2. One thinks, for instance, of the so-called "Oldest Systematic Program of German Idealism" (dated 1796–97), which has been attributed both to Hölderlin and to Hegel. In this text—in contrast to Hegel's *Aesthetics*—the idea of beauty is identified as the idea that unites all. The highest act of reason is said to be an aesthetic act, so that the philosopher requires just as much aesthetic power as the poet. See *Mythologie der Vernunft*, ed. Christoph Jamme and Helmut Schneider (Frankfurt a.M.: Suhrkamp, 1984).

exemplification. To be sure, art takes up such truth, and yet it does so only by renouncing its claim to an adequate presentation. In romantic art the inwardness of spirit is not sensibly presented; neither could it be, for inwardness is precisely such as to remain withdrawn from all external, sensible expression. In the romantic work of art there is incorporated merely a trace of the withdrawal of this spiritual moment from the sensible. While acknowledging that, by incorporating a trace of inwardness, romantic art makes a certain advance, Hegel observes that this advance also serves precisely to mark the limitation of art, namely, that it can only trace and not present the inwardness of spirit. Hegel draws the conclusion in all its severity: art "no longer fills our highest need"(*A* 1: 21/10)—that is, the need for spiritual self-presentation, for the presentation of the truth of spirit to spirit. Hegel declares that "the conditions of our present time are not favorable to art" (*A* 1: 22/10); and so, again in all its severity, he draws the conclusion: "In all these respects art, considered in its highest vocation, is and remains for us something past [*ein Vergangenes*]" (*A* 1: 22/11).

Hegel recognizes of course that art has not and will not simply come to an end, that artists will continue in the future to create works of art. He acknowledges even that artworks of the future might surpass those of the past, not only in particular respects but even in their degree of perfection. He even expresses the hope that such will be the case: "One may well hope that art will rise ever higher and come to perfection, but"—he adds immediately—"the form of art has ceased to be the highest need of the spirit" (*A* 1: 110/103). No matter how much the art of the future may exceed in perfection the art of the past, future art is destined to be little more than past art coming to meet us again from out of the future, a perpetual return of the same.[3]

Heidegger explicitly links his own undertaking to Hegel's thesis regarding the pastness of art—that is, to Hegel's foreclosure of the future

3. Gethmann-Siefert shows that there are several respects in which Hegel's alleged thesis of the pastness or even the end of art must be moderated. Over against his alleged classicism, by which it would be maintained that after the flowering of Greek art there is nothing but consistent decline, Gethmann-Siefert refers to the enormous efforts—including difficult travel to distant locations—that Hegel made in order to experience both the art of his time and that of the past preserved in the great museums. While, to be sure, Hegel does criticize what he considers the exaggerated hope of his romantic contemporaries that the entire character of the age could be changed through art, what, in Gethmann-Siefert's view, is at issue in the thesis of the pastness of art is the need for a differentiation of the function of art under the altered conditions of modernity. She insists that Hegel nowhere maintains simply that art is at an end; his view is rather, she argues, that in modernity its altered function is to be understood in relation to *Bildung* (Gethmann-Siefert, "Das 'Moderne' Gesamtkunstwerke," 184, 218–23).

of art. In the Epilogue to *The Origin of the Work of Art*, he characterizes Hegel's *Aesthetics* as "the most comprehensive reflection on the essence of art that the West possesses" (*UK* 68/204), adding that Hegel's reflection is comprehensive because it stems from metaphysics, because it is thought from out of metaphysics. Heidegger recalls three passages from the *Aesthetics*, the two cited above concerning, respectively, the pastness of art and the hope nonetheless for its future, along with a third passage in which Hegel declares: "Art no longer counts for us as the highest manner in which truth obtains existence for itself" (*A* 1: 110/103; cited in *UK* 68/204). If one considers that for Hegel truth obtains existence for itself precisely insofar as spirit becomes objective to itself, that is, is set over against itself yet recognized as itself, that is, is presented to itself, then it is evident that this declaration coincides with the others, most thoroughly with the declaration that art is something past. Yet, while it only repeats the Hegelian declaration in a slightly different way, it is significant that Heidegger includes this formulation and in fact cites it first—significant because for Heidegger the question will be, preeminently, whether in the artwork truth obtains existence for itself. This is the sole, overarching question of *The Origin of the Work of Art*, even though, as Heidegger poses it, the value of every term involved will undergo a fundamental shift. It will be imperative for us to return later to this question as it comes to be developed in the course of the essay.

But first it needs to be observed that in citing these three passages from Hegel's *Aesthetics* Heidegger does not simply affirm what they say. In place of affirmation, Heidegger reinscribes their content within a question, as a question. He writes: "But the question remains: Is art still an essential and necessary way in which the truth happens that is decisive for our historical Dasein, or is art no longer of this character?" (*UK* 68/205). Not only does Heidegger pose the question of the pastness of art, but also he leaves it standing as a question: "The decision regarding Hegel's declaration has not yet been made." Heidegger continues: "For behind this declaration there stands Western thought since the Greeks; such thought corresponds to a truth of beings that has already happened. The decision about the declaration will be made, whenever it is made, from and about this truth of beings" (*UK* 68/205).

With these remarks, cryptic though they be, it becomes clearer what Heidegger means in saying that Hegel's *Aesthetics* is thought from out of metaphysics. This means that Hegel's *Aesthetics* and hence the declaration about the pastness of art are governed by their relation to a truth of beings that first came into play in Greek philosophy and that defines the very

orbit of metaphysics. In this inception, according to Heidegger, the truth of beings, their Being or Beingness (*Sein/Seiendheit*), was determined as ἰδέα, that is, as τὸ νοητόν, as the intelligible paradigm over against sensible beings. Even in its culmination in Hegel's thought, metaphysics moves solely within the circle that joins beings and their Beingness, sensible and intelligible. Even if the movement of truth, as Hegel comprehends it, the movement by which it obtains existence for itself, is irreducible to the ἀνάβασις and κατάβασις represented by the Platonic figures of line and cave, that movement remains, according to Heidegger, within the circle definitive of metaphysics. Since it is this truth in its movement that prescribes the pastness of art, a decision as to whether art is indeed a thing of the past can be reached only by taking a stance with respect to this truth. In other words, the alleged pastness of art can be put in question only if there is a break with this truth, a decision from and about it that displaces it. Only then can the promise of art be renewed. Only then will there be grounds for hope that art might prove to be still an essential and necessary way in which that truth happens that is decisive for our historical Dasein. Yet the truth that may thus prove to happen in art will necessarily be other than the truth of beings that defines metaphysics.

Thus, it is toward another determination of truth that *The Origin of the Work of Art* is oriented, toward a determination of truth that will have twisted free of the metaphysical opposition between intelligible and sensible. In the terms developed in Heidegger's lectures on Nietzsche, which are virtually contemporaneous with *The Origin of the Work of Art*, this determination is to proceed within the context of a new interpretation of the sensible, an interpretation that no longer regards the sensible as only an image of a remote intelligibility. Indeed it is precisely in such a context that the phenomenological analyses of *Being and Time* uncover the originary sense of truth, which is thus also a truth of sense. Though, to be sure, the sense of truth as unconcealment is radicalized in the pivotal essay "On the Essence of Truth" and still more in *Contributions to Philosophy*, this link to sense and to the context of the newly interpreted sensible remains intact and is utterly consequential for the relation of truth to art. Setting truth into the artwork, setting it to work in the work so that it happens there—and only in such a setting—as truth, will not be a matter of setting something intelligible into a work that, simply by virtue of its sensible character, cannot measure up to that truth. The truth that, in Hegel's phrase, obtains existence for itself in the artwork, will be a truth that—to reverse what Hegel says of postclassical art—is so akin and friendly to sense as to be capable of being sensibly presented.

What is remarkable is that certain moments of reversal in this sense are to be found in the *Aesthetics*. Despite the general determination of art and all the systematic constraints derived from it, Hegel is driven to recognize forms of art that resist these constraints, that indeed run counter to the general determination that can so readily be situated within the scope of the basic metaphysical opposition. Especially in the field of painting, it is as though Hegel's concrete experience of art propelled his thought beyond the metaphysical constraints and allowed him to recognize types of painting that present a truth akin and friendly to sense.

It has been shown above (see chapter 5) that seventeenth-century Dutch painting came to play a decisive role in Hegel's understanding of painting in general, indeed that it exerted a counter-systematic force, prompting Hegel to posit a radical bifurcation of painting into two extreme kinds. It led him also to focus on the sheer appearance, the shining, so skillfully depicted by the Dutch masters. Thus he came to realize that painting could realign itself with sense, that it could take up a direction in which the shining of the sensible would become ever more its concern, the shining of the sensible in its very sensibleness and not merely as the sensible presentation of an alien, intelligible content. Such reversal becomes most conspicuous in what Hegel calls the magical effect of coloring, which produces an objectless play of shining and of shinings in shinings.

Thus, despite the general and systematic constraints, Hegel reorients painting to the sensible, foreseeing the dissolution of the object into the play of shining, as, a century later, will be seen, for instance, in Monet's late paintings of the rose garden at Giverny. Hegel foresees modes of painting in which what counts is no longer depiction but interpenetrations of colors and shinings of shinings. To the extent that painting is thus realigned with the sensible—and here, it seems to me, Hegel's text is fissured, for there are most certainly contrary tendencies—to this extent the sensible character of the artwork will no longer limit its presentational capacity. To this extent—at least in the specific domain of painting—there will be no limit delimiting a past to which art would be consigned. To this extent Hegel's *Aesthetics* broaches an opening to the future of art and promises a renewal of the promise of art.

And yet, it does so only by introducing a certain incoherence, by opening the fissure that otherwise remains inconspicuous in the text. For if art—painting, for example—is to be taken as so thoroughly sensible that it is no longer charged with presenting an alien, intelligible content, then it becomes imperative to set aside the general determination of art as sensible presentation of the idea and to redetermine thoroughly the sense of its

content. The question becomes: What is the character of that truth that, more akin and friendly to sense, could be appropriately and without limit presented through the eminently sensible work of art? What is the character of the more sensible truth that, as Hegel realized, is presented in Dutch painting, to say nothing of forms of painting that, as Hegel foresaw, could let the object dissolve into an interplay of shinings?

The question is complex and is not easily resolved within the context of the *Aesthetics*. One complication lies in the fact that the question can be focused not only on the enhanced sensibleness of truth but also on the transfigured sensibleness of the artwork. Thus one could envisage certain realignments by which these more extreme forms of sensibleness might prove capable of presenting adequately what mere sensible depiction could not present. Indeed a hint of such a realignment can be discerned in a passage from the 1826 cycle as preserved in a transcription. The passage reads: "Because of its inwardness, painting is the art of shining as such."[4] There is reference also to an "abstract interest" aroused by shining. What is thus hinted at is a form of painting that, precisely by abstracting from depiction of objects and concentrating instead on pure shining and its compoundings, would become capable of presenting the inwardness of spirit. Retrospectively, one could see in this hint an anticipation of Kandinsky's program and even a remote anticipation of abstract expressionism.

While the transformation of the sensibleness of art—that is, of the sensible *in* art—might thus be regarded as rendering it more capable of presenting forms of truth such as inwardness of spirit and unrestricted universality, it is not evident, on the other side, that Hegel's *Aesthetics* can be made to accommodate a sense of truth that has been twisted free of the metaphysical opposition and thereby rendered itself more akin and friendly to sense. At least it is by no means evident that this is possible without opening—indeed introducing—such fissures in the *Aesthetics* that its coherence would be utterly compromised.

Nonetheless, it would not be out of the question to regard Hegel's anticipation of a transformed relation to the sensible—these moments of reversal—as what is alluded to in a painting in which Magritte folds art back upon philosophy. The painting is entitled *Hegel on Holiday* (*Les Vacances de Hegel*), and it depicts an umbrella on top of which sits a glass of water. In its very title the work signals a divergence, within Hegel's thought,

4. *Philosophie der Kunst oder Ästhetik: Nach Hegel im Sommer 1826*; Nachschrift von Kehler, cited in Collenberg, "Hegels Konzeption des Kolorits," 154. See also the Pfordten transcription of the 1826 cycle: *Philosophie der Kunst: Vorlesung von 1826*, 206.

from the systematic necessities that otherwise govern his thought: for Hegel ought not be on holiday—that is, from a systematic viewpoint there should be no break in the continuing work of the concept in its disclosure of nature as visible spirit and of spirit as truth. In addition the painting itself poses a transformed relation to the sensible, to nature: whereas an umbrella normally provides protection from natural elements such as rainwater, now the water, contained in a glass, is perched atop the umbrella.

>>><<<

If by metaphysics of art one understands an approach that situates art by reference to the fundamental distinction between intelligible and sensible, that hence construes the artwork as a sensible presentation of the intelligible, then it may be said that Hegel developed the metaphysics of art to its limit and indeed beyond. Aesthetics, on the other hand, represents a kind of recoil or retreat from the metaphysics of art, a refusal of metaphysical determination. Its relation to the metaphysical determination of art is not unlike that of empiricism to metaphysics; it is like a shadow accompanying the metaphysics of art, a possibility to which recourse can be had in the refusal of metaphysical determinations. Its parameters remain the same; but rather than seeking out means to reduce the distance, so that the sensible might truly present the intelligible, it simply makes the distance constitutive. Rather than venturing to show that the artwork in its very sensibleness serves to present the intelligible, aesthetics retreats to the sensibleness and determines the artwork by reference to its way of affecting sense (αἴσθησις). According to the aesthetic conception, what is distinctive about an artwork is that it affects the senses in such a way as to evoke a certain feeling of pleasure or enjoyment. For aesthetics it is this feeling that attests to the beauty of the work, to the beauty that makes it a work of art.

Regardless of whether it is called aesthetics, as first happens in the eighteenth century, this possibility of retreat remains open. Yet, as soon as a metaphysical determination of art is ventured, this possibility has been suspended and the confinement to sense surpassed, even if the possibility of recoil remains always open. It is because Hegel has, in his very venture, already thus suspended this possibility that, though retaining the word because of its currency, he sets his own project completely apart from aesthetics and indeed disparages the aesthetic approach to art.

Nietzsche, on the other hand, resumes the aesthetic approach and seeks to understand art aesthetically, even while broaching a radical transformation of aesthetics. In a sense, then, Nietzsche avails himself of the same possibility of retreat that energizes all aesthetics. And yet, recoiling

from the completion of the metaphysical determination of art, the Nietzs-chean retreat is not just another instance in which such determination is refused; rather it becomes the inversion of the metaphysics of art as such and is carried out as a moment within Nietzsche's overall project of in-verting Platonism.

But does Nietzsche's aesthetics in fact take the form of a recoil from the completion of the metaphysics of art achieved by Hegel? One notes, for example, that in the set of aphorisms collected under the title *The Will to Power as Art*, Hegel is barely mentioned and nothing whatsoever is said of Hegel's philosophy of art.[5] Yet precisely such a connection is indicated by Heidegger and marked by him in Nietzsche's text. Heidegger poses the connection in terms of Hegel's assertion regarding the pastness of art: "What Hegel asserted concerning art—that it had lost its power to be the definite fashioner and preserver of the absolute—Nietzsche recognized to be the case with the 'highest values,' religion, morality, and philosophy: the lack of creative force and cohesion in grounding man's historical ex-istence upon beings as a whole. Whereas for Hegel it was art—in contrast to religion, morality, and philosophy—that fell victim to nihilism and became something past, something nonactual, for Nietzsche art is to be pursued as the counter-movement" (*HN* 1: 108/1: 90). In Nietzsche's own words: "Our religion, morality, and philosophy are decadence forms of man. The *countermovement*: art" (*WM* §794). Here the character of the Nietzschean recoil is clearly indicated: it is a reversal of the pastness that Hegel ascribes to art. Whereas for Hegel art is something past, something surpassed by religion and philosophy, for Nietzsche it is religion and phi-losophy that are now something past and art that offers the possibility of surpassing the nihilism to which they have led. For Nietzsche it is art that holds the promise for the future.

The full import of this reversal becomes evident if one notes its con-nection with the classical distinction between the intelligible and the sensible. That religion and philosophy have now become something past means that the truth that would surpass the sensible and that Hegel takes

5. This collection of aphorisms was put together by Peter Gast and Elisabeth Förster-Nietzsche. Though Nietzsche's papers included plans and preliminary drafts for a work with this title, the book as it was published cannot be considered a work by Nietzsche. Heidegger's lecture course on Nietzsche's aesthetics, which was presented in 1936–37, draws heavily—though not uncritically—on *The Will to Power*; indeed Heidegger's lecture course bears the same title as the section of this book that is devoted to art: "The Will to Power as Art." In §849 Nietzsche mentions Hegel along with Herder, Winckelmann, and Goethe, counterposing these four to certain of their contemporaries (presumably the German romantics) who confuse classicism with a kind of naturalness.

art to be incapable therefore of presenting has now become insignificant. It means that the intelligible has ceased to matter, that it has lost all directive force; it means, in the idiom of *Twilight of the Idols,* that the "true" world has finally become a fable. That it is now art that offers an opening upon the future is a result of its siding with what now truly counts, with the sensible. Thus precisely the connection that Hegel took as limiting art and rendering it something past—its connection to the sensible—is what now, with Nietzsche, gives art the capacity to open a future beyond the nihilism that has overtaken religion and philosophy, the nihilism that was indeed integral to them from the beginning. The reversal by which it is religion and philosophy—rather than art—that are past belongs thus to the inversion of the hierarchical ordering of the intelligible and sensible. Now it is the sensible that is primarily to be affirmed, and art opens upon the future precisely because it is a yes-saying to the sensible.

In this regard Heidegger cites a remarkable statement from Nietzsche's early notebooks. The statement predates slightly the publication of *The Birth of Tragedy.* It reads: "My philosophy an *inverted Platonism*: the farther removed from true being, the purer, the finer, the better it is. Living in semblance [*Schein*] as goal."[6] Heidegger comments: "That is an astonishing preview in the thinker of his entire later philosophical position. For during the last years of his creative life he labors at nothing else than the overturning of Platonism" (*HN* 1: 180/1: 154). The effect of overturning Platonism would be to remove art from true being, to free it from the metaphysical demand that it present the intelligible, to let art live in semblance, in relation to the shining of the sensible. As such, art could be taken up philosophically only by way of aesthetics.

In view of this vindication of aesthetics and in view of its connection—emphasized by Heidegger—with the inversion of Platonism, it is striking that Heidegger expresses almost nothing but disparagement regarding aesthetics. In the Epilogue to *The Origin of the Work of Art,* Heidegger voices this disparagement in terms that echo—negatively—the Nietzschean project of freeing art so that it might live amidst the shining of the sensible. Observing that aesthetics takes the artwork as an object of αἴσθησις, of sensible apprehension, Heidegger comments that today this apprehension is called experience. He continues: "Yet perhaps experience [*Erlebnis*] is the element in which art dies. The dying occurs so slowly that it takes a

6. The statement is dated "end of 1870–April 1871" and is now to be found in vol. 3/3 of *Werke: Kritische Gesamtausgabe,* ed. Giorgio Colli and Mazzino Montinari (Berlin: Walter de Gruyter, 1978), 207. It is cited in *HN* 1: 180/1: 154.

few centuries " (*UK* 67/204). In a letter to Rudolf Krämer-Badoni, respond-
ing to some comments about *The Origin of the Work of Art*, Heidegger is
equally emphatic: "The entire treatise opposes the interpretation of art in
terms of 'mere enjoyment of art' [*blosser Kunstgenuss*]. Thus 'beauty' is
not thought in terms of enjoyment [*Gefallen*], but rather as a way of shin-
ing . . . , i.e., of truth."[7]

It appears, then, that Heidegger sets aside both alternatives provided
by the ancient parameters: on the one hand, the metaphysics of art would
consign art to the past, rendering it, even in the future, still past; on the
other hand, aesthetics, setting art within the element of experience and
enjoyment, would expose it to a slow death. To be sure, in the Epilogue to
The Origin of the Work of Art he leaves the question of the pastness of art
open. Yet he leaves the question open not in order to hold open the pos-
sibility of renewing the metaphysics of art, but rather because this is the
question about art that must be addressed in the attempt to think beyond
the ancient parameters. But that Heidegger diverges in this regard from
Hegel is unmistakably indicated in the letter to Krämer-Badoni: "When
in the Epilogue to my treatise I . . . cite Hegel, to the effect that art 'on the
side of its highest vocation is something past,' that is neither an agreement
with Hegel's conception of art nor an assertion that art is at an end. Rather
I would like to say that the *essence* of art is for us questionable. I 'can' not
take a stand with Hegel, for I have never stood with him; this is prohibited
by the abysmal difference [*abgründige Differenz*] in the determination of
the essence of truth."[8] Suffice it to say, in the present context, that Hei-
degger puts the essence of art in question by taking up the question of the
origin of the work of art, that is, as he says at the outset of the essay, the
question of the origin of the essence of art. In other words, Heidegger's
question regarding art concerns the element in relation to which art be-
comes what it is. Since for Heidegger, as for Hegel, that element is truth,
Heidegger's self-differentiation from Hegel appeals precisely to their dif-
ference in the determination of truth, a difference that consists primarily
in the different ways that negativity is thought as belonging to truth, in
the one case dialectically, in the other as abysmal difference.

Why, then, does Heidegger engage Nietzsche's aesthetics in the lecture
course "The Will to Power as Art," which is virtually contemporaneous
with *The Origin of the Work of Art*? Why engage Nietzsche's aesthetics

7. "Ein Brief Martin Heideggers an Rudolf Krämer-Badoni über die Kunst," *Phänomenolo-
gische Forschung* 18 (1986), 178.

8. Ibid., 179.

if it has already been decided in advance that experience and enjoyment do not constitute the proper element of art but only expose it to slow death? What is to be gained by passage through Nietzsche's aesthetics? To formulate it most generally: Heidegger shows that in this final recoil from the metaphysics of art, in this last aesthetics, aesthetics comes to undermine itself in such a way that its deconstruction opens toward the proper element of art. This movement beyond constitutes an overcoming of aesthetics.

Nietzsche's is the last aesthetics. It is aesthetics in its final possibility, aesthetics as it takes shape finally when the very defining order of aesthetics as such is reversed. Nietzsche's aesthetics is at the same time the inversion of aesthetics.

This inversion is most succinctly expressed in a passage that Heidegger cites from *The Will to Power*: "Our aesthetics heretofore has been a woman's aesthetics inasmuch as only the recipients of art have formulated their experience of 'what is beautiful.' In all philosophy to date the artist is missing . . ." (*WM* §811; cited in *HN* 1: 83f./1: 70; Nietzsche's ellipsis). Heidegger comments: "This is precisely what is decisive in Nietzsche's conception of art, that he sees it in its essential entirety in terms of the artist; this he does conspicuously and in explicit opposition to that conception of art that represents it in terms of those who 'enjoy' and 'experience' it" (*HN* 1: 83/1: 70). This opposition, shifting aesthetics from the point of view of the recipient to that of the artist, has the effect of reversing the defining order of aesthetics as such, the order by which its basic orientation is to the one who experiences the artwork. This reversal changes the gender, as Heidegger stresses: "Philosophy of art means 'aesthetics' for Nietzsche too—but masculine aesthetics, not feminine aesthetics" (*HN* 1: 84/1: 70). Thus, Nietzsche's inversion of aesthetics—this final possibility in which aesthetics is reconstituted through its own inversion—consists in the turn from feminine to masculine aesthetics. The task posed for such masculine aesthetics is to comprehend art in reference to the artist, to the one who creates the artwork, rather than in reference to the recipient who experiences and enjoys it. Nietzsche's aesthetics would reinstall the artist at the center of aesthetics, as its directive point of view.

This reversal is not unproblematic, and a host of questions gather around it. Deferring for a moment Heidegger's commentary, one should note what Nietzsche himself says in the passage immediately following his declaration that aesthetics heretofore has omitted the artist, has been feminine aesthetics. Nietzsche says: "This . . . is a necessary mistake; for the artist who began to understand himself would misunderstand himself:

he ought not to look back, he ought not to look at all, he ought to give. —
It is to the honor of the artist if he is unable to be a critic" (WM §811).
Thus, having only just posed his inverted, masculine aesthetics, Nietzsche
points to its complexity, perhaps even its impossibility. Nietzsche's remark
puts in question the project of understanding art from the point of view of
the artist: if even the artist could understand himself only by misunder-
standing, by disrupting his very bearing as an artist, then what would be
required in order to understand art in reference to the artist? Could the
philosopher understand the artist otherwise than by being an artist? But
then what kind of exchange would be required between his bearing as art-
ist and as philosopher? In any case the passage poses the question of access
to the artist as the perspective from which then to interrogate art as such.
How does one gain the standpoint of masculine aesthetics?

There is another, still more pressing question, one that moves in the
direction of Heidegger's commentary. It is again, but at a different level, a
question of the possibility of masculine aesthetics: Can aesthetics become
masculine and still remain aesthetics? Or is aesthetics not intrinsically
feminine? In general, aesthetics conceives of art in terms of experience
and enjoyment. Specifically, it focuses on the way in which the senses are
affected by the artwork and on the way in which that affection, in turn,
produces a feeling of enjoyment. The fundamental problem of aesthetics
is, then, to explain the connection between the experience and the en-
joyment, that is, between the sense-affection and the feeling produced. In
Kant's theory of aesthetic judgment, specifically in his conception of the
judgment of taste, this problem is formulated with the utmost clarity and
is addressed in a way that remains decisive for all subsequent philosophy
of art, not least of all because it too, though otherwise than Nietzsche,
destabilizes the very project of aesthetics.

In any case the point is that the very project of aesthetics is linked
to the point of view of the recipient. Aesthetics is intrinsically feminine.
Therefore, the shift to a masculine aesthetics is, at the same time, a shift
away from aesthetics as such. Heidegger composes an appropriate figure.
Referring to Nietzsche's shift from feminine to masculine aesthetics, he
observes: "In that way Nietzsche's interrogation of art is aesthetics driven
to the extreme, an aesthetics, so to speak, that somersaults beyond itself"
(HN 1: 92/1: 77). The image fits perfectly: aesthetics is inverted, turned up-
side down, but through this very inversion it is compromised as aesthet-
ics, displaced as such, carried beyond itself.

However, Nietzsche himself persists with the project of masculine
aesthetics. Thus his focus is on the artist and specifically on the state—

Nietzsche calls it an aesthetic state—in which the artist creates the art-work. This state, which mixes the corporeal and the psychic, Nietzsche calls *rapture* (*Rausch*).

What is rapture? It is a feeling. To this extent, then, Nietzsche's mas-culine aesthetics, focusing on feeling, remains aesthetics. And yet, this is a very different kind of feeling from that enjoyment on which feminine aesthetics focuses, an enjoyment taken to be produced in the recipient whenever the senses are affected in a certain way by something beautiful. In contrast to the affective pleasure of the recipient on which feminine aesthetics focuses, the rapture of the artist is a pleasure consisting in "an exalted feeling of power [*ein hohes Machtgefühl*]" (*WM* §800). Heidegger cites a parallel passage from *The Twilight of the Idols*: "What is essential in rapture is the feeling of enhancement of force and plenitude [*das Gefühl der Kraftsteigerung und Fülle*]" (*HN* 1: 118/1: 98).[9] Furthermore, rather than being affectively produced by things, rapture makes things reflect itself. Nietzsche writes: "Rapture: the feeling of enhanced power; the in-ner compulsion to make of things a reflex of one's own fullness and perfec-tion" (*WM* §811). Consequently, says Nietzsche, "Artists should see noth-ing as it is, but fuller, simpler, stronger: to that end, a kind of youth and spring, a kind of habitual rapture, must belong to their lives" (*WM* §800).

Not only does the aesthetic state of rapture shape things so that, as artworks, they reflect the very state that shapes them; but also, Nietzsche adds, this state has an abundance of means of communication. As the high point of communication, it is—says Nietzsche, quite remarkably—"the source of languages": "Languages have here their place of origination: the languages of tone as well as the languages of gestures and glances." There is even a present-day remainder and reminder of this origination of language from rapture: "But even today one still hears with one's muscles, one even reads with one's muscles" (*WM* §809).

Nietzsche ascribes utmost significance to the artist's engagement with form. The artist is one "who accords no value to anything that cannot become form" (*WM* §817). Again: "One is an artist at the cost of regard-ing that which all nonartists call 'form' as content, as 'the matter itself' [*'die Sache selbst'*]" (*WM* §818). Yet the necessity of the artist's engage-ment with form derives from the intimate connection between form and the aesthetic state of rapture. Nietzsche gives an important indication regarding this connection, regarding its reciprocal character, in the pas-

9. Nietzsche, *Götzen-Dämmerung*, in vol. 6/3 of *Werke: Kritische Gesamtausgabe*, ed. Giorgio Colli & Mazzino Montinari (Berlin: Walter de Gruyter, 1969), 110.

sage in which he characterizes rapture as an exalted feeling of power. In this context he writes: "Logical and geometrical simplification is a consequence of enhancement of strength [*Krafterhöhung*]: conversely the apprehension of such simplification again enhances the feeling of strength" (*WM* §800). Heidegger explicates the connection as follows: "Form defines and demarcates for the first time the realm in which the state of waxing force and plenitude of being comes to fulfillment. Form founds the realm in which rapture as such becomes possible. Wherever form holds sway, as the supreme simplicity of the most resourceful lawfulness, there is rapture" (*HN* 1: 140/1: 119). To be sure, rapture is form-engendering force, in contrast to the formless undulations of feeling that Heidegger—much more unambiguously than Nietzsche—associates with Wagnerian music. Yet the reciprocity, the double directionality, of the connection is of utmost consequence. Rapture engenders form, yet form is the realm—the spacing—in which rapture becomes possible. Thus, rapture is such that it engenders the very space in which it can hold sway as such, in which it can occur as rapture. The connection between rapture, which engenders form, and form, which grants to rapture the very spacing of its occurrence, could, then, be represented as an active spiral, as a spiraling in which each carries the other still further. At the same time, the connection is one of intimacy (*Innigkeit*), each drawing the other forth in its essential occurrence.

Much of Heidegger's interpretation is devoted to bringing out the radicalness of Nietzsche's aesthetics. Thus he shows how, with the inversion of feminine into masculine aesthetics, Nietzsche brings aesthetics to its final, extreme possibility, the possibility that, inverting aesthetics as such, exhausts the possibilities, brings aesthetics to the point of impossibility. Yet Nietzsche's aesthetics, as Heidegger interprets it, is still more radical: by inverting aesthetics, exhausting its possibilities, reversing the very defining principle of aesthetics, Nietzsche's aesthetics submits aesthetics to a displacement that carries it beyond itself, opening toward a thinking of art that would no longer be aesthetics at all.

Neither—let me add—would it be a renewed metaphysics of art. For what, more comprehensively, would have been exhausted is the ancient paradigm. Now, if one pursued this most radical strain in Nietzsche's aesthetics, new resources beyond that paradigm (or behind it) would be required.

And yet, while bringing out the radicalness of Nietzsche's aesthetics, while showing to what extent it broaches an overcoming of aesthetics, Heidegger also marks its limit.

Heidegger insists that with Nietzsche aesthetics is by no means over-
come. Nietzsche's failure to overcome aesthetics results, according to Hei-
degger, from Nietzsche's focusing exclusively on one side of the creative
process, namely, that which has to do with imposing law and form upon
oneself—ordering the chaos within oneself—so as to empower the feeling
of plenitude. This side of the process is centered in rapture as the form-
engendering force, as the feeling of enhanced power wrought by imposing
form on oneself and by then making things reflect that state, forming them
accordingly. Heidegger maintains that rapture is only one side, that there is
another, equally essential side: "The other side, if it makes sense to speak
here of sides at all, we must present by recalling the essence of rapture and
of beauty, namely, ascent beyond oneself [das über-sich-hinaus-Steigen]"
(HN 1: 136/1: 116). Such is, then, for Heidegger—distancing himself from
Nietzsche—the direction in which a genuine overcoming of aesthetics
would be required to move: it would be imperative to attend to the ascent
beyond (outside) oneself, in contrast to a feeling turned back upon oneself,
ordering and empowering oneself.

Heidegger offers the most significant indication concerning the over-
coming of aesthetics in the course of his discussion of Plato, a discussion
that otherwise might seem quite out of place in lectures devoted to "The
Will to Power as Art." In this discussion Heidegger refers to ἔρως as effect-
ing an opening of oneself to ideas. Then he adds that ἔρως corresponds to
what in Nietzsche's aesthetics is called rapture (see HN 1: 195/1: 167). The
decisive passage comes then in Heidegger's discussion of the Phaedrus. He
refers to the Platonic discourse on the beautiful as ἐκφανέστατον, as the
most shining, as the idea that most shines forth. Heidegger's interpreta-
tion thus moves in a direction that would take the beautiful to designate
the way in which being as such shines forth in the midst of the sensible,
the way in which it shines forth to us in our immersion in the sensible,
bodily domain so as to draw us beyond (and beyond ourselves). In effect
what Heidegger then proposes is a radicalization of this Platonic discourse:
"As soon as man lets himself be bound by being in his view upon it, he is
cast beyond himself, so that he is stretched, as it were, between himself
and being and is outside himself. Such elevation beyond oneself and such
being drawn toward being itself is ἔρως" (HN 1: 226/1: 194). One should
recall, in this connection, that in the Phaedrus the beautiful is called not
only ἐκφανέστατον but also ἐρασμιώτατον: the loveliest, that which most
calls forth love, ἔρως.

Nietzsche fails to recognize the ascent to a beyond that is beyond

oneself. For him there is only the self-impelling spiral of what he calls self-overcoming, which fails still to break out of the circuit of the self, out of the most extreme subjectivism, a subjectivism so extreme that it dissolves even the subject itself. This failure regarding the beyond is for Heidegger the most decisive failure of Nietzsche's aesthetics; in this respect and despite the remarkable transgressions marked by Heidegger's interpretation, Nietzsche, it seems, remains, in Heidegger's phrase, the last metaphysician.

Two other limits need to be mentioned. The first concerns the recipient, the one who (according to aesthetics as such) experiences and enjoys the artwork. Since, in his inversion of feminine into masculine aesthetics, Nietzsche focuses on the artist and proposes to understand art in all respects by reference to the aesthetic state of the artist, this strategy must also be carried out in reconceiving the experience of the recipient. In other words, the recipient, too, must be understood by reference to the aesthetic state of the creator-artist. Nietzsche indicates most succinctly just such an understanding of the recipient when he writes: "the effect of artworks is arousal of the art-creating state, rapture" (*WP* §821; cited in *HN* 1:138/1: 117). In other words, the effect of an artwork is simply to arouse in the recipient the very state—of rapture—in which the artist would have created the work. And yet, says Heidegger: "The view that the observation of works somehow follows in the wake of creation [*sei eine Art Nachvollzug des Schaffens*] is so little true that not even the relation of the artist to the work as something created is any longer that of a creator" (*HN* 1: 138/1: 117f.). Heidegger thus insists that the relation of the recipient to the artwork is not constituted by repetition or duplication of the creation of the work. Heidegger insists even further that not even the relation of the artist to the work he once created is a matter of repeating or reenacting that creation, of recovering the aesthetic state that governed the creation. One might well wonder whether the relation of the artist to the work is simply a matter of creation even at the time he produces it, considering the need for that "other side," the need to be bound by something beyond oneself so that one is stretched beyond oneself. If the artist is in this sense ecstatic, then he is not simply the creator of the work.

Heidegger does not press this critique any further, presumably because the context of a course on "The Will to Power as Art" is insufficient for doing so. But he does indicate the appropriate direction in which it could be pursued: "But that could be demonstrated only by way of an inquiry into art that would begin altogether differently, proceeding from the work

itself; through the presentation of Nietzsche's aesthetics offered here it
ought to have become clear by now how little he treats the work of art"
(*HN* 1: 138/1: 118).

Along with the criticism of Nietzsche's masculine aesthetics as ap-
plied to the recipient, there is another, a criticism of Nietzsche's concept
of artistic form. The point of the criticism becomes evident in view of such
passages from *The Will to Power* as the following: "To become master of
the chaos one is; to compel one's chaos to become form: to become logi-
cal, simple, unambiguous, mathematics, *law*—that is the grand ambition
here" (*WM* §842). According to Heidegger, Nietzsche's concept of form re-
mained merely mathematical and logical. Nietzsche, he insists, could have
gone beyond this limited concept of form only by proceeding not from the
artist, but from the artwork itself.

One might well wonder, though, whether this—or something much
closer to it—is not the way Nietzsche proceeded in *The Birth of Tragedy*,
where it is less a matter of the artist than of the artistic forces of nature
that work in and through the artist and where it is the tragic artwork more
than its creation that is Nietzsche's theme.

In any case, Heidegger's criticisms of Nietzsche serve to invoke the
parameters first put in force in *The Origin of the Work of Art*. It is only
from this work that one can hope to decide whether these parameters ef-
fectively displace the ancient parameters so as to open inceptually to a
thinking of art that will have overcome both aesthetics and the metaphys-
ics of art and that thereby will have proved capable of transfiguring the
philosophy of art as such.

>>><<<

Reopening the future of art requires that truth be determined otherwise
than in the metaphysics of art and otherwise than in the sheer reversal or
inversion to which it is submitted in Nietzsche's thought in general and
consequently in his aesthetics.[10] Equally required is a redetermination of
the sensible, one in which it could be shown how the newly determined
sensible is more capable of presenting the truth, perhaps even entirely ca-
pable, as in Greek sculpture. In this regard it is less a matter of the sensible
in general than of the specific guise assumed by the sensible in art. It is pri-
marily a matter of considering *how* the sensible is *there* in the artwork.

10. This inversion is expressed in the *Twilight of the Idols* in the passage "How the 'True
World' Finally Became a Fable" (ibid., 74f.), to which Heidegger devotes a detailed commentary
(*HN* 1: 231–42/1: 200–10). It is expressed even more succinctly in the aphorism: "Truth is the
kind of error without which a certain kind of living being could not live" (*WP* §493).

With this insight into what is required in order to rethink art at the limit where all the classical lines defining the ancient parameters are effaced and in order to foresee an opening of the future of art, a renewal of its promise—with this insight Heidegger has, in my judgment, made a momentous and irreversible advance. *The Origin of the Work of Art* brings to bear on art redeterminations both of the sense of truth and of the truth of sense. These two operations repeatedly intersect, and their interweaving forms the very fabric of Heidegger's text. On the one hand, the ever more radical determination of the essence of truth, under way from *Being and Time* on, is reiterated in the essay, and its full force is brought to bear on the work of art, as correctness gives way to unconcealment. On the other hand, the question of the sensible in art, though undergoing a kind of refraction, is deployed across a new, strange landscape; and thereby the very sense of sense—of its guise in the artwork—is submitted to redetermination. Truth and sense are precisely the terms that, in their metaphysical guise, could never quite be matched, and it is that impossibility that proved to constitute the limit of artistic presentation and that led Hegel—except in those remarkable moments of reversal—to declare the pastness of art. Undoing this bind requires the most radical rethinking of truth and sense, of the truth that obtains existence for itself in the artwork and of the sensible as it is there in the work.

From the very outset the strangeness of the new landscape on which Heidegger's essay is set out is conspicuous. In the opening sentences Heidegger declares that to inquire about the origin (*Ursprung*) of the artwork is to ask about the source of its essence (*die Herkunft seines Wesens*). Thus from the beginning Heidegger indicates that his inquiry is not simply directed at determining what art is, at providing a presumably more adequate determination of the essence of art. Rather, in posing the question of origin, the inquiry is aimed at that which determines the essence, at that which is anterior to every specific determination of what art is. Here a parallel can be drawn with the questioning in *Being and Time:* just as the ontological questioning is directed not simply at Being but at the sense of Being, at that from which Being comes to be determined, so likewise in the question of art the concern is not simply with its essence but with that from which the determination of its essence is effected. To the extent that a new determination is actually forged, it will be thought from out of this anteriority, from the origin.

To be sure, one finds in the essay certain formulations that could readily be taken simply as new determinations of what art is, of its essence. Most notable among these is the formulation that emerges from

Heidegger's discussion of a painting by van Gogh, one of the many paint-
ings in which he depicts shoes; though Heidegger does not indicate pre-
cisely which painting he is discussing, he does identify it as—or assume
that it is—a painting of peasant shoes. Yet even the verb form with which
this formulation is introduced hints that more is at stake than a mere al-
ternative determination. Here is how Heidegger introduces the formula-
tion: "So wäre denn das Wesen der Kunst dieses: das Sich-ins-Werk-Setzen
der Wahrheit des Seienden"—roughly translated: "Then the essence of art
would be [italics added] this: setting the truth of beings to work/into the
work" (*UK* 21/162). Taken without further specification, such a character-
ization holds no less for Hegel than for Heidegger; what counts as regards
the difference is how, in this formula, truth is determined and how its
setting in the sensible work is understood. What is decisive is the deploy-
ment in and through which truth is determined; for it is this deployment
that governs what in any epoch art is and is taken to be. Heidegger himself
expresses this anterior deployment by the word *essence* (*Wesen*), detaching
this word from its intrametaphysical sense, letting it slide in the direction
of this anteriority. It draws along with it the discourse of origin, which,
says Heidegger, is to be thought by way of the essence of truth. Hence,
the origin of the work of art, the origin from which it is determined in
any epoch what art is, is to be thought by recourse to the essence of truth.
Thus, at the end of the Epilogue to *The Origin of the Work of Art*, Hei-
degger writes: "The history of the essence of Western art corresponds to
the change in the essence of truth" (*UK* 69f./206). Therefore, one can say
that as truth is deployed in a certain way, so the essence of the artwork
will be determined in a corresponding way. If the essence of truth is deter-
mined as adequation to the idea, then art will be—and will, as with Hegel,
be determined as—the sensible presentation of the idea. If, on the other
hand, there is a change in the essence of truth, if in a certain future truth
were to be deployed otherwise, then the essence of art would come to be
otherwise determined.

The question of the sensible in art is in play almost from the beginning
of Heidegger's essay. After circling, at the very outset, through the circle
of circles in which the entire essay will circulate, the circle joining artist,
work, and art, Heidegger turns directly to the work, to the actual work as
we discover it in its immediacy. He observes that artworks are as naturally
present as are things, that they have invariably a certain thingly charac-
ter. He elaborates: "There is something stony in a work of architecture,
wooden in a carving, colored in a painting, spoken in a linguistic work,
sonorous in a musical work" (*UK* 4/145). He notes, on the other hand, that

the artwork is something over and above its mere thingly character; and so, he continues, it seems that the thingly nature of the work is a kind of substructure on which the other, artistic aspect of the work is built. He concludes that in order to approach the artwork in its full actuality, it is necessary first to bring into view the thingly aspect of the work.

The question of the sensible in art is thus initially refracted into the question of the thingly aspect of the artwork. As thus refracted, the question of the sensible in art determines virtually the entire first part of the essay, in which, in order to bring the thingly aspect of the work to light, Heidegger turns back still further to investigate what a thing as such is. His ensuing review of the three principal concepts of the thing leads to the conclusion that these concepts only obstruct access to things and to the artwork. Within the broader compass of the essay, this deconstruction of thingness serves to indicate that the question of the sensible in art is not to be resolved in the form of the question of the thingness of the artwork. And yet, within this initial venture, another refraction has already been broached. Heidegger has observed, for instance, that there is something stony in a work of architecture. This inherence would seem to reveal a certain materiality belonging to the work. The sensible in art would lie—so it seems—in the work's materiality.

But rather than pursuing the question along this line, Heidegger again turns to the work itself, repeating the phenomenological gesture, yet still more concretely, turning not just to the artwork in its actuality in general but in its singular actuality. Van Gogh's painting now makes its appearance on the scene. It is a rather bizarre appearance, since it is effected by a kind of ruse, a pretense that the picture is being brought onto the scene merely to facilitate the visualization of some peasant shoes, merely as a pictorial aid. Yet the description of the shoes as they are presented in the painting quickly dispels the pretense, for it turns out that the picture itself is what lets us discover what such shoes truly are.

>>> <<<

Heidegger's discussion of this painting has sparked more controversy than any other passage in the essay. His alleged assumptions, for instance that the shoes are those of a peasant, have been challenged by the art historian Meyer Shapiro, and the intricate web of the controversy has been spun out by Jacques Derrida in the extended polylogue that concludes *The Truth in Painting*.

The peculiar form of Derrida's polylogue is adapted to the subject of the discussion. One voice belongs to someone who arrives on the scene only after the discussion has begun—like the author of the polylogue who

comes long after "there will have been . . . a correspondence between Meyer Shapiro and Martin Heidegger" (*TP* 293/257). Another discussant leaves and then later returns, alternating between the inside and the outside of the discussion (as one of the participants in the original debate will prove to have done with regard to the painting). Most remarkably, none of the voices are tied to—that is, attributed to, returned to—proper names nor even to stable, recognizable identities; in this way the polylogue mocks or parodies precisely what it is about, namely, the debate about whose shoes are painted in van Gogh's painting, a debate intent on tying the shoes to a name, common or proper.

Shapiro's charge is that the shoes are not those of a peasant woman but rather "the shoes of the artist, by that time a man of the town and city."[11] Shapiro concludes that Heidegger has simply projected upon the painting "his own social outlook with its heavy pathos of the primordial and earthy," that he has "imagined everything"—presumably, the entire description of the shoes—"and projected it into the painting."[12]

Derrida's text—at least one of its voices—points out that Shapiro, who returns the shoes to van Gogh the city dweller and denies them to the peasant woman, is himself, as uprooted emigrant, a city dweller and to this extent draws the shoes toward his own sphere; in addition, he is the expert, the art historian, who wants to hold onto what is properly his, to bring it back toward himself—even if thereby opening himself to the very charge that he makes against Heidegger. Yet what is most remarkable is that—without showing the slightest awareness of the difficulties—Shapiro moves back and forth between what is inside the picture and what is outside it. One of the voices calls attention to this peculiar movement: "So what is one doing when one attributes shoes? When one gives or restitutes them? What is one doing when one attributes a painting or when one identifies a signatory? And especially when one goes so far as to attribute painted shoes (in painting) to the presumed signatory of that painting? Or conversely when one contests his ownership of them?" After a brief interruption, this voice—at least, it seems, the same voice—continues, rendering the question still more precise: "The question's just been asked: what is one doing when one attributes (real) shoes to the presumed signatory of

11. Meyer Shapiro, "The Still Life as a Personal Object: A Note on Heidegger and van Gogh," in *Theory and Philosophy of Art: Style, Artist, and Society; Selected Papers* (New York: George Braziller, 1994). Shapiro's essay is dated 1968.

12. Ibid. Shapiro goes on to charge that Heidegger missed an important aspect of the painting, namely, the artist's presence in the work. In this charge Shapiro repeats the same illicit move that Derrida's polylogue will expose him as making in the mere attribution.

a painting that one presumes to represent these same shoes?" (*TP* 303/266). What one is doing in weaving in and out between the inside and the outside of the painting is remaining entirely within the framework constituted by an understanding of art as depicting the real. In his concern with returning the shoes in the picture to their rightful owner, to van Gogh himself, Shapiro remains entirely within the conception of art as imitation.

Later in the polylogue one of the voices will explain that *The Origin of the Work of Art* is, on the other hand, situated entirely outside this framework; indeed there is no contesting the fact that Heidegger denounces thoroughly—perhaps even a bit too thoroughly—the conception of art as imitation. This voice explains that consequently Heidegger's attribution, however it may function, cannot function in the simple way that Shapiro's does, moving—without qualms—from inside to outside, from representation (the shoes in the picture) to represented (the shoes outside the picture). Here is what is said: "Thus Shapiro is mistaken about the primary function of the pictorial reference. He also misunderstands a Heideggerian argument that should ruin in advance his own restitution of the shoes to van Gogh: art as 'putting to work of truth' is neither an 'imitation,' nor a 'description' copying the 'real,' nor a 'reproduction,' as would represent [*qu'elle représente*] a singular thing or a general essence. For the whole of Shapiro's case, on the other hand, calls on real shoes: the picture is supposed to imitate them, represent them, reproduce them. Their belonging has then to be determined as a belonging to a real or supposedly real subject" (*TP* 356/312).

But what about the Heideggerian attribution? What about Heidegger's restitution of the shoes as it occurs, initially at least, in his taking the shoes to be those of a peasant woman? What is decisive is that in the final move Heidegger reattaches the shoes elsewhere: "Heidegger does not attach the shoes to a wearing (the wearer or the worn/borne [*porteur ou porté*] as subject, especially not as a real subject outside the painting"; rather, he attaches them more "preoriginarily" (*TP* 404/354), attaches them to the earth. Because this is the reattachment to be made, Heidegger does not even really need *peasant* shoes in order to tie them back to that to which they belong. It is only a matter of proximity: "The value of proximity plays a decisive role in this text and in Heideggerian thought in general. The shoes of the peasant are *closer* to that earth to which a return had to be made. But in principle the same trajectory would have been possible with city shoes" (*TP* 409/358).

As the polylogue nears its end, it becomes apparent that Shapiro is no less off the mark in his charge that Heidegger projected his peasant pathos

on the work of a painter who had become a man of the town and city. In this regard one need only recall van Gogh's invectives (in his letters to Theo) against city dwellers; or to recall, as does a voice in the polylogue, that it was van Gogh himself who said: "When I say that I am a painter of peasants, it is indeed truly so and you will see better from what follows that it is there that I feel in my element [*c'est là que je me sens dans mon milieu*]" (*TP* 420/367f.). To say nothing of what can be seen in the paintings, in the *Potato Eaters* or *Peasant Woman of Brabant*, for instance, though not only these, not only these by any means.

>>> <<<

Yet, even beyond the terms of the Heidegger-Shapiro debate, even beyond the resolutions and the complications that Derrida's text brings to it, there is a strangeness about Heidegger's discussion of the van Gogh painting, a strangeness about the moves Heidegger carries out—often almost inconspicuously—in the discussion. It is imperative not to fill out too readily the spaces left by what goes unsaid in the discussion. Thus, following his description of the painting, Heidegger declares that it "has spoken [*hat gesprochen*]" (*UK* 21/161). But is it not rather the philosopher that has spoken, that has described the shoes as they are presented in the painting? What would it mean for the painting to speak? And if somehow it did speak, how would its speech be related to that of the philosopher who describes the painting? To what extent is there a circulation of language around the painting, and how is this complex of speaking related to the painting's proper mode of presenting something, namely, through line, figure, and color? Can one speak properly of a painting, or is such speech always somewhat off the mark, improper to the very way of disclosure that belongs to painting?

Heidegger says also that "in the vicinity of the work we were suddenly somewhere else than where we usually tend to be" (*UK* 21/161). How is it that in being near the work we are transposed into another place? What does an artwork have to do with place and with our being in place?

In this entire series the move that is perhaps most strikingly discontinuous is that which leads from the attestation that the painting discloses what the shoes are *to* the declaration that in the work there is a happening of the truth of beings. This leap—most remarkably—spans an interval even greater than the most gigantic; it is a leap across an expanse that exceeds even that contested in the ancient γιγαντομαχία περὶ τῆς οὐσίας. How is it effected? What kind of demonstration could be brought to its defense?

The demonstration is a remembrance, one in which the strange land-

scape of the essay comes to coalesce with another that is no less strange, no less remote, no less foreign. This other landscape is that of a Greek temple, of a temple bound in the most extraordinary ways to the landscape, to the things of that landscape, and, above all, to the elements that belong there with it. Before broaching the description in which the remembrance is enacted, Heidegger mentions "the temple in Paestum" (*UK* 26/166), to which presumably the description refers, though it is curious—assuming that the description has a singular reference—that no indication is given as to which of the three temples at Paestum is meant.

At the outset of the description Heidegger declares that the temple "depicts nothing [*bildet nicht ab*]" (*UK* 27/167). Only slightly veiled in this declaration is a repetition of the denunciation of mimesis and, correspondingly, an insistence on differentiating the artwork from the mere image in the sense of a copy or likeness (*Abbild*). An artwork does not provide a setting for truth merely by resembling the truth that would be set into it. Even in the most likely cases, such as Meyer's poem "Roman Fountain," which Heidegger cites, the artwork enacts a kind of mimesis, not by directly copying such a fountain, but only by means of language. If the work evokes an image of such a fountain, it does so only through the evocative power of words.

But in the case of the temple, it is all the more manifest that such a work depicts nothing, that it is not a likeness or copy of anything. Rather: "It simply stands there [*steht einfach da*] in the middle of the rock-cleft valley" (*UK* 27/167). As it stands there, it grants a place for the god, and in its enclosed opening it lets the god be present. Through the presence of the god in this sacred space, the surrounding expanse is delimited. Thus, in Heidegger's words: "It is the temple-work that first fits together and at the same time gathers around itself the unity of those paths and relations in which birth and death, disaster and blessing, victory and disgrace, endurance and decline acquire the shape of destiny for human being. The prevailing expanse of this open relational context is the world of this historical people" (*UK* 27f./167). Thus the precinct delimited by the god's presence is the very space of the life of a polis: as world it is the articulation and gathering of the axes, the directionalities, that guide life and determine a people. Through the artwork a world is set up (*aufstellen*), and, reciprocally, the work is itself set up within this world.

The bond to the earth is no less manifest. Heidegger writes: "Standing there [*Dastehend*] the building rests on the rocky ground" (*UK* 28/167). This statement marks the bond that connects the temple's standing there to its resting on the earth. As standing there, as resting in itself, in its

self-repose, it rests on the earth. And yet, as resting on the earth, it stands there. In this connection what is utterly decisive is the *there* (*da*): as an artwork the temple brings with it a *there* (*da*), a space in which things can come to presence. Providing such a *there*, the temple lets the rock—that is, the earth—become manifest, indeed in its very obscurity: "This resting of the work draws up out of the rock the obscurity of that rock's unarticulated yet uncompelled support" (*UK* 28/167). Yet, most remarkably, it is not only the earth that becomes manifest in this *there* brought by the temple. Heidegger continues: "Standing there [*Dastehend*—here the word is repeated], the building holds its ground [*standhalten*—stands firm] against the storm raging above it and so first makes the storm itself manifest in its violence" (*UK* 28/167). Thus, in its very self-repose, the temple provides a *there* where the storm becomes manifest. This *there* is also a space of shining, as Heidegger goes on to observe: "The luster and gleam of the stone, apparent [*anscheinend*—appearing, shining forth] only by the grace of the sun, first brings the light of day, the breadth of the sky, the darkness of night, to shine forth [*bringt . . . zum Vorschein*]" (*UK* 28/167f.). One could say: In its *there*, the temple not only lets these uranic elements shine forth but itself shines from them, so that in the *there* there is a reciprocity between the shining of the temple (of its stone) and that of the heaven. The *there* gives space for a shining capable even of making the invisible visible; for, as Heidegger writes, "The temple's firm towering makes visible the invisible space of air" (*UK* 28/168). Thus Heidegger refers to what the early Greek thinkers regarded as the elements, as the elemental: the light of day and the breadth of the sky broach the fire of heaven and the shining upper air that the Greeks called aither, which was set apart from the space of air. Then, too, there is the sea: "The steadfastness of the work contrasts with the surge of the surf, and its own repose brings out the raging of the sea" (*UK* 28/168). Yet in the *there* brought by the temple, not only the elements but also creatures and things are allotted a space of manifestation: as Heidegger writes, "Tree and grass, eagle and bull, snake and cricket first enter into their distinctive shapes and thus come to shine forth [*kommen . . . zum Vorschein*] as what they are" (*UK* 28/128). Such coming-forth is—says Heidegger—what the Greeks called φύσις. In and through these comings-forth, that is, by virtue of φύσις, the earth itself becomes manifest in its obscure sheltering of all things. Above all, it is the artwork, set forth or made from the earth, that lets the earth be set forth (*herstellen*) as that which shelters.

Such is, then, the complex within which the setting of art happens—or, in the case of the Greek temple, would have happened. Heidegger draws

the complex together: "Standing there, the temple-work opens a world and at the same time sets the world back upon the earth, which itself only thus comes forth as indigenous ground [*als der heimatliche Grund*]" (*UK* 28/168). Now it is evident what an artwork—at least such an artwork—has to do with place and with our being in place. If, furthermore, one identifies this intimacy (*Innigkeit* or—as he also calls it—*Streit*) of world and earth as a way in which truth happens—and Heidegger will make this identification—then it also becomes evident how the transition can be made from the singularity of the work to its providing a setting for a happening of the truth of beings. What enables this transition is that the intimacy of world and earth comes to be set into the artwork, or rather, that the essential traits of this intimacy, its drafts (*Wesenszüge*), are fixed in place in the work. As fixed in place, as thus admitted into a πέρας, the intimacy is, as it were, condensed into a figure, composed as the *Gestalt*.

If, as in Hegel's *Aesthetics*, one undertook to derive—or at least to make understandable—the manifold forms and styles of art, presumably one would need to begin at this point and to distinguish between the various ways in which the *Gestalt* could be composed. But Heidegger ventures no such derivation, and, at least in comparison with Hegel's *Aesthetics*, this constitutes a limitation of Heidegger's essay.

The further question prompted by comparison with Hegel's *Aesthetics* is that of the differentiation of art into arts, into the particular arts, into what Nancy calls the singular plural of art. In the artwork essay Heidegger reiterates the determination of figure in the following statement: "Truth, as the clearing and concealment of beings, happens in that it is composed [*gedichtet*]" (*UK* 59/197). Though Heidegger goes on to conclude, from this connection, that all art is in essence *Dichtung*, a marginal note marks the connection as problematic, at least as it is presented here. The note, marking a limit, a gap, in the text reads: "The connection between clearing and *Dichtung* insufficiently presented."[13] In any case, it is in relation to the character of art as *Dichtung* that Heidegger raises the question of the plurality of arts. The passage, the only sequence that touches on this question, refers to the relation between, on the one hand, the arts of architecture, painting, sculpture, and music and, on the other hand, poetry (*Poesie*). While denying that these other arts can be traced back to poetry,

13. The note first appears in the Reclam-Ausgabe (1960). It is reproduced in the *Gesamtausgabe* version of the essay. One insufficiency would seem to lie in Heidegger's reliance on the connection between *dichten* in the sense of composing (as in setting together clearing and concealment in the intimacy of world and earth) and *Dichtung* in the broad sense of poetic art.

Heidegger does insist that poetry has a privileged position among the arts as a whole, that poetry (*Poesie*) is the most originary form of *Dichtung*. This priority, he explains, is based on the priority that language itself has in bringing beings to appear, so that, as he writes: "Building and plastic creation [*Bauen und Bilden*] always already happen only in the open region of saying and naming" (*UK* 62/199). The question—again a question of limits—is whether such a straightforward priority of poetry over the other arts is sufficient. It is a question, not so much of denying that in every opening language is somehow already in play, but rather of considering the complexity of the relation of language as such to the other arts. The need for such consideration is evident if one reflects, for instance, on the way in which the title of a painting belongs to the painting, especially in cases where this very relation is presented in the painting itself. Among the most striking examples are those in which Klee inscribes the title on the edging of the picture or even inscribes the title or parts thereof in the picture itself. Both types of inscription are found in Klee's whimsical watercolor *Where the Eggs and the Good Roast Come From*. There are also works in which Klee presents the dyad of the said and the seen both in the title and in the picture itself. Such a doubling of the double occurs in the work entitled *Signs in Yellow*, which consists of black sign-like marks set against a background made up of blocks of various shades of yellow.

What is needed, then, in place of an assertion of simple priority, is an inquiry into the way that each of the arts, set already within the opening of language, engages that opening from a distance proper to each. As the painter, for instance, ventures to paint a blue of the sky that exceeds—while also being linked to—what the word *blue* says. Or as music, related to speech through the bond to the human voice, is nonetheless so other than speech that it can come, as accompaniment, to enhance speech, as in song.

>>> <<<

Just before Heidegger launches on the description of the Greek temple, he observes that when we visit "the temple in Paestum" we find that "the world of the work present there has perished." Such decay cannot be undone, he says, and so "the works are no longer the works they were" (*UK* 26/166). The historicity of the artwork is such that now it has lost the setting out of world and earth that it once achieved—as one can readily see by visiting the site or even in photographs of the temples as they look today. Heidegger's description thus describes an artistic happening of truth that happens no more. What does this entail as regards the status of the deter-

mination of art that is exemplified in this artwork that—even when we visit it "at its own site"—is no longer the work it was?

It seems—and indeed has usually been assumed—that through the analysis carried out in *The Origin of the Work of Art* Heidegger arrives at a determination of the essence of art that surpasses the limits of the metaphysical concept of art and that is unrestrictedly valid. It would seem, then, that it was only because metaphysics failed to recognize the originary essence of truth—because it took truth to consist in adequation to the idea rather than in an unconcealment infused with concealment—that it took art to be limited in its capacity as a setting for truth. And it was this limit that, in the end, led Hegel to declare that art was a thing of the past. What to metaphysics could appear only as a limit constituted by the sensibleness of art could now, with the redetermination of the essence of truth, be regarded precisely as the ingredient of concealment that an adequate setting for truth must provide. One would thus suppose that, all along, art would have been—and still is and will be—a happening of truth like that displayed in the two primary examples that Heidegger discusses in *The Origin of the Work of Art*, the van Gogh painting and the temple at Paestum. The true essence of art would, it seems, now have been determined, and the only thing that might still be puzzling is why the essay, in its title, names as its theme the origin rather than the essence of the artwork.

And yet, Heidegger does not claim to have arrived at an unrestrictedly valid determination of art, at a determination that would hold across the entire history of Western art, if not of art as such. In *Contributions to Philosophy* he declares: "The question of the origin of the work of art does not aim at a timelessly valid determination of the essence of the work of art, which could at the same time serve as the guiding-thread for a historically retrospective explanation of the history of art."[14] Behind this declaration stands the following consideration: to suppose that there is an invariable essence repeatedly exemplified—not only by the van Gogh painting and the temple at Paestum but throughout the history of art—would be to take for granted the determination of essence as κοινόν, as a universal that hovers, as it were, above the particular artworks that exemplify it. In effect, this would be to remain within the purview of the idea.

What can be ventured as regards the history of art is not the claim that it secretly exemplified the determination developed in *The Origin of*

14. Heidegger, *Beiträge zur Philosophie (Vom Ereignis)*, vol. 65 of *Gesamtausgabe* (Frankfurt a.M.: Vittorio Klostermann, 1989), §277.

the Work of Art but rather the recognition that it remained determined by metaphysics. In Heidegger's words from *Contributions to Philosophy:* "Metaphysics comprises the basic Western position toward beings and thus also the ground of what heretofore is the essence of Western art and its works."[15]

The way in which Heidegger's determination of the essence of art must be understood becomes more evident if one refers to his discussion in *Besinnung*, specifically in the section entitled "Art in the Era of the Fulfillment of Modernity."[16] Here Heidegger's move is not at all simply to vindicate art by reverting to a more originary determination of truth. Rather, he stresses that art is determined by metaphysics, indeed that in the present era art brings to fulfillment the metaphysical essence that has determined it since the Greeks. In this era, he says, art has the same essence as technology—essence understood *seynsgeschichtlich*—and, like technology, it is engaged in the arrangement of beings (*die Einrichtung des Seienden*), the being of beings having already been decisively established, in its very abandonment, as machination (*Machenschaft*). He concludes that to this extent art does not provide a space for decision, that it does not open a site where a turning from the abandonment of Beyng to the truth of Beyng, from refusal and withdrawal to the inception of *Ereignis*, might commence.

Yet in this context Heidegger also invokes the determination of the essence of art put forth in *The Origin of the Work of Art*, referring to *die Wesenssetzung der Kunst als Ins-Werk-Setzen der Wahrheit*. This setting forth of the essence of art is, says Heidegger, a leap ahead (*Vorsprung*) into another history; indeed—he insists—it would be a mistake to interpret the history of metaphysical art on the basis of this determination. In effect, then, Heidegger is declaring that the art that has been and that which, at least for the most part, *is* today—art as determined by metaphysics—does not accord with the determination given in *The Origin of the Work of Art*. Rather, this determination leaps ahead into the other beginning and foresees, says Heidegger, "a change in the essence of art." It is precisely such a change that is required in order that art be endowed with a future, with a future that does not just endlessly reiterate the metaphysical past of art. Only through such a change can the promise of art be renewed.

Heidegger grants nonetheless that this determination of the essence

15. Ibid.

16. Heidegger, *Besinnung*, vol. 66 of *Gesamtausgabe* (Frankfurt a.M.: Vittorio Klostermann, 1997), §11.

of art can be initially understood through historical recollection. In this regard one can, then, begin to comprehend how the two primary examples in the artwork essay actually function. They are not simply instances that exemplify a universal determination. They are not examples that could simply be replaced by any others from the history of art or from contemporary art. Rather, they are artworks in which there is an opening toward the determination of art in the other beginning, the determination with which the artwork essay leaps ahead toward that beginning. In the one case, that of the van Gogh painting, the work is situated in the crossing to the other beginning and to this extent enables the leap ahead. In the case of the Greek temple, it is a matter of recollecting the passage to what precedes the first beginning. As *Contributions to Philosophy* makes evident, crossing to the other beginning requires passage (*Zuspiel*) between these two moves; it requires that both be carried out together, that metaphysics thus be exceeded simultaneously in both directions. It is in this way that the past can come to meet us from out of the future, not as a pastness that would reduce the future to mere reiteration, but now as a past that would contribute to the opening of the future.

And yet, is it a matter only of a leap carried out by thinking? Is it only in and through thinking that the leap ahead toward a change in the essence of art would be effected? Even Heidegger's examples and the role they play in the analysis suggest otherwise: namely, that there are at least some artworks that themselves attest to such a transformation, indeed that it is in reflection on these works that the thinker can most effectively carry out the leap toward another beginning. In fact, despite all his hesitation about modern art, Heidegger intimates that in the works of such artists as Cézanne, Klee, and Chillida he discovered something akin to what he was compelled to venture in thinking. For example, in his notes on Klee,[17] Heidegger refers to the way in which Klee ironizes the technical by binding it back into the natural and representing the outcome as a hybrid growth. In this regard Heidegger refers to a 1926 pen-drawing by Klee that he saw in Basel. In its title *Überkultur von Dynamoradiolaren*, it refers to little sea animals call radiolaren that have star-shaped skeletons, which are ironized in the drawing as windmills or dynamos that produce electrical energy. That there are other such artists—one thinks

17. These notes remain unpublished. For a report on them, see Otto Pöggeler, *Bild und Technik: Heidegger, Klee und die moderne Kunst* (Munich: Wilhelm Fink, 2002), esp. chap. 3; also Günter Seubold, "Heideggers nachgelassene Klee-Notizen," *Heidegger Studies* 9 (1993), 5–12.

immediately of Kandinsky and Schönberg—and that Heidegger seems not to have ventured more than the most minimal writing about even the artists he recognized is indicative of a limit. Or, to turn it otherwise, an imperative emerges, the imperative that we attend to the way in which *in the work itself* such exceptional artists succeed in carrying out what we, in the wake of Heidegger, venture in thinking.

>>> <<<

In Heidegger's essay not only the sense of truth but also the truth of sense is at issue. While determining truth as unconcealment, Heidegger ventures also to rethink the sensible in the direction indicated in his contemporaneous lectures on Nietzsche: what is required is a reinterpretation of the sensible outside the metaphysically prescribed opposition to the intelligible and also, most significantly, a reconsideration of the way in which the sensible, thus reinterpreted, enters into art. Already in *Being and Time*, if less conspicuously, the old opposition is set aside: sensible things are described, not in terms of a presence that would image an intelligible, but rather in terms of their engagement in various horizons, which, taken as a whole, constitute a world. Sensible things show themselves by standing out in a world rather than by imaging a higher truth, the intelligible. Heidegger analyzes the operation of these horizons, the deployment of world ; his investigation culminates in the analysis of truth—truth, not as intelligibility, but as the unconcealment that lets sensible things come to appear.

The Origin of the Work of Art advances this recovery of sensible things. In the descriptive remembrance of the Greek temple, it is shown how the *there* in which sensible things come to presence is opened and sustained by both world and earth, indeed by the strife or intimacy of world and earth. Insofar as art proves capable of instigating this complex, it can determine the way in which elements and things come to be manifest. In Heidegger's words, the Greek temple, "in its standing there [*dastehend*], first gives to things their look" (*UK* 29/168).

But what about the sensible in art? What about the sensible as it would be—and would be thought—in the leap ahead into the art of another beginning? What about the sensible in the artwork as determined in the project carried out in Heidegger's essay?

Heidegger returns to the question of the sensible in art in his account of production or setting-forth (*Herstellen*). He observes that works are set forth from—made of—this or that work-material (*Werkstoff*): stone, wood, metal, color, language, tone. He stresses that in art the material does not disappear as it does in the functionality of equipment. Rather, the temple-work, for instance, lets the work-material, the stone, come forth into the

open and, in its own way, be manifest. Heidegger says: "The rock comes to bear and rest and so first becomes rock; metals come to glitter and shimmer, colors to glow, tones to sound, the word to say. All this comes forth as the work sets itself back into the massiveness and heaviness of stone, into the firmness and pliancy of wood, into the hardness and luster of metal, into the brightening and darkening of color, into the sounding of tone, and into the naming power of the word" (UK 32/171). Here, then, there is a kind of double or reciprocal relation between the artwork and the work-material: the artwork is made of the material, and yet also the artwork lets the material be set forth in the opening of world. Set forth out of the work-material, the artwork lets the material be set forth. In this passage Heidegger also indicates—without calling attention to it—that it is precisely in this double dynamic that the work-material becomes something more than mere material, that its distinctively *sensible* character comes into play, metals coming to glitter and shimmer, colors to glow, tones to sound. Heidegger insists that the transformation is even such that the so-called work-material ceases to be such at all. In Heidegger's words: "Nowhere in the work is there any work-material" (UK 34/173). The sensible in art is not to be thought as materiality.

What, then, is the stone of the temple if not a work-material? What is the color of a painting if not, first of all, a work-material, even if, in the painting, what counts primarily is not its sheer materiality but its glowing and shining? Toward the end of *The Origin of the Work of Art*, Heidegger returns to the already dismissed question of the thingly character of the work and confirms its dismissal: "Now we no longer raise this question about the work's thingly character" (UK 56/193). He explains that what initially seemed to be the thingly character and what then seemed to be the work-material prove to be, instead, the *earthy character* of the work (*das Erdhafte des Werkes*).

And yet, at the very least, one would need to insist that this earthy character is also sensible, that the metal of a Greek bronze must not only be earthy but also must glitter and shimmer under the Greek sun. Consider the famous Poseidon of Artemision, a bronze dating from about 450 BC. In this work the god is represented at the moment when he raises his right arm to hurl the trident against an adversary. In this case the sensible character of the bronze seems incomparably more significant than its alleged earthy character. Does it even have an earthy character? What is earthy in this representation of the god of the sea, especially considering that the ancients regarded metals not as earth but as water or fluid (ὕδωρ)? Is earth the element of this work? And, even if so, is it not its purely sensible char-

acter—the shining proper to bronze—that is set forth more than its earthy character?

From this point on, questions regarding the earthy character of the work begin to accumulate, and these questions are indicative of the need to press beyond the limits of Heidegger's essay to further differentiations, especially regarding the character of the sensible in the artwork.

Especially urgent is the question as to whether what is usually considered the thingly character or the work-material can throughout all the arts be characterized as earthy. What is specifically earthy about tones, much less about words? Is it not more likely the relation to the voice, their vocality, that is decisive and not whatever relation—remote it would seem—they might have to the earth? Is it decisive for a painting's colors that the pigments have been ground from earthy material? Is it not rather the glowing and shining of color and all that comes with this that is decisive? If the artwork brings the earth forth, gathering it to its intimacy with the world, does it do so by having an earthy ingredient, by being composed of earth? Must it be in this sense earthy in order to set forth the earth? Is this the case even when a work is doubly related to the earth, both setting it forth and taking it as an explicit theme? Is there anything earthy about the orchestral and vocal tones of Mahler's *Song of the Earth*?

To be sure, the setting-forth of earth occurs as a moment within the artistic happening of truth as such; and Heidegger's essay does indeed offer—especially in conjunction with *Contributions to Philosophy*—an account of what is required for such happening, for the setting of truth as such into the work. In order for truth to happen at all, it must install itself in an open space, in a *there* (*da*). This is why Heidegger stresses the character of the temple as standing-*there* (*dastehend*): the templework stands in such a way that it opens a *there* for the happening of truth. In turn, then, as this case indicates, truth can install itself in a *there* only if it takes a stand in a being. In the idiom of *Contributions to Philosophy*: truth must be sheltered in a being, must appropriate a being as shelter, so that truth happens as appropriation, as *Ereignis*. And yet, this coming to be sheltered in a being is not something subsequent to truth. It is not as though truth first exists in itself and only subsequently comes to be sheltered in a being. In Heidegger's words: "But truth does not exist in itself beforehand, somewhere among the stars, only subsequently to descend elsewhere among beings" (UK 49/186). In short, truth and its sheltering belong together. Truth happens only in being sheltered in a being, as when it is set into an artwork.

And yet, in order that such a being, an artwork, be capable of shelter-

ing truth, it must be such that—whatever else is required of it—it sets forth the earth. One might even suppose that this setting forth of such an element is what most decisively distinguishes the determination of art proposed in the essay from the metaphysical determination.

How, then, does—or will (in another beginning)—the sensible occur in art such that it sets the work back into an element that, like the earth, is self-withholding? Is it perhaps the shining of the sensible in the work, not the work's earthy composition, that sets it back into such an element, so that, as with Hegel, the work would be genuinely detached from materiality and its sensibleness transfigured into appearance, into shining? How would the shining have to be understood and differentiated in order that it prove capable of setting the work back into such an element?

Hegel, it seems, caught a glimpse at least of this possibility when, referring to a kind of painting occupied less with content than with the production of shining, he praised its capacity to capture, among other things, the "shinings of the sky, of the time of day, of the lighting of the forest, the shinings and reflections of clouds, waves, seas" (A 2: 189/812)[18]—in short, its capacity to set forth various elements through transfigurement into shining.

Yet, whatever the guise in which the sensible sets the work back, must the element into which it is set back—the element that is thereby set forth—be the earth? Must it be *only* the earth? Could it be that artworks are set back into various elements, that they thus set forth various elemental dimensions of nature? But what, then, of the duality of world and earth, which provides the primary axis, the principal design, of Heidegger's essay? Would this axis, this design, not have to be rethought, indeed reconfigured? Would the origin of the work of art not be exposed then to a mutation that has yet to be thought but that perhaps has already been attested from the side of art itself? For there are certain works—perhaps most notably, by those such as Cézanne, Klee, and Chillida, to whom Heidegger has called attention, yet not only by these, not by any means—in which there appears to have been carried out in the work itself just that which, at this limit, thinking would foresee and put forth as the promise of art.

18. This passage as well as others in which, counter to the systematic constraints, Hegel tends to reorient painting to the sensible, are discussed in context and in detail in chapter 5.